D1094777

Bathory, Rebecca,
Return to Fukushima /
2017.
33305239055712
sa 06/05/17

RETURN TO FUKUSHIMA

REBECCA BATHORY

RETURN TO
FUKUSHIMA

No part of this publication may be reproduced or transmitted in any form or by any means
without the prior permission of the publisher. Any copy of this book issued by the publisher
as a paperback or hardback is sold subject to the condition that it shall not by way of trade
or otherwise be lent, resold, hired out or otherwise circulated without the publishers' prior
consent in any form of binding or cover other than which it is published and without a
similar condition including these words being imposed on a subsequent purchaser.

The information and images in this book are based on materials supplied to the publisher
by the contributors. While every effort has been made to ensure its accuracy,
Pro-actif Communications does not under any circumstances accept responsibility for
any errors or omissions. The copyright with regards to all contributions remains with
the originator.

A catalogue record for this book is available from the British Library.

First Edition 2017
First published in Great Britain in 2017 by Carpet Bombing Culture.
An imprint of Pro-actif Communications
www.carpetbombingculture.co.uk
email: books@carpetbombingculture.co.uk
©Carpet Bombing Culture. Pro-actif Communications

Photography by: Rebecca Bathory
Editorial by: Patrick Potter

ISBN: 978-1908211-48-4

CARPET
BOMBING
CULTURE

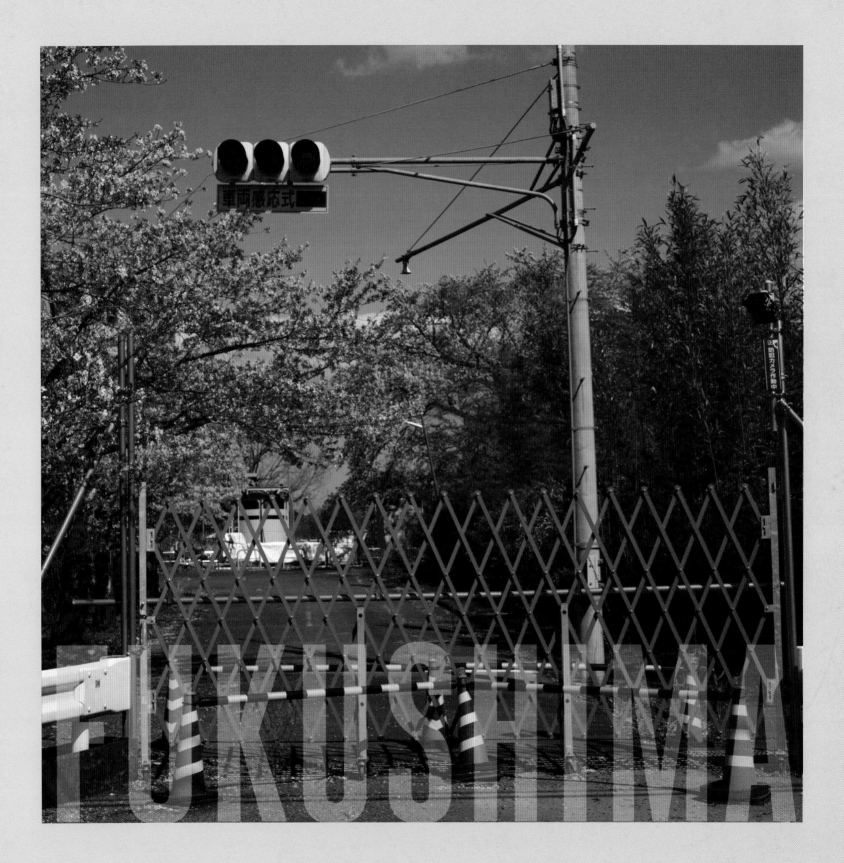

車両感応式

FUKUSHIMA

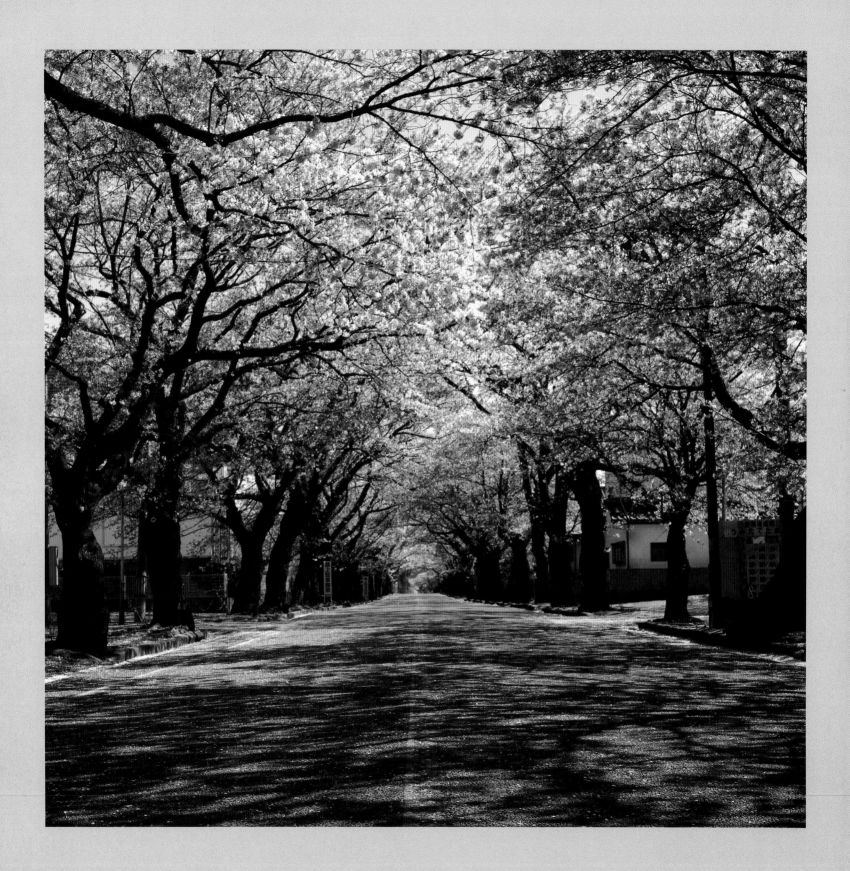

FUKUSHIMA

ON THE THIRD OF MARCH 2011 the worst earthquake to hit Japan in recorded history triggered a series of cascading malfunctions in the Fukushima Daiichi nuclear power plant. The black waves of a massive tsunami overwhelmed the perimeter walls, flooding the site and causing the reactors to automatically shut down. Soon after, the plant was cut off from the national grid by earthquake damage.

Without electricity to power the cooling systems the reactors overheated. Superheated water split into pressurised hydrogen gas causing a huge explosion. There were three core meltdowns.

A plume of radioactive smoke was driven North West by the prevailing winds. Plant workers struggled desperately while torrents of radioactive water escaped into the sea.

Nuclear meltdown. It is the worst nightmare of modern humanity. Forces we barely understand that seem so fundamentally powerful and dangerous that we think of them only in terms of profound unease. Isotopic radiation - the worst of all monsters, the invisible fiend that can alter our very DNA. An idea so terrifying that the thought of it alone kills more people than the effects of the isotopes.

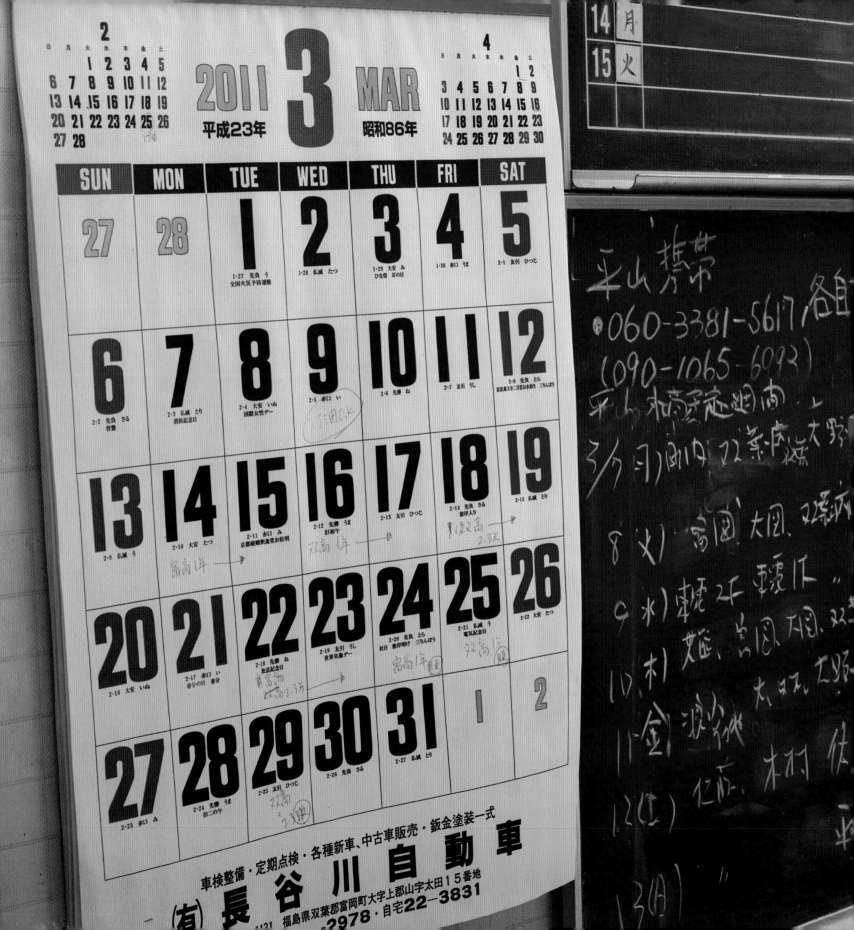

A thirty mile exclusion zone was established and a mass exodus of residents scattered out across Japan. Whole towns and villages were evacuated. Some villages were completely washed away by the sea. In these places, once called home, the clock stopped on 3/11. Cats and farm animals starved in the streets. Food rotted in restaurant bowls. Silence reigned.

In 2016, for the first time - residents of the town of Tomioka were allowed to return, to walk their streets in the midst of a beautiful display of cherry blossom. Rebecca Bathory was given permissio to return to photograph in the exclusion zone - to capture for future generations this dark yet hopeful moment in their history.

Although this was the worst nuclear disaster since Chernobyl, there are many reasons to be hopeful. The damage was not as severe and the Japanese have spent billions on removing layers of contaminated soil and debris from the area. There are high hopes that Japan will be able to use the 2020 Olympics in Tokyo as a platform to celebrate the regeneration of Fukushima province. However, with many displaced people now saying they no longer wish to return - the future is uncertain.

And if they return, what kind of new life would they want to build? Is it a new future of low energy usage and renewable resources? Or a return to business as usual with Japanese power plants reopening? Japan, world renowned for her technological prowess, is now soul searching about her energy future. The world is watching.

This collection of images is intended to capture the sadness of a moment in history, a moment that is relevant to us all as we are increasingly being forced to decide what our future will look like. In the end, these macroeconomic decisions are measured out in individual human lives, losses and hopes.

Where do you stand on nuclear power? Don't answer, not yet, at least until you return to Fukushima...

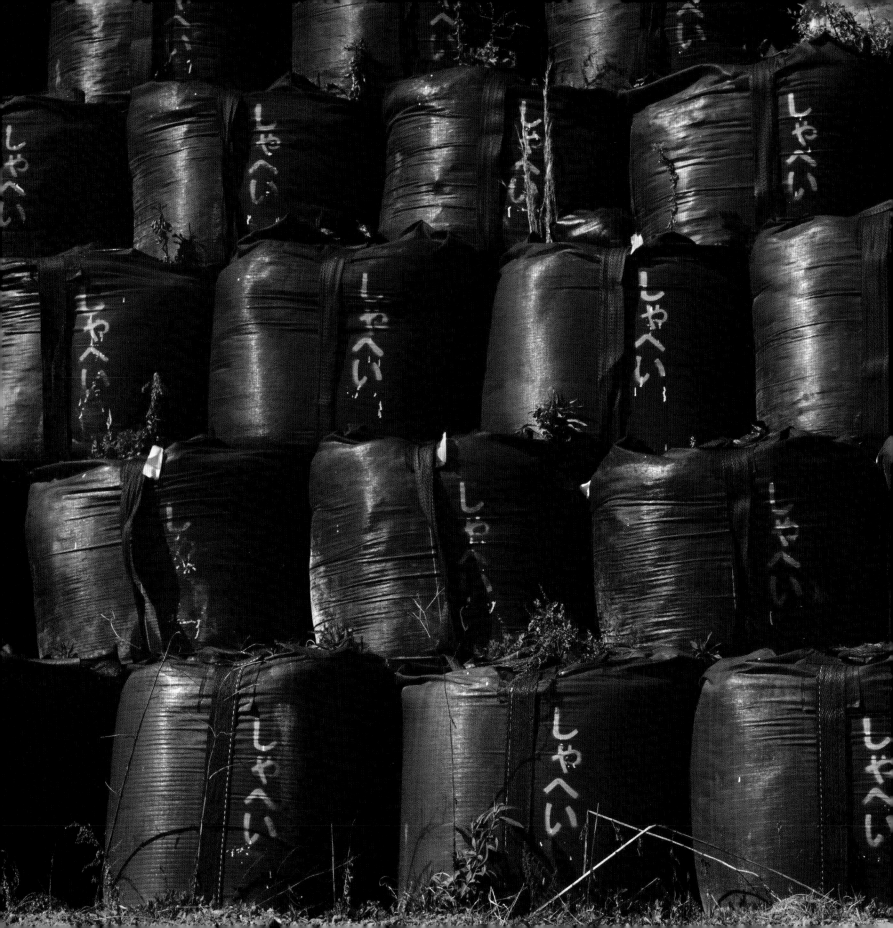

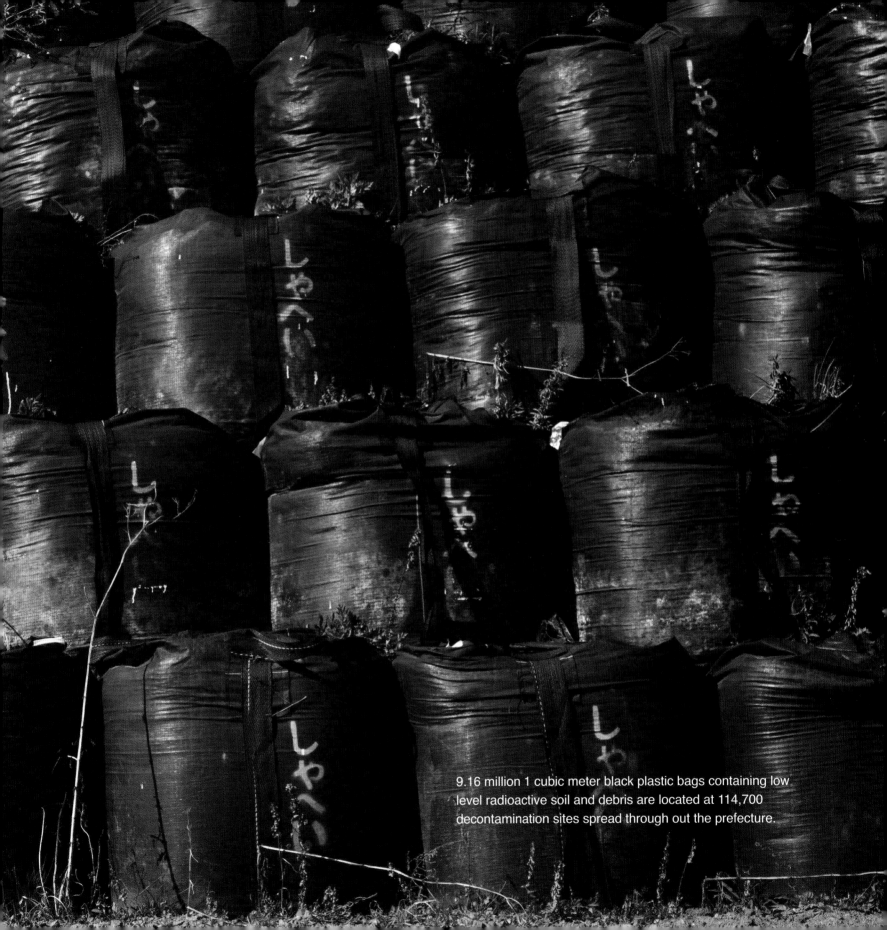

9.16 million 1 cubic meter black plastic bags containing low level radioactive soil and debris are located at 114,700 decontamination sites spread through out the prefecture.

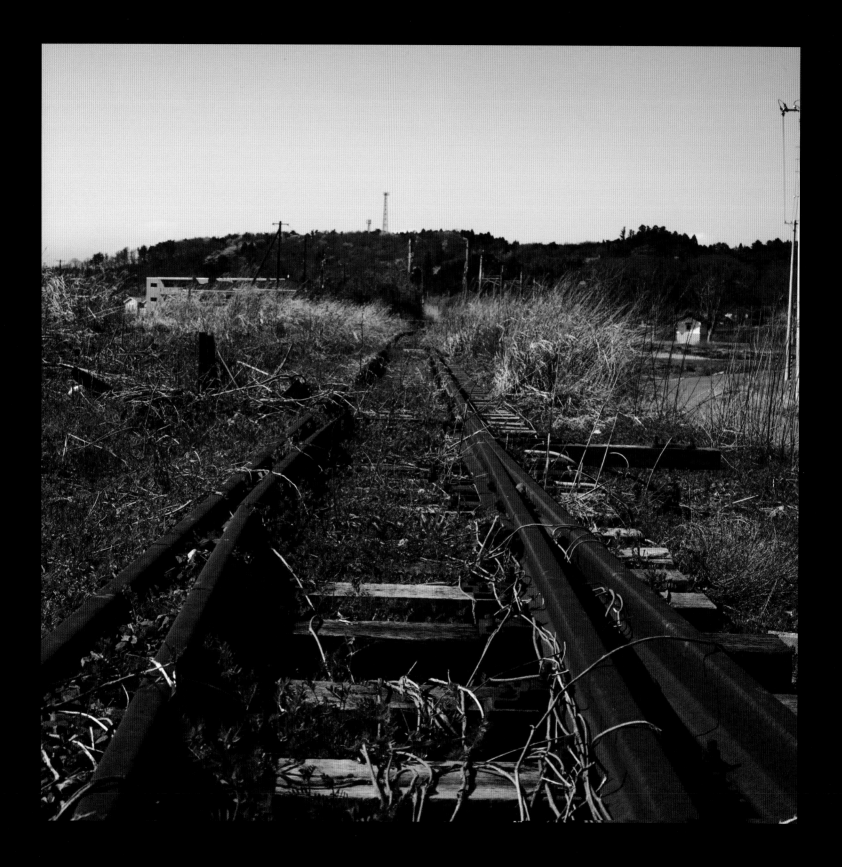

DEVASTATED BY A NUCLEAR
DISASTER

Rebecca Bathory

NUCLEAR ACCIDENTS HAVE BEEN OCCURRING SINCE THE 50's. My first trip to such an area devastated by nuclear disaster was the biggest in history, Chernobyl, which happened in April 1986, I have now visited three times over three years to document the exclusion zone and what remains. I've photographed this land through different seasons, and experienced and seen different buildings each time. The radiation there will live for thousands of years, contained within a newly constructed sarcophagus, built to replace the old weathered one made in the 80s to stop nuclear fallout across the world.

I photographed in Chernobyl because as nature claims back the buildings that once thrived with life, in years to come they become just ruins and the photos I have taken on these trips will serve as a historical record. These photos are a reminder for me of that tragic event, and to those that view them show the fragility of human existence and how powers such as this should be treated carefully so as not to allow events like this to happen again.

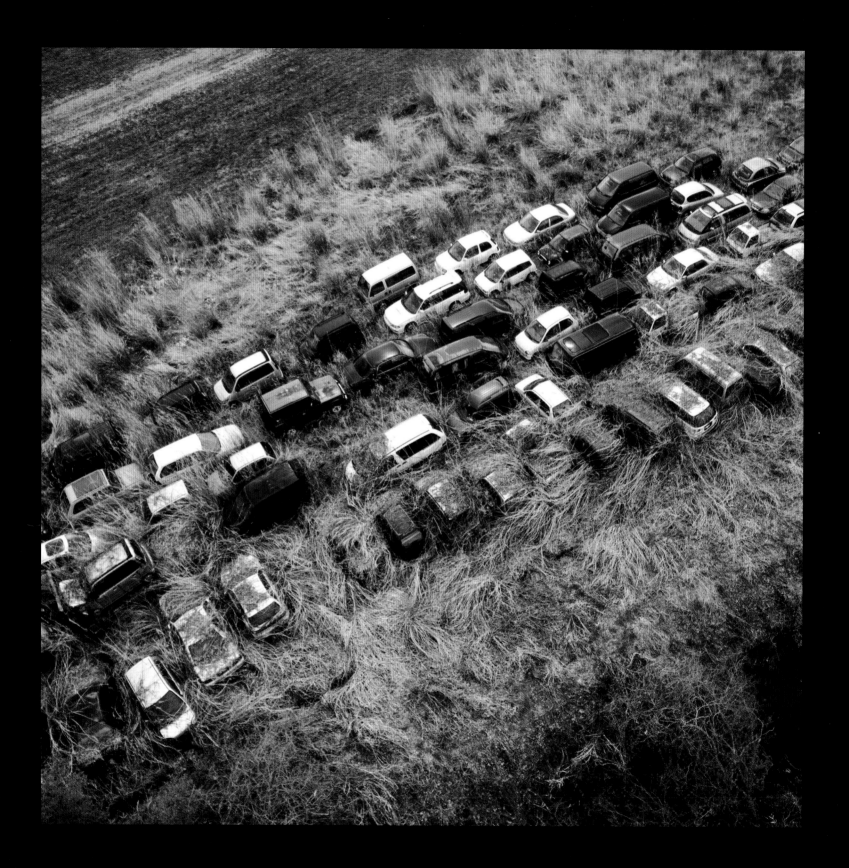

Fukushima is the latest nuclear disaster but one that is just as devastating as Chernobyl. A series of equipment failures and nuclear meltdowns occurred on 11th March 2011 after the Tohoku earthquake. It reached a level 7 on The International Nuclear and Radiological Event Scale (INES), which has only been matched by the Chernobyl incident. The tsunami caused by the earthquake, that triggered damage on reactors 1, 2, 3 and 4, occurred 50 minutes after the initial quake. A 13 metre wave was just 3 metres too high, and overcame the 10 metre wave gate that the power station had in place.

As news of the terrible earthquake and tsunami filtered to the UK over the news, I watched and felt true sadness for Japan. The 9 magnitude earthquake was the biggest ever recorded in Japan, and the fourth largest in the world. I was overwhelmed with grief for the people who had lost their lives. With casualties reaching 30,000 and more than 125,000 buildings destroyed.

I first became fascinated with photographing abandoned buildings three years after the Fukushima disaster, and whilst researching new locations to visit I came across photos of what has now become the exclusion zone. Memories of the event came back to me. Around the time that I first visited Chernobyl I reseached the possibility of photographing the newly deserted Fukushima. I made some inquiries but faced a wall of rejection and realised that at that time it was impossible to seek the permission to shoot there.

Photographers have in the last five years photographed there, but it is incredibly hard to gain permission to the exclusion zones. I desperately wanted to visit and the fact so few photos existed made me want to visit even more but I had to give up on the idea due to the restrictions in place.

In 2016 I began to photograph dark tourism sites around the world for a new book and decided I would make another attempt to gain access. Dark tourism involves travelling to sites around the world that are associated with death and tragedy. Although not many people visit Fukushima as dark tourists, I have known a large amount of people with the same interest as myself also wanting to go. I began to make plans to travel to Japan to see Hiroshima and the Japanese Suicide Forest, hoping to visit Fukushima as well. Once my flights were booked, I noticed a Polish photographer Arkadiusz Podniesinski had been there and had created a series of documentary photos that had been published in the media. I reached out to him to ask how he had gained access and decided to try my best to make it happen. With the new leverage of researching my PhD in dark tourism and creating a new book, I began to make a plan.

A couple of weeks before my flight, I noticed that Arkadiusz Podniesinski was looking for a professional photographer to join him on a five day trip to the exclusion zone and I couldn't believe that the dates coincided with my schedule. I spent several days arranging it so that I could extend my trip and join him.

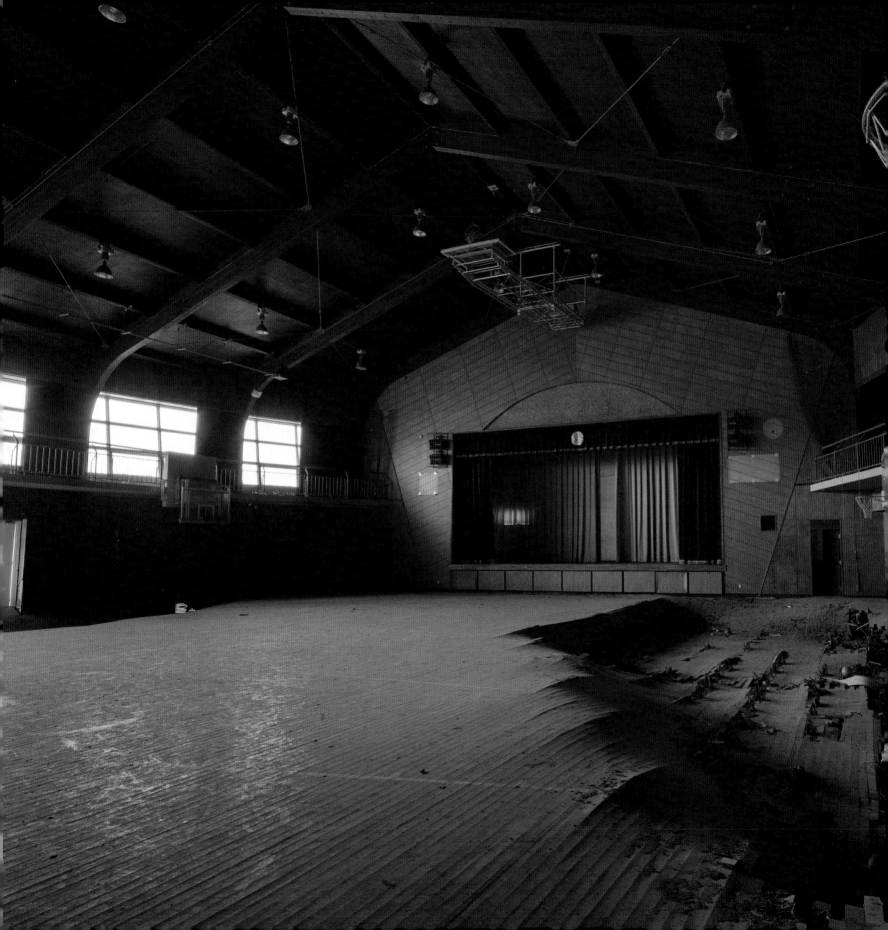

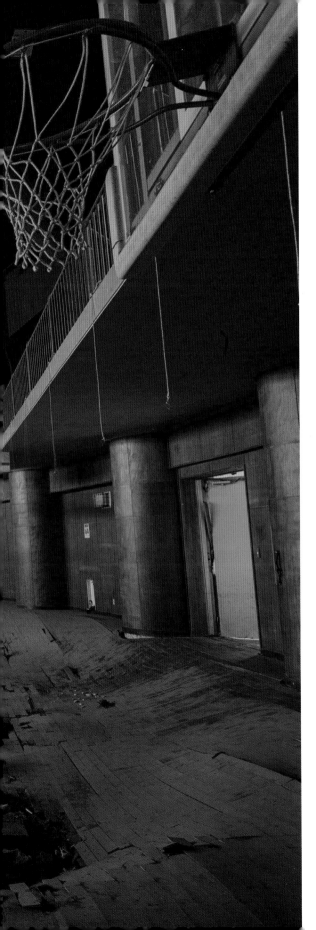

All government permits and permissions were arranged and before I knew it I was a part of his team, with a translator and government officials, able to visit areas within the red and orange exclusion zones. I considered myself very lucky as at the time of writing this the Fukushima disaster was still not fully understood. Not many photographers are allowed into these restricted zones, so I feel privileged being able to share with you images of what this nuclear disaster means for the world.

I expect that with time (as with Chernobyl) access will be allowed and tourists will take advantage to wander inside to take photos. But in its current state not much documentation is available, especially in the media. During the clean up the site will change over time and for me it was important to capture it now, just five years after it happened. It will probably never reach the decaying state of Chernobyl, as I believe Japan's huge clean up efforts will one day see this place habitable again.

My visit to Fukushima was intended to capture photos and explore areas that have not been photographed before with a sensitive artistic approach. I wanted my photos to capture the beauty that still exists in the area, because despite the tragedy of the earthquake and tsunami that caused the evacuation of the town, it is still a place of serenity and peace. Even more so, as human life is removed, nature claims back this devastated area. I coincided my visit in April 2016 with the blooming of the cherry blossom, Japan's Sakura. With earth day occurring that month, it was poignant for me to capture the exclusion zone in this time of celebration of nature, and as the symbol of spring, new life blossomed around this place of tragedy.

For me, I accept that catastrophe and death occur in our life, and although terrible for those that live through such pain, it is a reminder of our own mortality. Even through disaster nature will replenish the land and those that died will be remembered and honoured. It is particularly important for me to capture in photographs Fukushima as it currently exists, not only for historical records, but to inform people about this tragedy so it is remembered. As the memory fades and those terrible images of that day no longer flood the media, it can be so easy for us to forget.

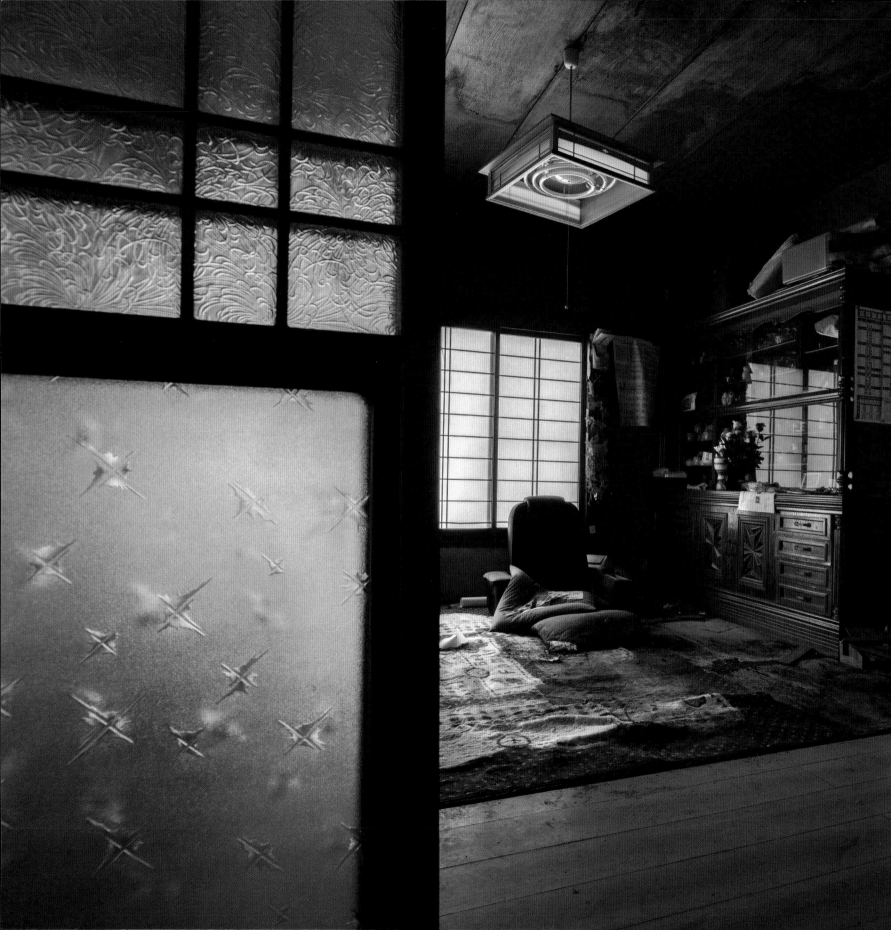

I took a documentary approach in the same way as those that have photographed there before. I wanted the view to relate to the tragedy, selecting sensitive items and personal objects that show the human element of the disaster. The aerial photographs create a bigger picture and help you to visualise the whole scene from an alternative angle.

I wanted to capture how a moment of time, a moment from which hopefully these towns will continue to be cleaned up and rebuilt and one day residents will return to their homes and rebuild their towns, very much in the same way Hiroshima has become a thriving city again. I hope that these photos may be viewed in years to come in the same way that the photographers captured the aftermath of Hiroshima.

For my photography series in Fukushima, I used medium format Mamiya Leaf Credo 80 to capture the shots in high 80mp resolution. I used a 3 Legged Thing tripod to allow the shots to be perfectly sharp and Lee filters big stopper on some of the outdoor shots. I took the Phantom 3 Pro drone to capture some aerial shots to give a different perspective. All carried in a Lowepro Protactic 450AW, and the drone in a Lowepro Drone guard 450AW backpack.

On the first day of the trip I woke at 6am, with several bags full of camera equipment, including an extra one to carry the drone. After an hour long train journey in rush hour Tokyo, I met Arkadiusz and his driver on the outskirts. As I chatted to him about his intentions for the trip, I realised that he had just stepped off a plane from Ukraine where he had been visiting Chernobyl. He had been to Fukushima four times previously so I asked him why he was returning this time and he replied that he wanted to photograph the town Tomioka as it was famous for its cherry blossom. He also wanted to revisit certain places he had been to create a film, and explore some places he had not yet been.

On arrival into Tamioka we drove to the orange zone, and to the check point of the red zone. Here was the cherry blossom tunnel that this town was once famous for. Despite the radiation it thrived and held so much beauty in a town torn apart by destruction. We spent some time here photographing the cherry blossom and then drove into the orange zone, close to the ocean where thousands of garbage bags had been stacked up containing nuclear waste. This was quite literally where the

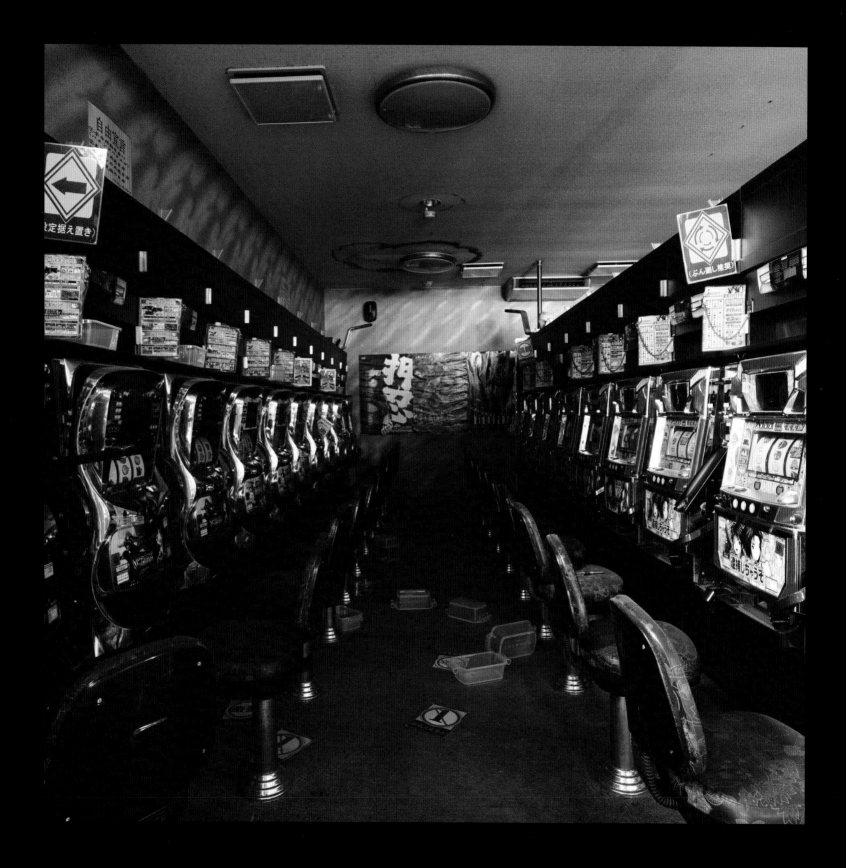

tsunami had come in and wreaked havoc across the land. There was evidence of this with buildings slanting to one side and cars on their roofs, rusting by the side of the road. These clean up bags would become a familiar site throughout the exclusion zone in these five days of my exploration.

As we wandered around Tamioka we had to be very vigilant as we weren't supposed to be in the buildings. We ducked into the odd one occasionally, and found a supermarket and Pachinko slot casino. For me it was exciting discovering and exploring these buildings, and unlike a lot of abandoned buildings I visited, these were untouched, left abandoned in the same state they were on the 11th March five years ago.

I wanted to see it with my own eyes, and I wanted my feelings and thoughts to be my own

After some time exploring we returned to the cherry blossom tunnel where a TV film crew had earlier been setting up lighting, so that they could film live later that evening. We decided to take advantage of this opportunity with the cherry blossom lit up in the moonlight, and managed to capture some eerie photos of the street. As the sun went down with the cold wind beating down on me, I felt chilled and isolated on this street.

Again, on day two we awoke at 6am, and after a quick breakfast headed to the Tamioka town hall, to meet a government official. We had been granted permission to explore the red zone for three hours only. This was very exciting for me and Arkadiusz, as the last time he had made it inside Tamioka his official guide had not let him out of his sight, but this time we were given free access to explore on our own. Together we checked the buildings, slowly creating a picture in my mind of that fateful day. I had not researched too much about the disaster before the trip, I wanted to see it with my own eyes, and I wanted my feelings and thoughts to be my own, to form a story based on my own experience there, and allow it to unfold the more I ventured around the exclusion zone.

洛上駐車厳禁

富岡町

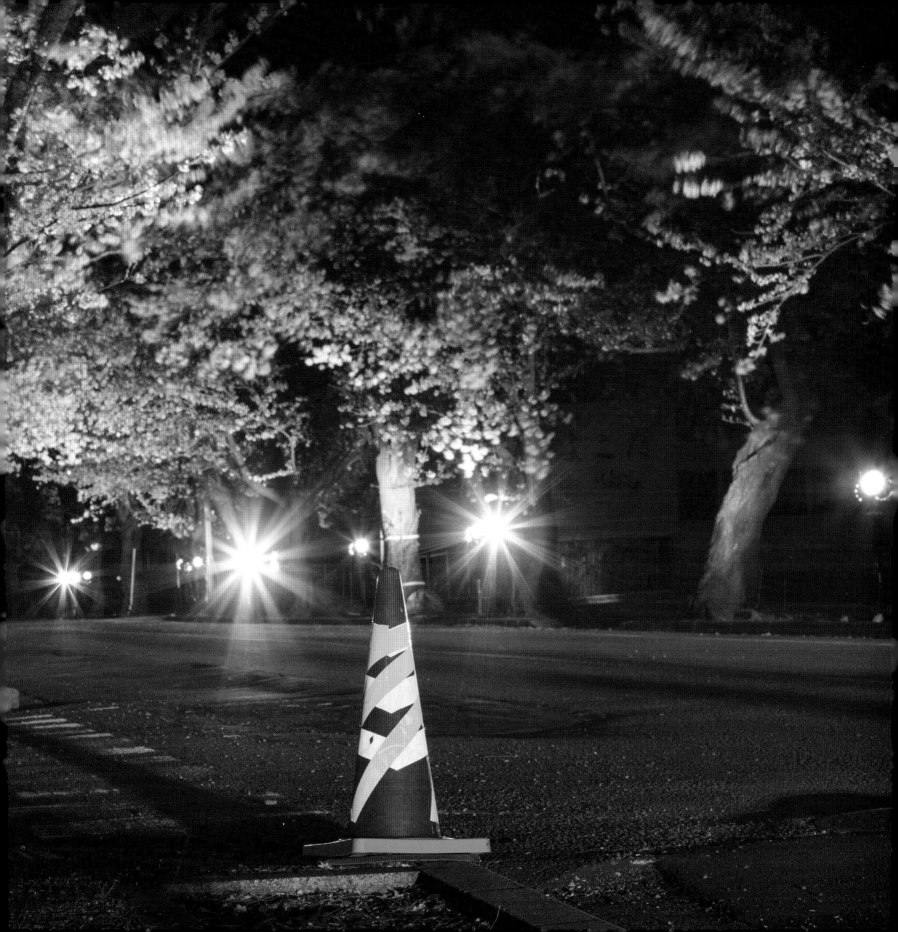

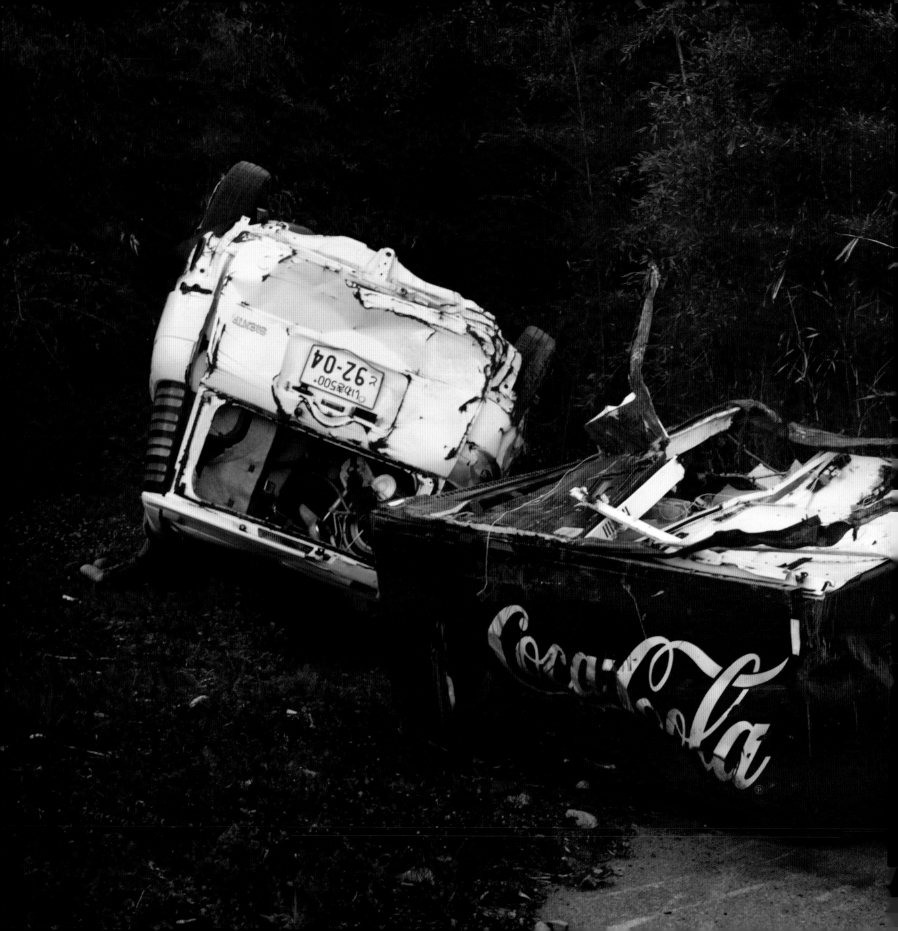

We found a shrine, restaurant, hospital, bookshop, hair salon and DVD shop amongst others. I was overwhelmed each time I entered a building, knowing they were pretty much untouched since the disaster. I have photographed hundreds of abandoned buildings, but it is very rare to find one that hasn't been tampered with somehow by humans, whether by photographers moving objects around for photos, or people vandalising them. It felt very special to be in an abandoned place where furniture and objects had been left untouched the same as on the day it happened, emotions began to build, when seeing signs of this tragedy.

...emotions began to build

We had radiation checks on our way out, and our car and clothing were both scanned for contamination. With no signs of contamination we headed to the orange zones for more exploring, finding various buildings to photograph.

On day three we decided to fly the drone to get aerial footage of some abandoned cars. Unfortunately the cars were inside the red zone and even though we were not, standing at the edge, it wasn't long before the police had seen the drone and were coming to alert us that we were not allowed to do this. Luckily I had already got the drone shots I wanted and landed it before they came. However, for the next three hours about ten police offices continuously checked our passports chastising us for being there. They proceeded to tell us where we could and could not fly the drone, then eventually let us go. Even walking in orange zones there is a high police presence, we were asked why we were there on many occasions, and had to be careful not to get caught in buildings. The red zone areas had authorities at the gates, and we were strictly forbidden to enter without an official.

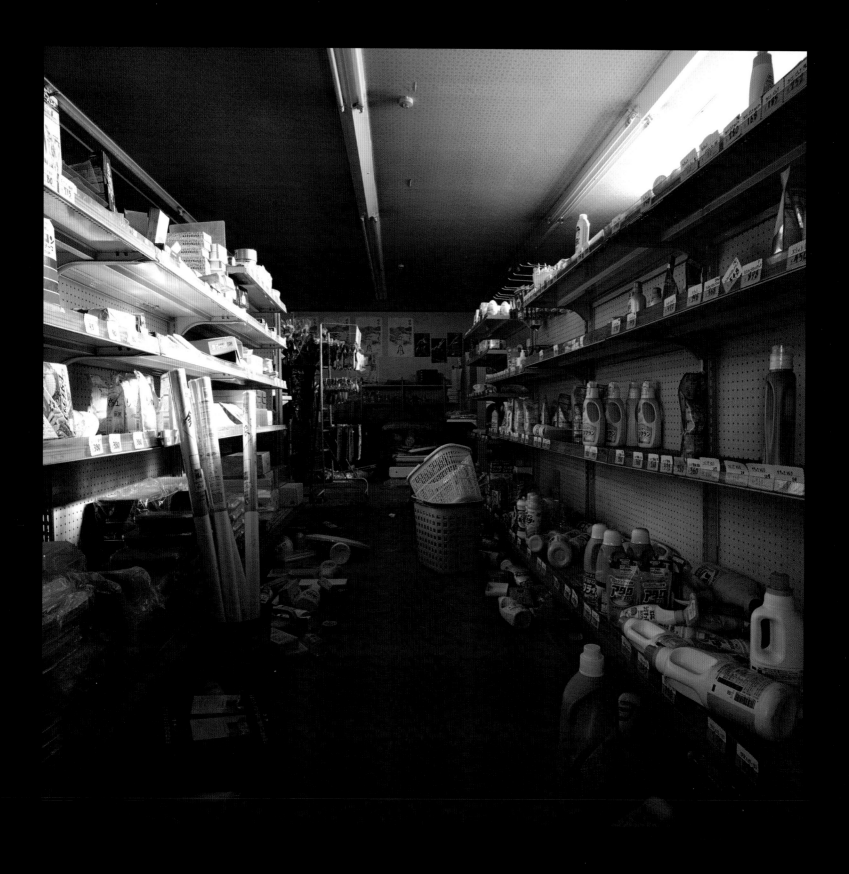

We spent the rest of the day exploring Namie, but it was the book store that really made me pause for a few minutes to reflect. In Pripyat (Chernobyl) the disaster went unnoticed, most people didn't even realise anything had happened. Here, the earth shook and things came tumbling to the ground. I imagine people would have been filled with terror while fleeing for their lives. Standing in this book store there were fallen shelves with books piled on the floor. It was similar in a nearby DVD shop, thousands of contaminated DVDs laid on the ground covered in dirt. I felt emotions unlike I've ever felt before in abandoned buildings. People must have feared for their lives and fled these towns, without the chance of taking their personal items or even to lock their doors behind them.

For some strange reason the power was still on in this book store, a computer still turned on, as well as the automatic door, covered with cobwebs, opening and closing, making an eerie, creepy noise. It had me really spooked until I realised where the noise was coming from. It began to feel like the disaster had just happened, time had stood still and yet these doors were on repeat over and over again. I walked over a pile of books, in this store that was once somebody's livelihood, a place where people took pleasure in walking down the aisles of books, picking out their favourite titles. I felt bad walking all over them to take my photos, books are such special things, and now they just lay before me, contaminated and decaying.

As I was taking my last photo, a sudden, deafening alarm shot through the building, and Arkadiusz came running towards me saying that he had tripped an alarm. We ran to the car and drove away from the site as quickly as we could. We returned an hour or so later to the same deafening alarm sound. In a place as desolate as this there was no-one to hear it. We decided to go inside and turn it off. We found a photo album containing images of employees wearing the same uniforms we saw scattered on the floors. They smiled back at us, holding books, standing by the shelves. Flicking through this album made me truly sad, these people had suddenly lost their jobs and faced a new life. A calendar was hanging on the wall showing that fateful date, time standing completely still in this place.

Emotionally, day four hit me the hardest, everything just kept unfolding as we drove, walked, explored. The story beginning to build in my mind. During some moments it felt like I was living it myself. We were asked to put on radiation suits and go with a government official to explore the red zone of Futaba. It was highly radioactive, so in some areas marked with red flags we only stayed for a minute or two. We photographed the town hall and a race cart track. We got as close as we could to the power plant, I could see it in the distance.

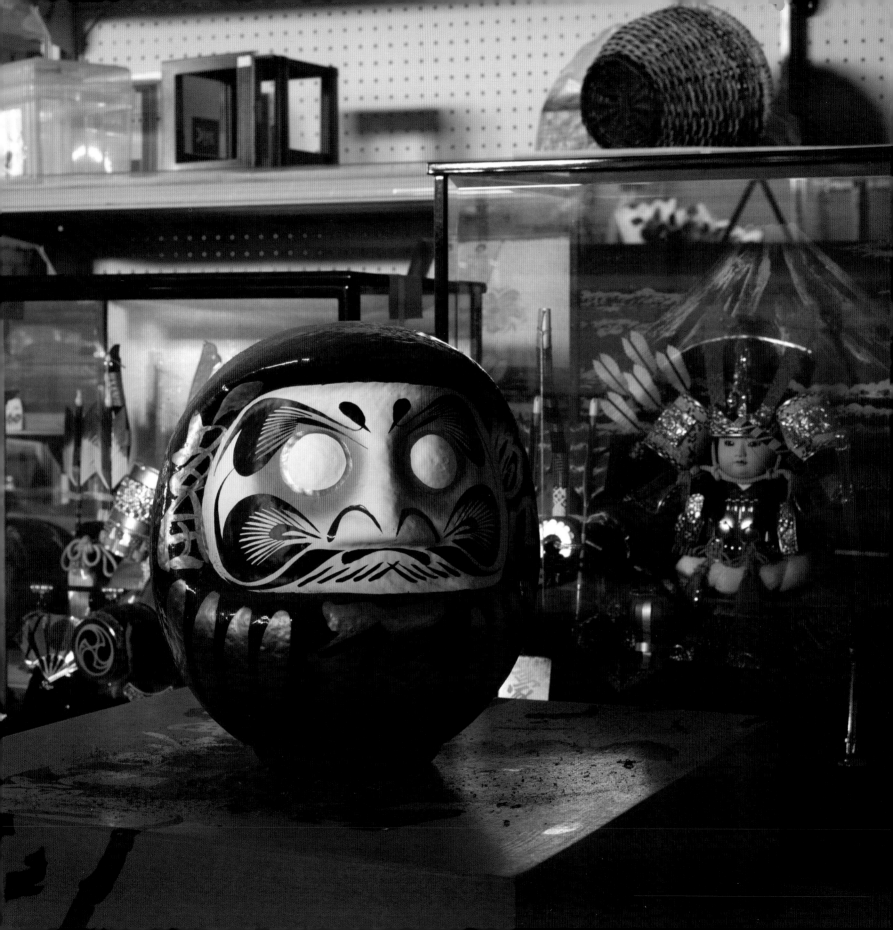

At the seafront in the red zone, I saw a building that had been destroyed, showing the water mark where the tsunami had reached. I watched the waves beating along the shore, metal gates, twisted and rusting rubble, decaying pieces of buildings, all lying along the shore. I stood at the edge of a broken jetty that was crumbling into the sea, and thought of that huge wave, it's height incomprehensible. It swept in so quickly and caused so much chaos on the land, and took so many lives. I cried at the edge of that jetty, how powerful nature is and how easily life can be taken away by such a force.

The day finished at a farm of a man who had gone into the danger zone after the disaster and found over 200 animals, which he took back to his farm. I took photos of these cats and dogs, they openly showed us affection and seemed happy living here.

After a short drive we went to another farm, one with a much sadder story. I wasn't really told what to expect. Arkadiusz knew I liked to take photos of dead things, as he had watched me capturing a mummified cat earlier that day. He told me we would be photographing some bones of cows that had died. But nothing could have prepared me for what I'd witness next.

With the memory of those living animals just half an hour before, I now faced pen upon pen of dead animals. Their bones littering every single one. Deeper into the pens I saw heads hanging from ropes that had originally been used to tie them to the railings. I wanted to tell this story to others, how real it was, how that wave had swept in and killed hundreds of animals and how they couldn't escape. My heart was in my throat, my soul changed forever. It all became too much, I had witnessed loss, pain, suffering, destruction, tragedy, death and decay, unlike any other abandoned building I have ever been to.

I know emotionally that I will not be able to return here. I felt excitement in the first few days, capturing these photos, in that same way as I have done in previous years. The rush of seeing something unique and unlike what I've photographed before. But this fourth day changed it all, the story unfolding bit by bit and I felt true heartbreak. I felt like I'd crossed the line between what I should and shouldn't photograph. Maybe this is why there aren't that many photographs of this place. It's a heart wrenching story, told through these photos.

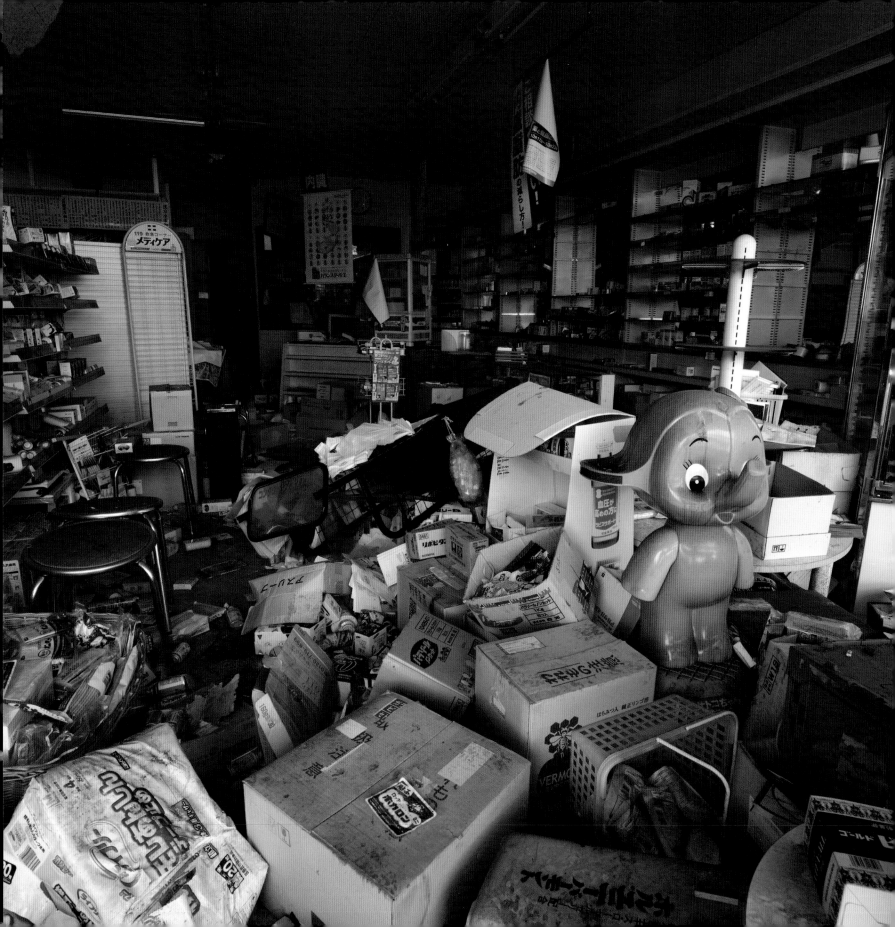

On our final day we drove around looking for larger buildings, and after a while we found a school we were able to enter and spent the next couple of hours inside. Our last stop was a supermarket inside the red zone. It was close to the border so we snuck in amongst the tall grass and ran inside. The supermarket was in pitch black and the stench of rotting food hit me immediately. As I wandered around, torch in hand, it felt like something out of a zombie apocalypse movie, produce scattered on the floor. As my nose slowly became accustomed to the smell, I wandered towards a skylight that allowed some extra light to touch some of the aisles and allowed me to photograph. As time ran out, I took a moment to take in those last five days, to stand there alone in the dark and remember those that had suffered and to pray for each of them. Those that had lost their lives, and those who had their lives shattered.

I knew this whole experience had touched me, far more than I had ever imagined it would

Finally we exited this vast space and began the fight through the bushes once again to reach our driver on the edge of the red zone. Using a walkie talkie we told him to come back and get us. We crouched down low until we could see the car pull up and then ran as fast as we could towards it. My heavy camera which I had slung over my shoulder hit my hip bone hard, and I winced in pain. In the car my head pounded and my emotions got the better of me. I sat in pain, both physically and mentally, and knew this whole experience had touched me far more than I had ever imagined it would. As we drove back to Tokyo I was lost in thought of what I had witnessed, content in the knowledge that I had done my best to show this world through my lens, what it is like today.

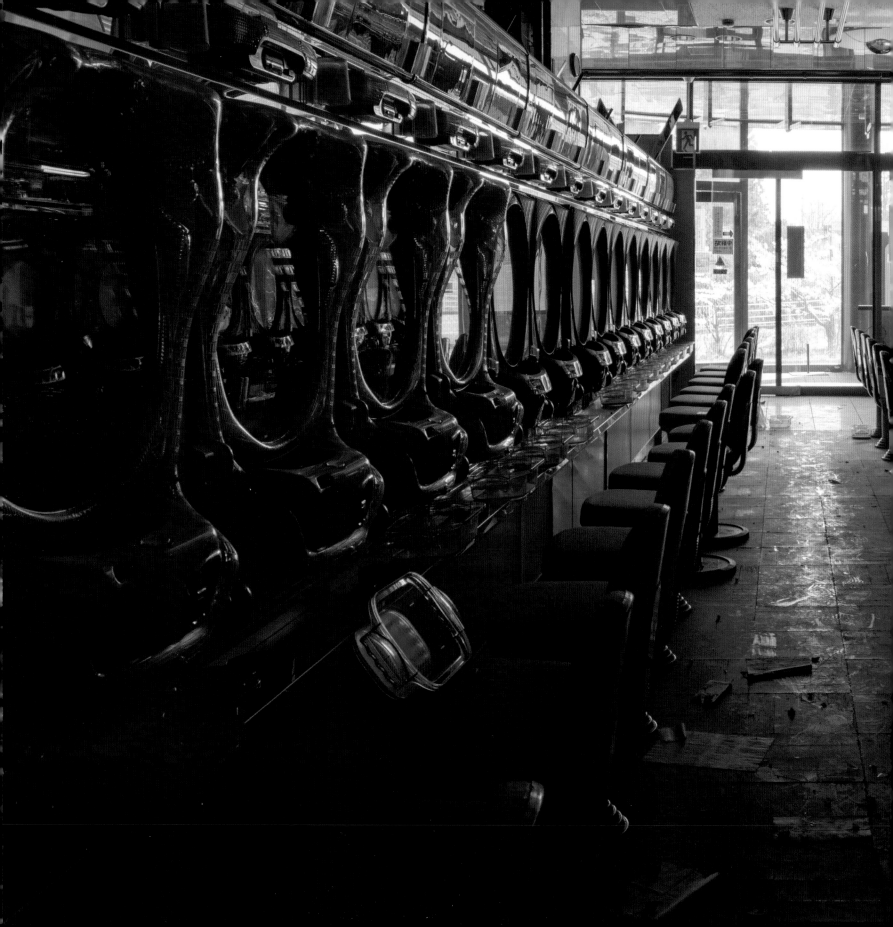

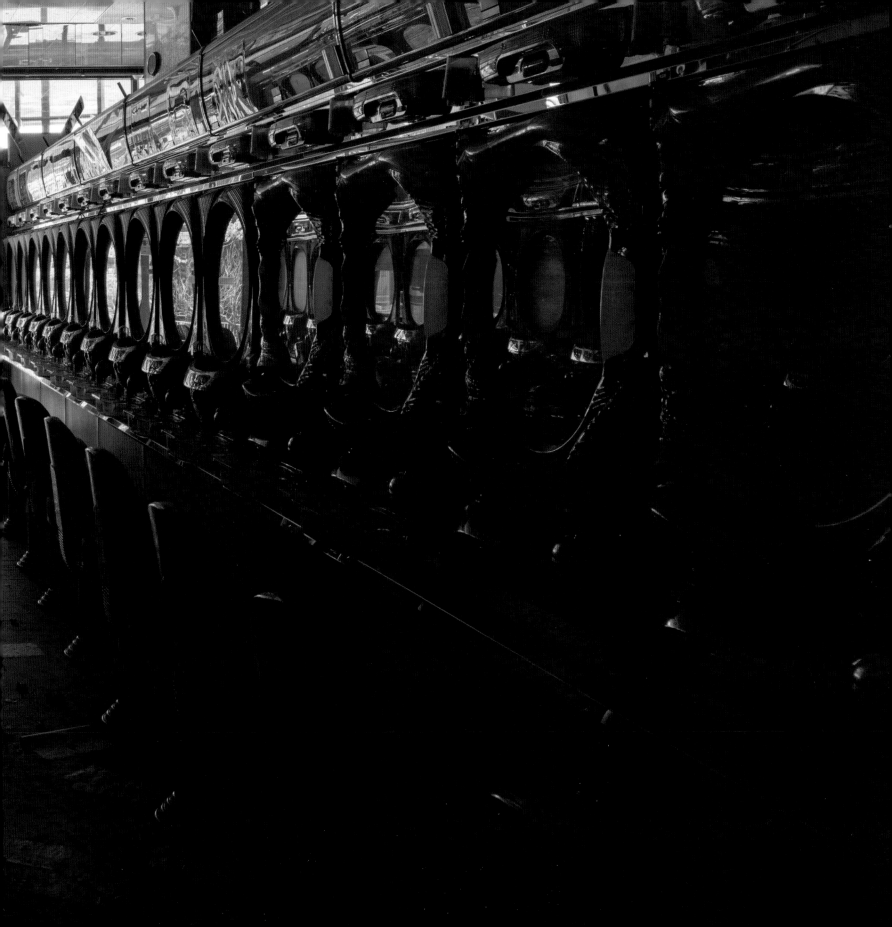

震災後
SHINSAIGO

The 3/11 earthquake moved the earth on it's axis.
Now, for Japan, history moves around the axis of the
earthquake. Shinsaimae - before the disaster.
Shinsaigo - after the disaster. Like BC and AD. The
earthquake was the event horizon for 21st century
Japan. Life for the people in and around the
exclusion zones changed so fundamentally that it
marked the beginning of a new era.

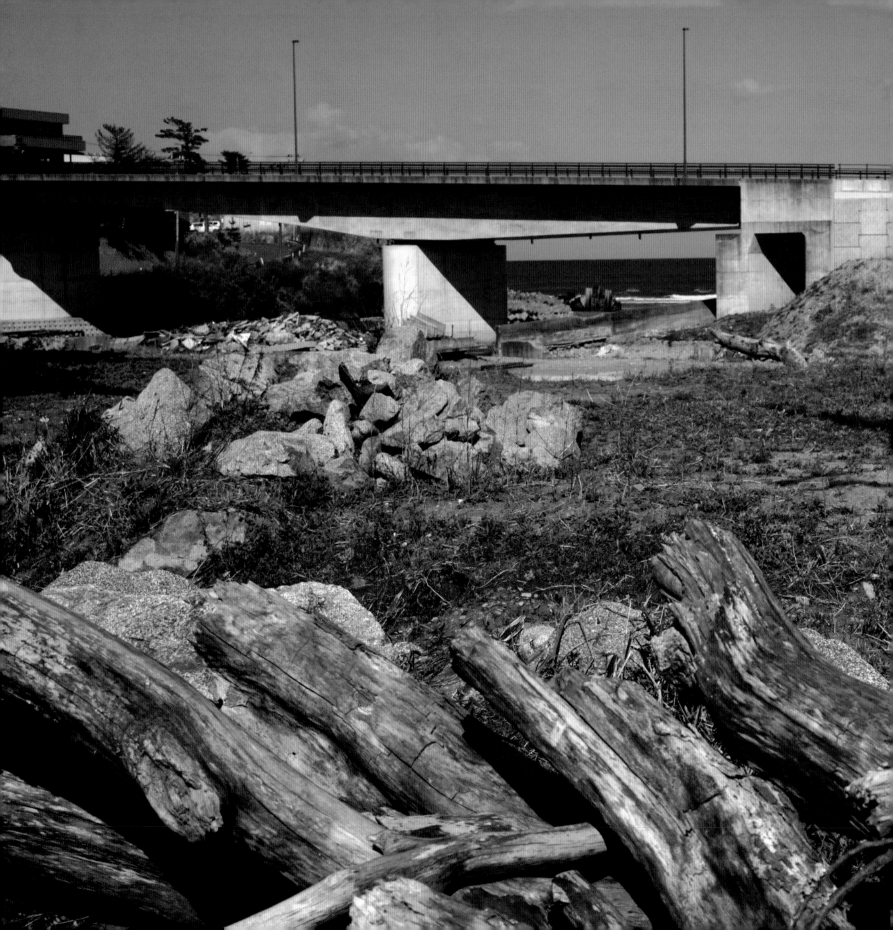

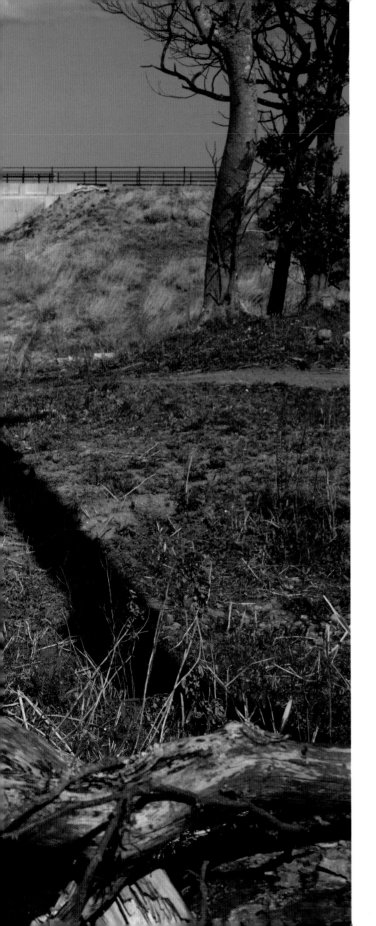

Kasetsu

In 2015 Japanese police issued a statement saying 228,863 people are still displaced. Many of these continue to live in prefabricated shelters called Kasetsu. 'Temporary shelters' still in use five years later. Lives on hold. Limbo.

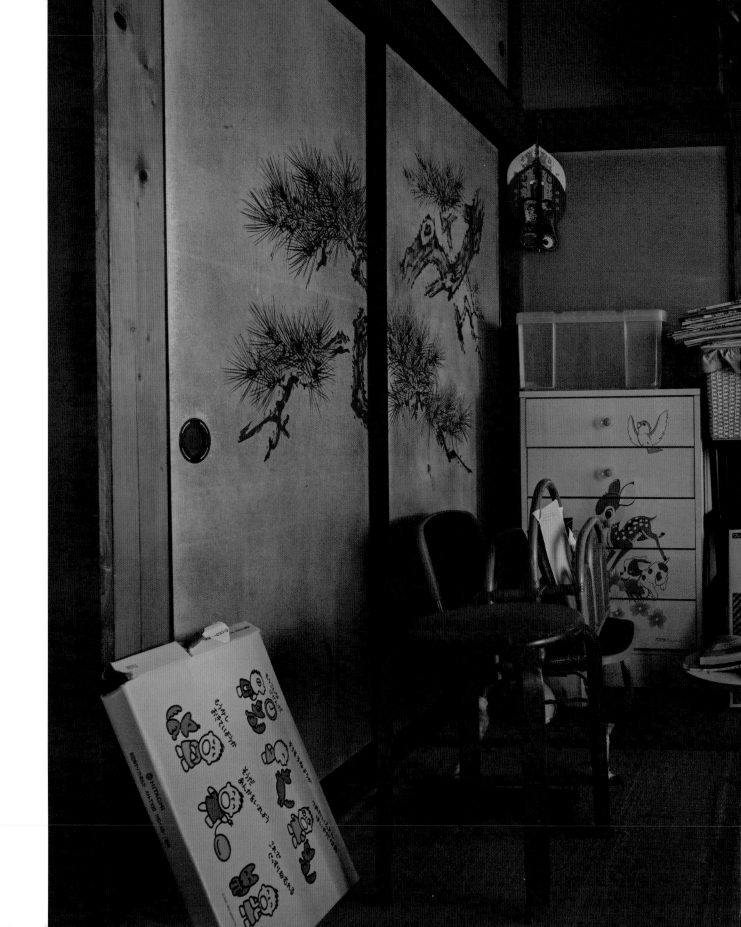

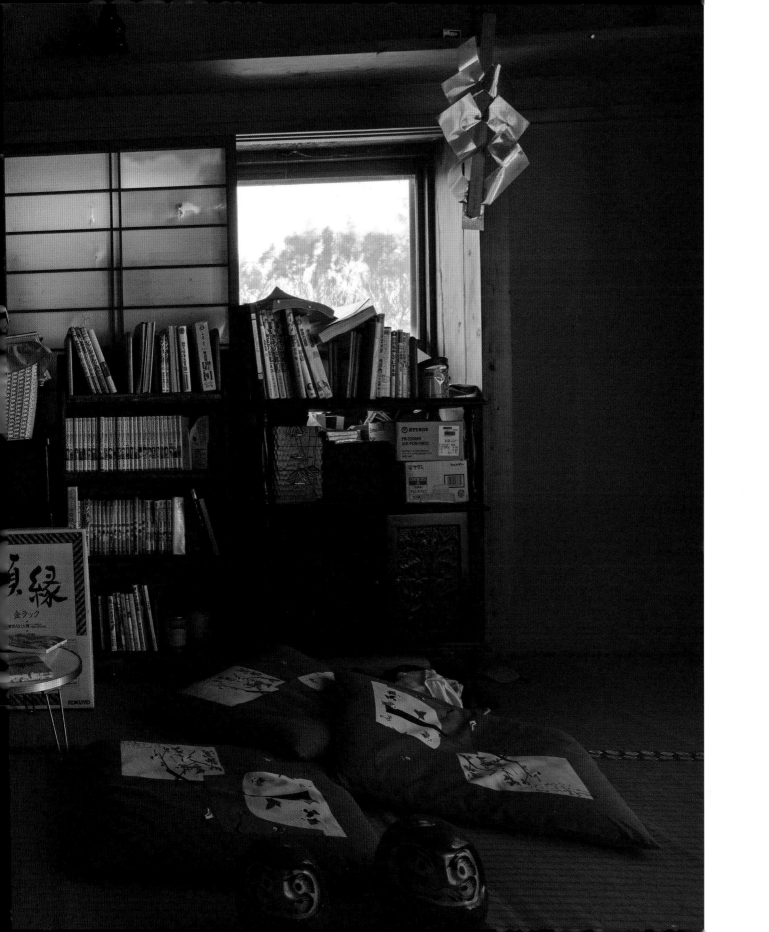

"ALL I'VE THOUGHT ABOUT
THESE YEARS IS THE
NUCLEAR POWER PLANT.
WHY DID WE BUILD IT
IN THE FIRST PLACE?
WHAT IS IT ALL FOR?"

- Survivor, Greenpeace Video

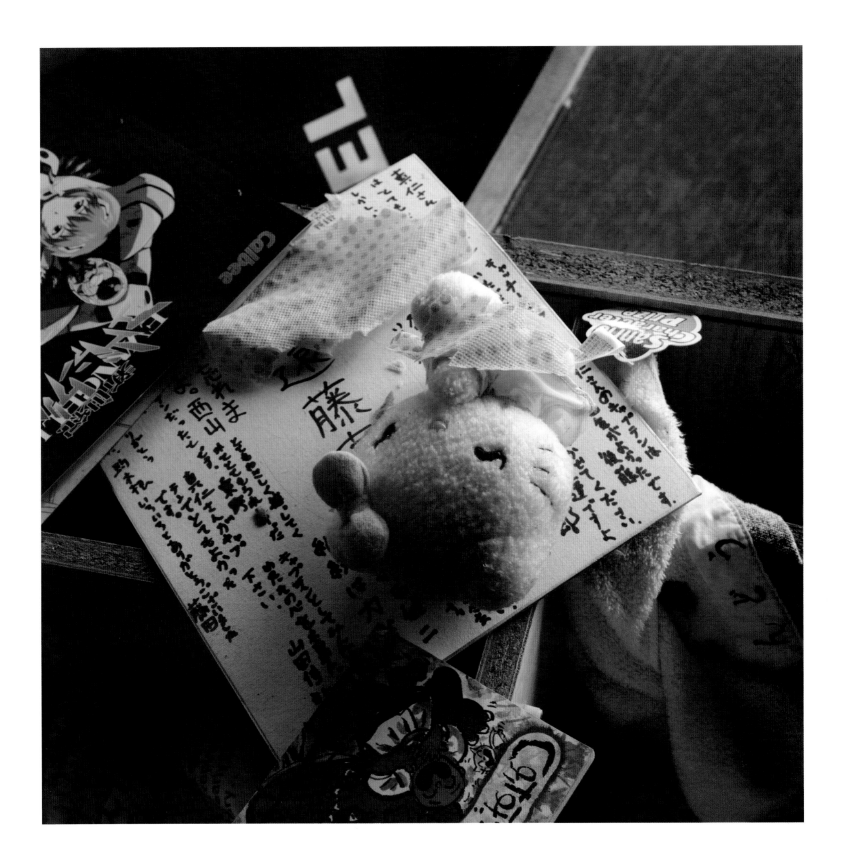

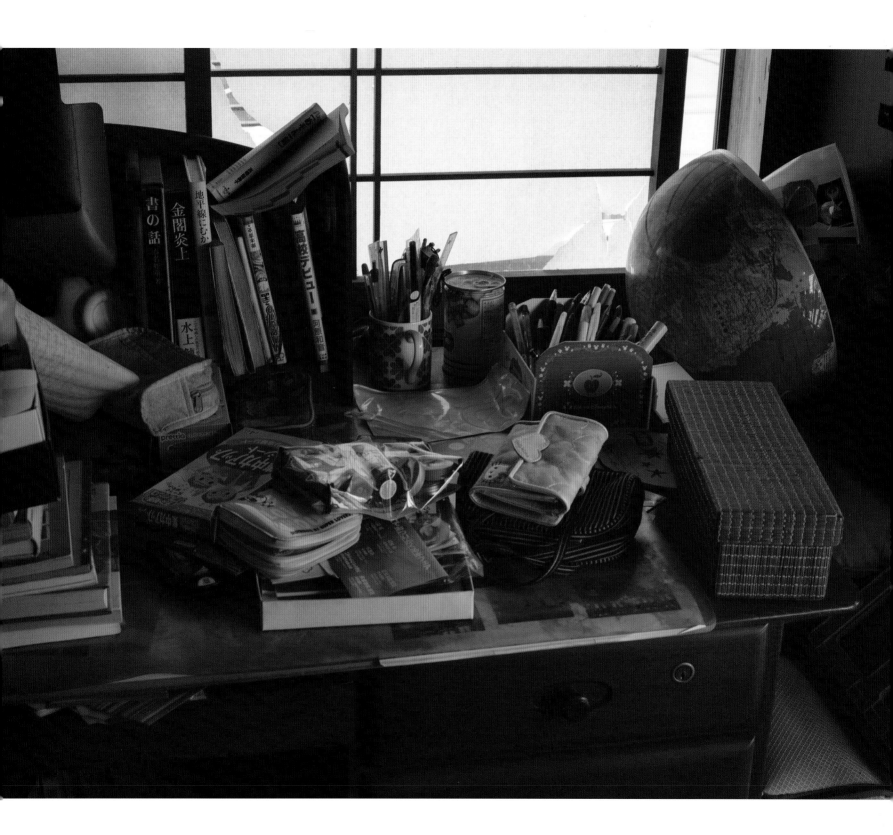

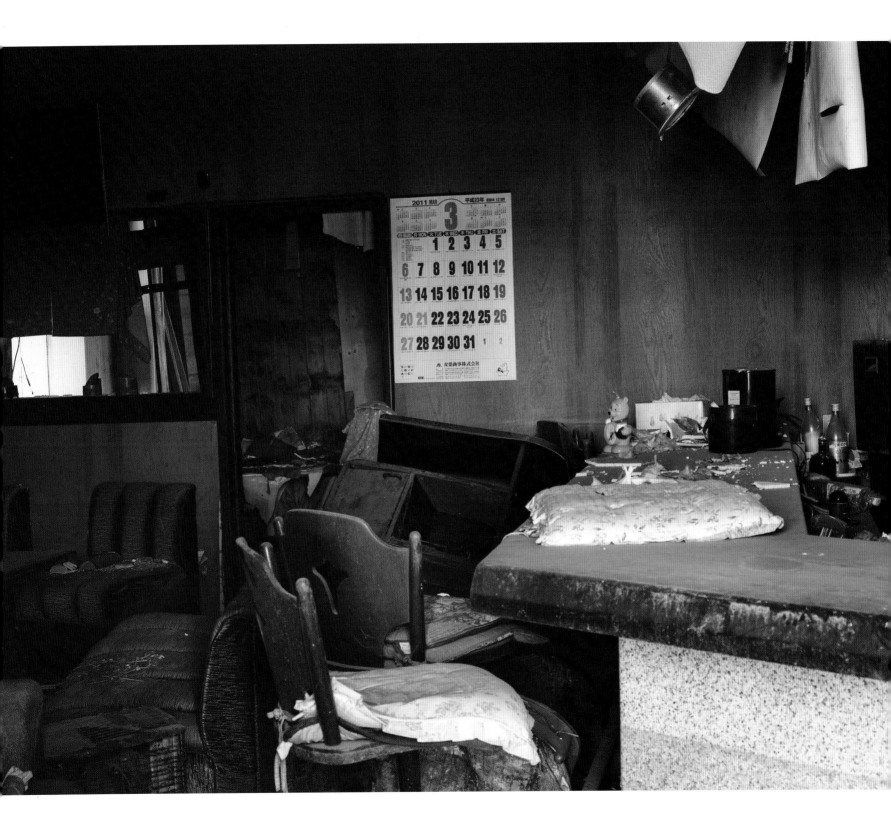

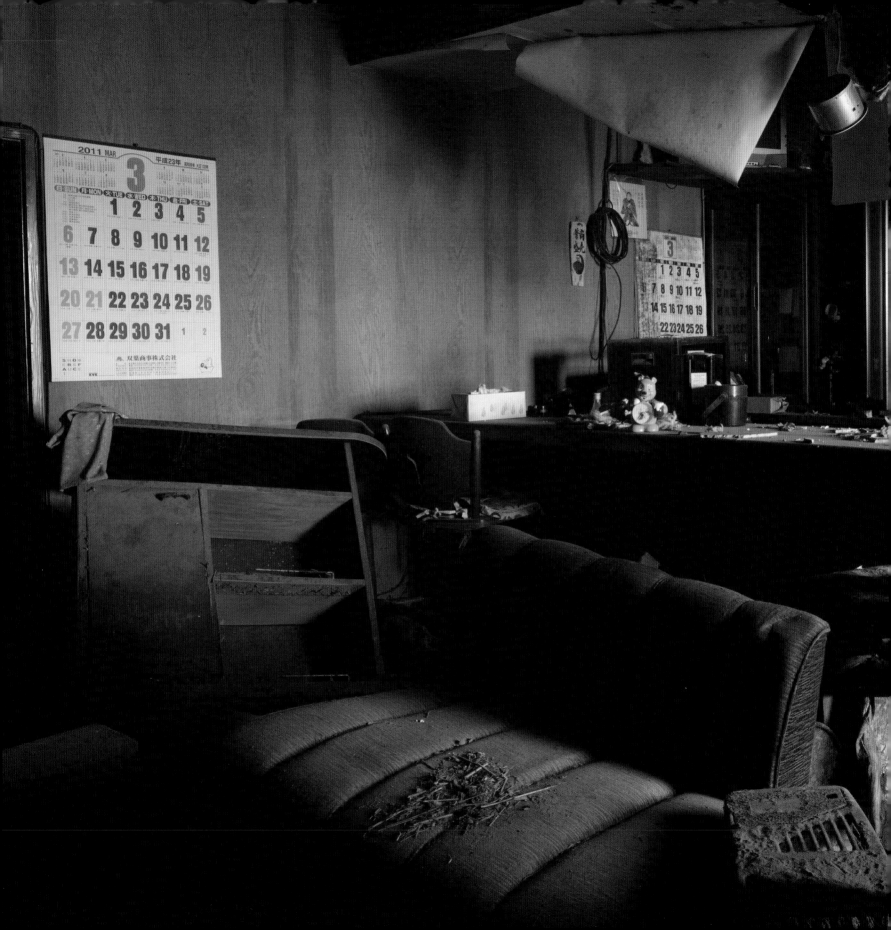

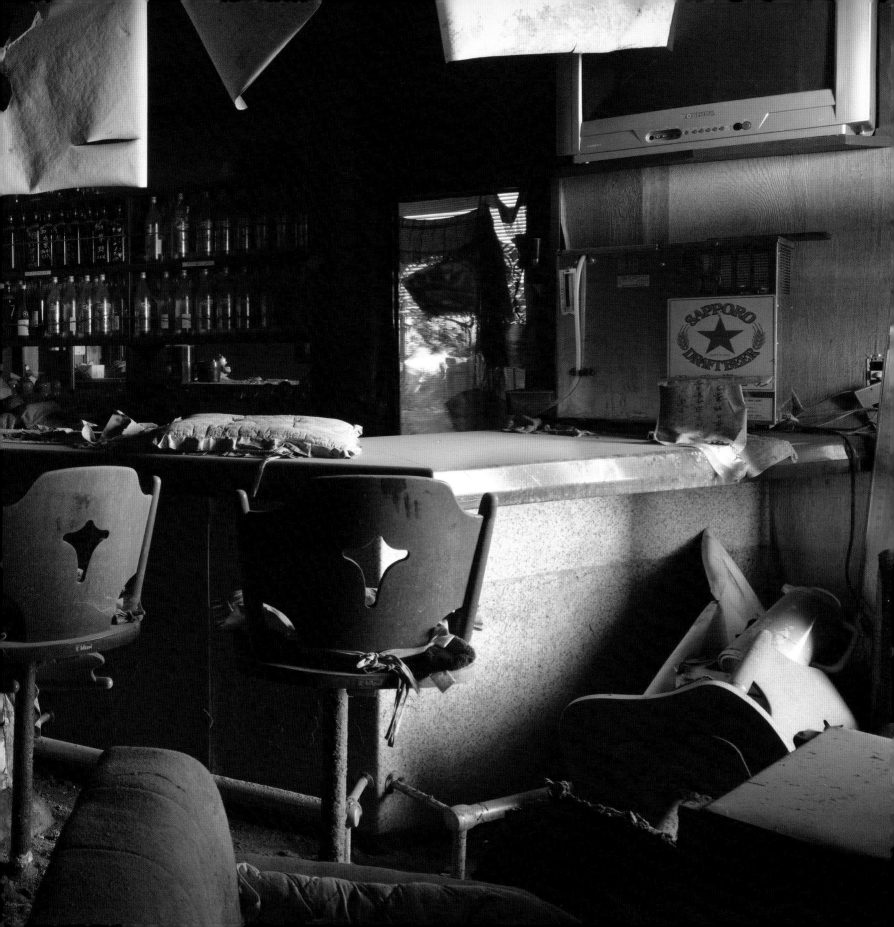

除染
JOSEN

Decontamination

The process of decontamination is mainly a process of removing a layer of soil and debris from urban centres to reduce the level of contamination on the ground. The government has given up on it's original resettlement target of 0.23 microsieverts per hour. Resettlement will now involve residents being given dosimeters to monitor their own exposure. According to the International Commission for Radiological Protection the safe exposure limit should be set at 20 millisieverts per year, a limit that Japan is currently investigating.

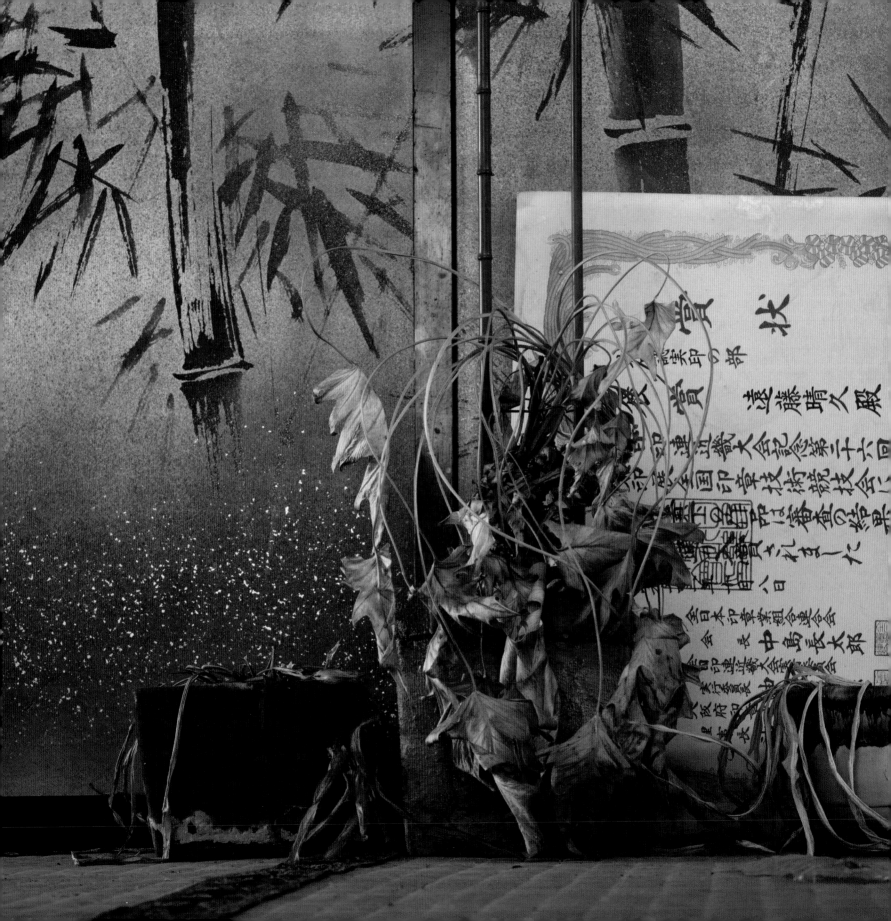

"Come,
see the true
flowers of this
pained world."

- Matsuo Bashō

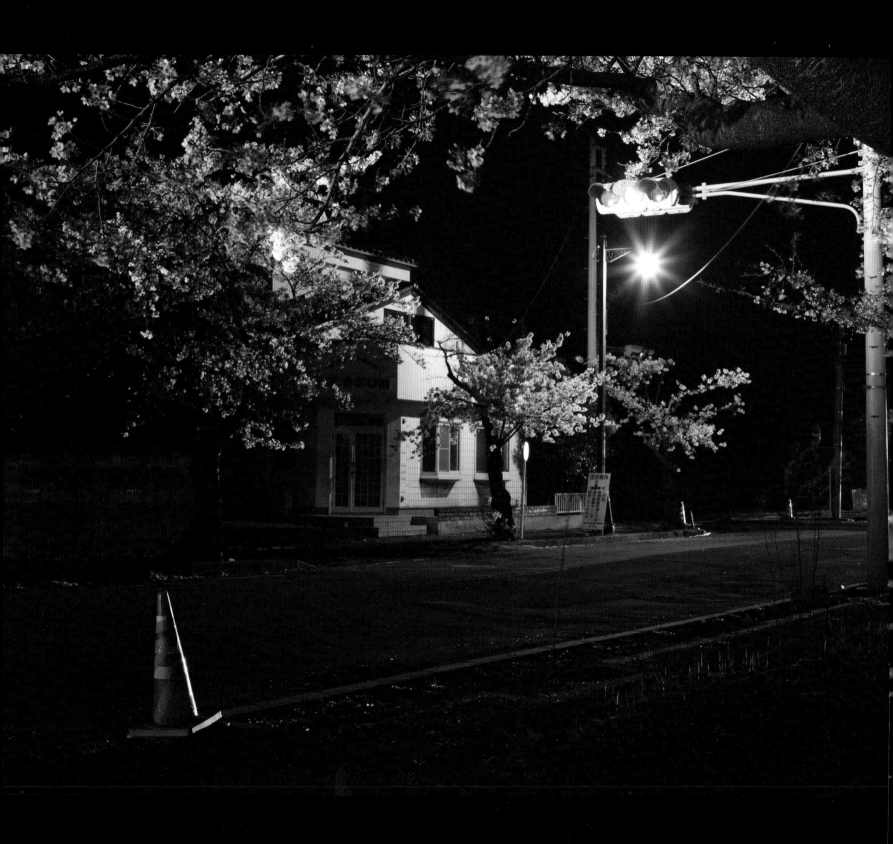

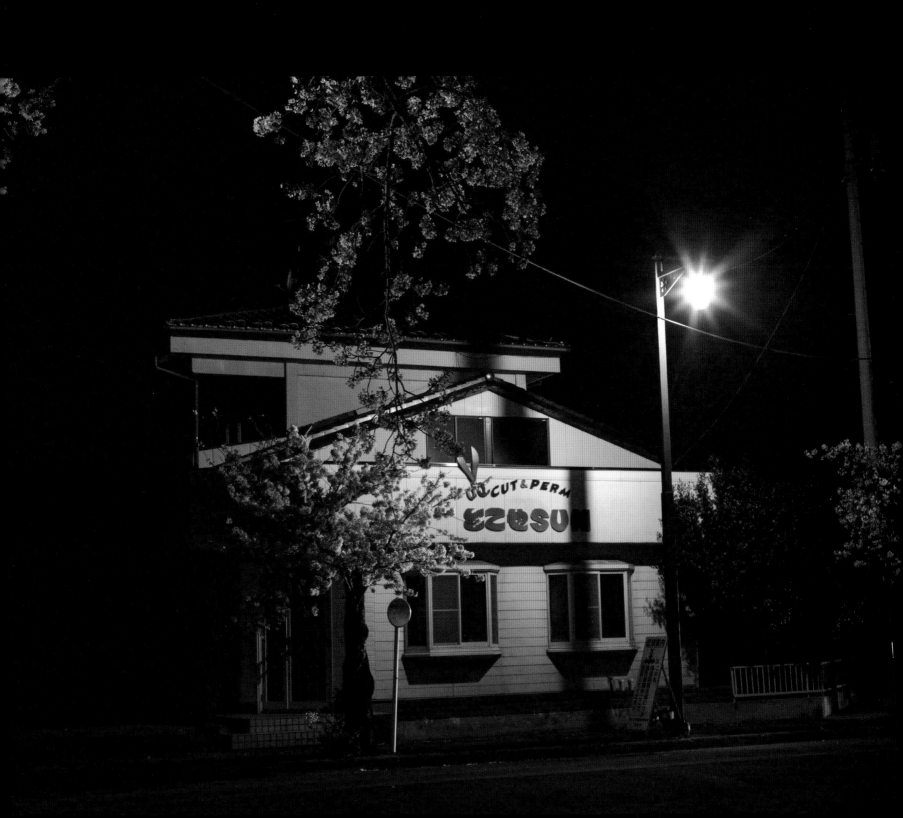

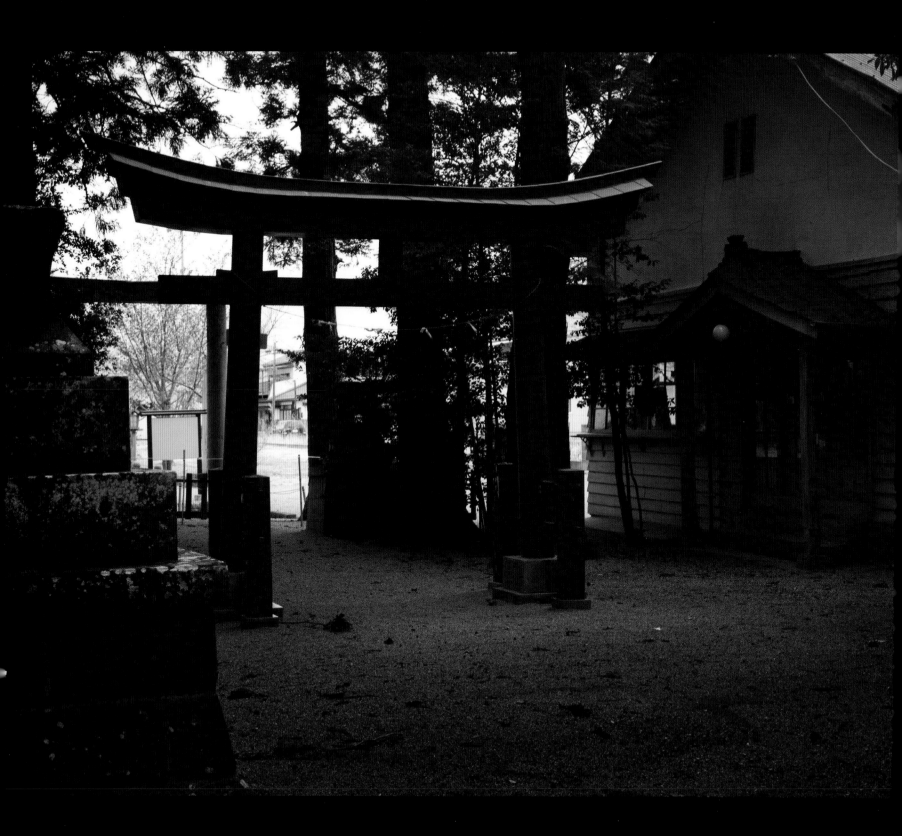

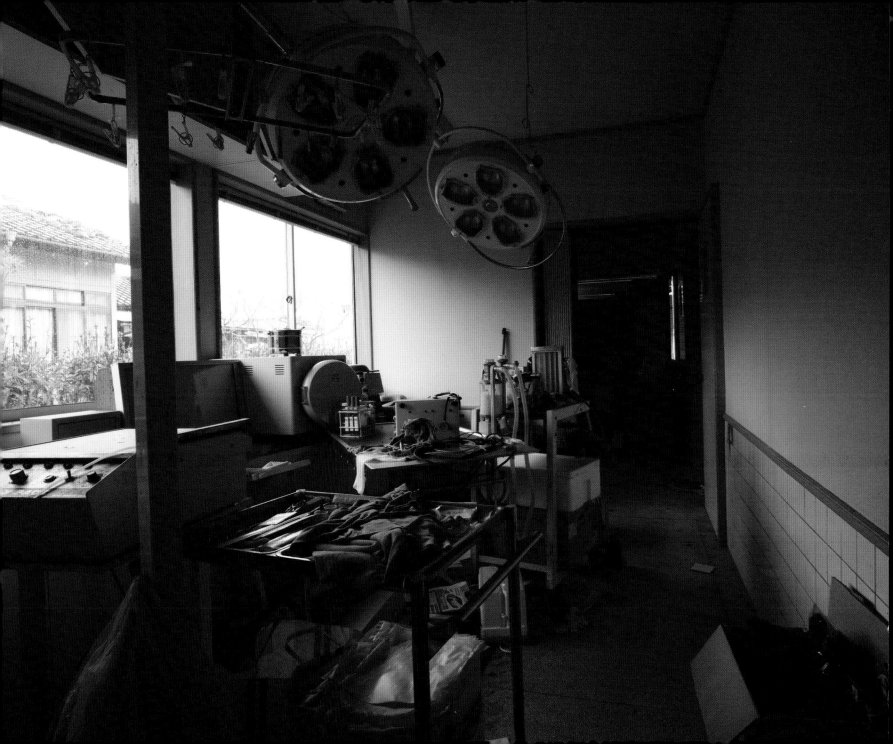

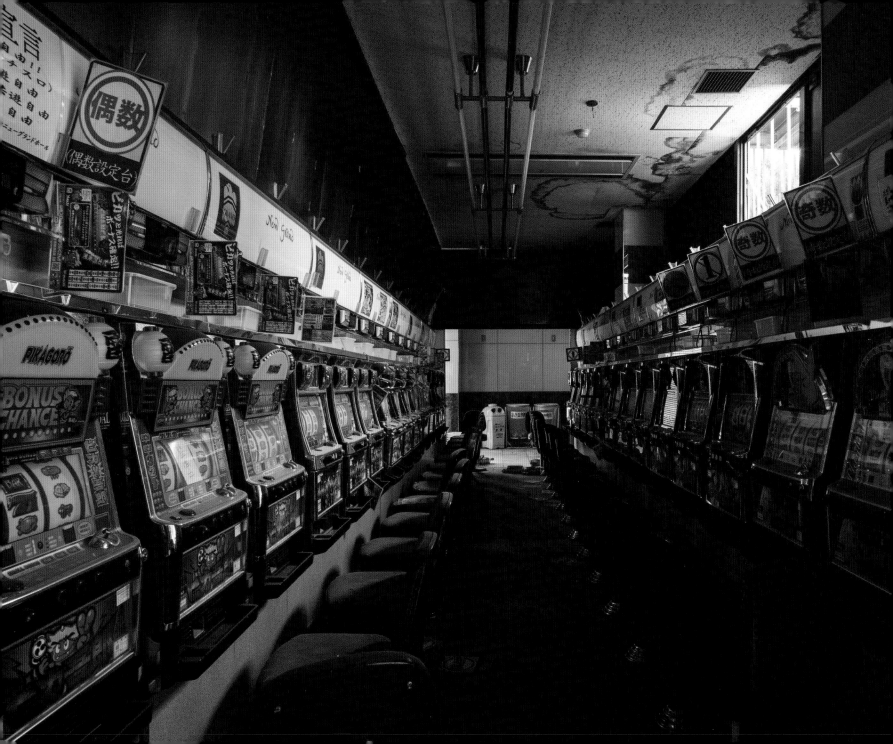

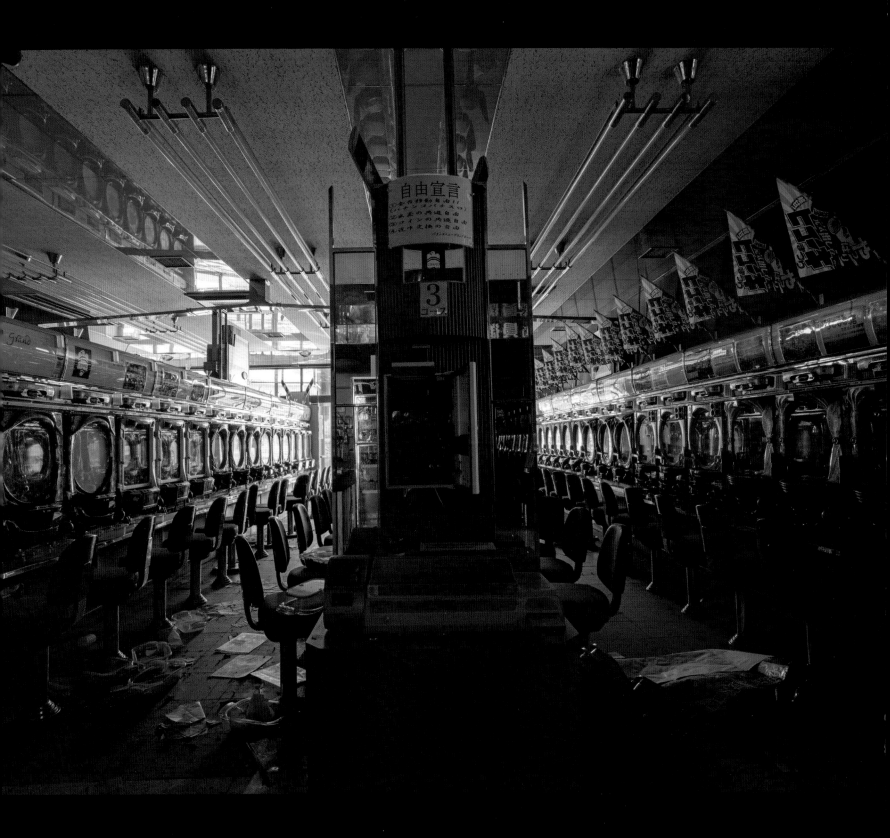

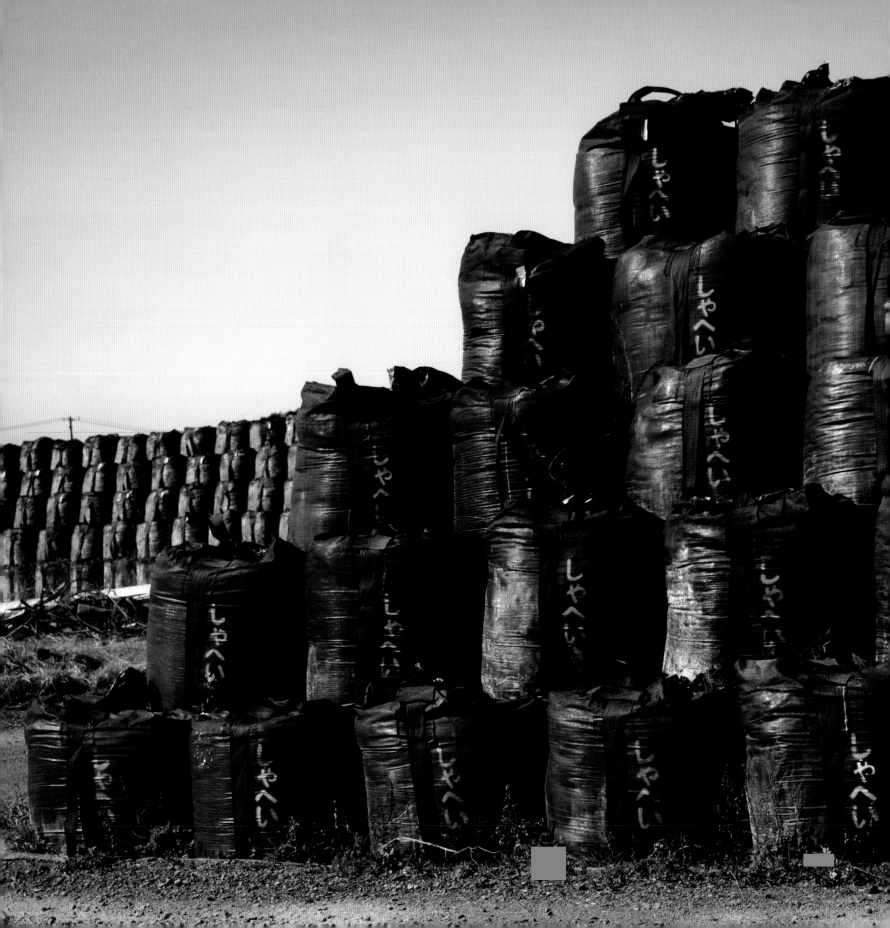

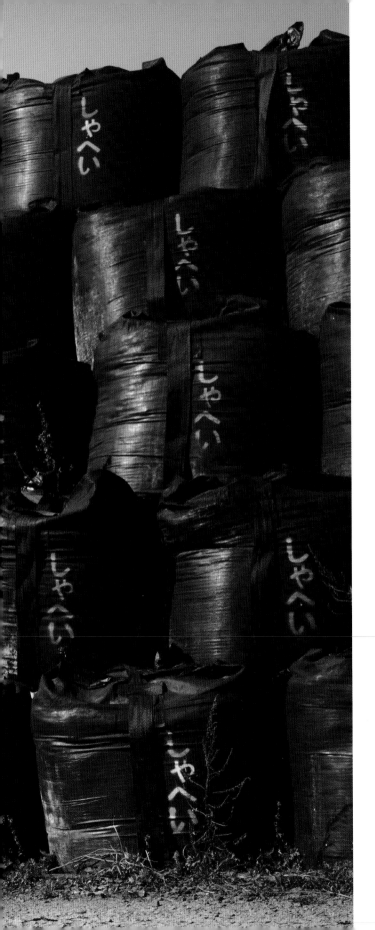

Chukan Chozo
- Interim Storage

The decontamination process collects earth and rubble on a massive scale, which must be stored somewhere while a permanent disposal solution is sought. These mountains of black bags are an unsettling new part of the Fukushima landscape. Politicians say they will be there for no more than thirty years. Residents are not so sure. Local government fights battles with national government over the locations of these interim dumps. Nobody wants them in their backyard.

復興
RENEWAL

"Children were traumatised but the women here protected the children and the children have become strong, committed and public spirited. You can't help but feel optimistic about Fukushima's future." - Anne Kaneko, Fukushima Blog

Nahara was the first complete town within the exclusion zone to allow resettlement. The return of the population has been slow, but the seeds of hope are sown. The Japanese have a strong sense of attachment to their home towns. It is hoped that this will eventually overcome their fears.

"The clock that stopped in 2011 has now begun to tick." - Mayor of Nahara

The cherry blossom of Tomioka speaks of new life and new hope. Nature can recover from the disaster, human beings can too. There is hope that the Tokyo Olympics in 2020 will be an opportunity to celebrate the recovery of the Fukushima region before the eyes of the world. There is hope that Japan can become a beacon for the world in the development of renewable energy.

Food coming from the Fukushima region is testing as safe by stringent Japanese safety standards. The limit on radiation levels in Japanese food is much lower than that applied in Europe or the USA. A new generation of farmers is working hard to make Fukushima produce not only trusted but also cool.

The vision of agriculture of how it should be for Fukushima and for all of Japan, was they are looking far more heading to the future than the rest of us I think in Japan. (Russell - http://www.nhk.or.jp/)

Fukushima needs tourism to stimulate its economic recovery and there is much natural beauty, and many historical treasures to discover. The number of visitors has been increasing steadily in recent years. If you have the opportunity to see the cherry blossoms for yourself, don't be put off by a misunderstanding of the risks.

"YOU GET DEPRESSED WHEN YOU CAN'T SEE YOUR FUTURE. THE PEOPLE HAVE BEEN UPROOTED AND NOW THEY'RE WILTING."

- Chairman, residents' association

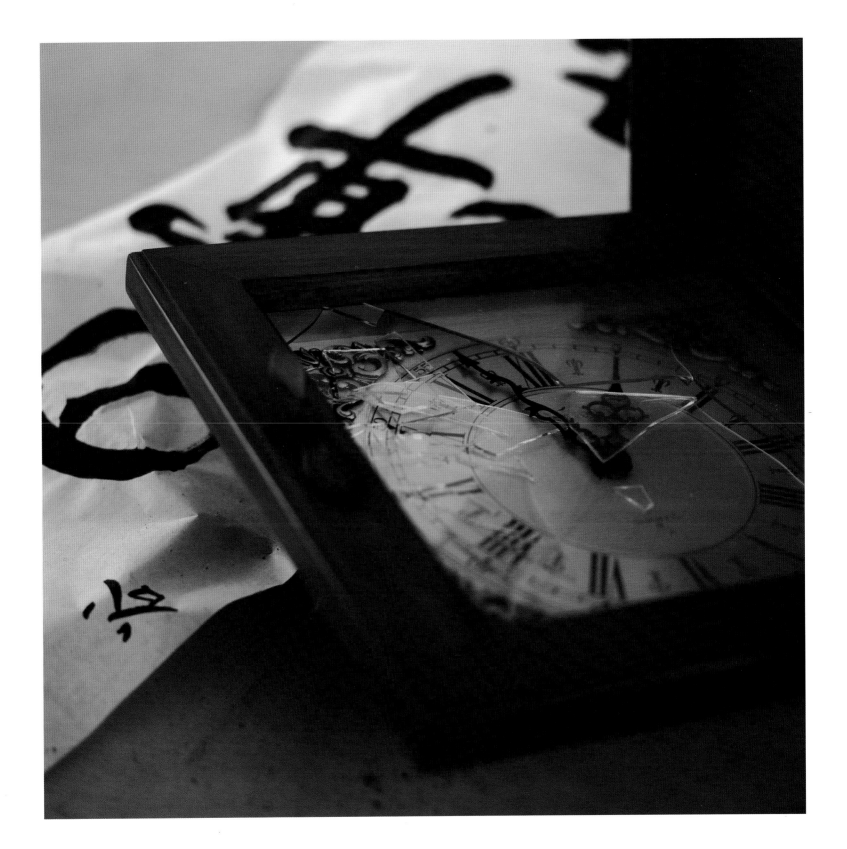

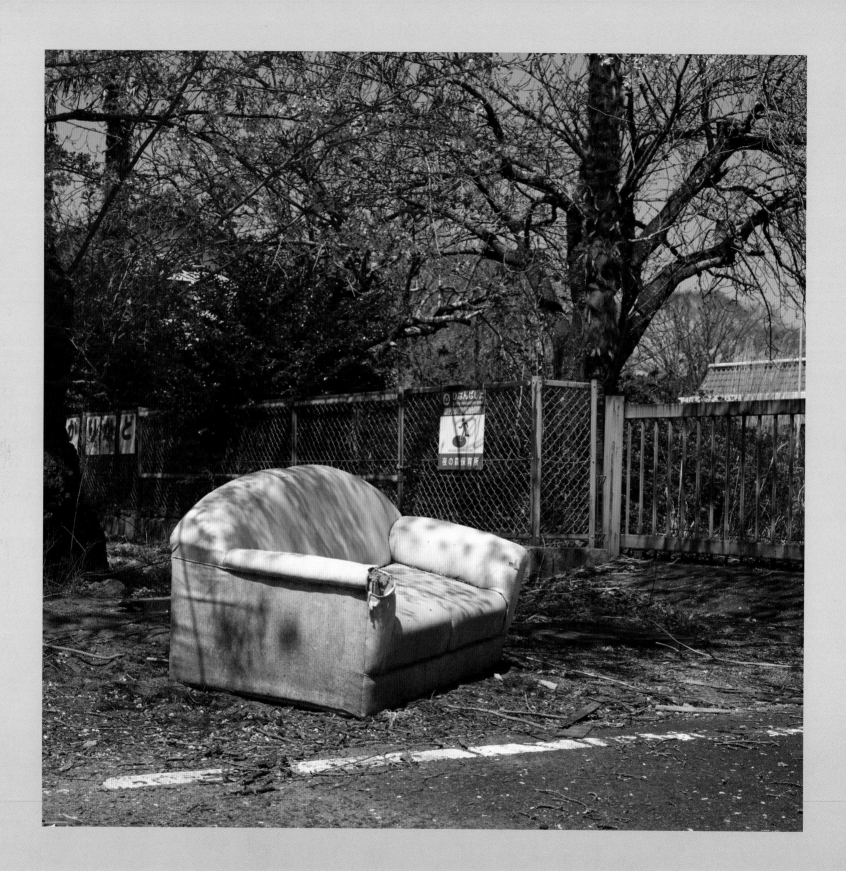

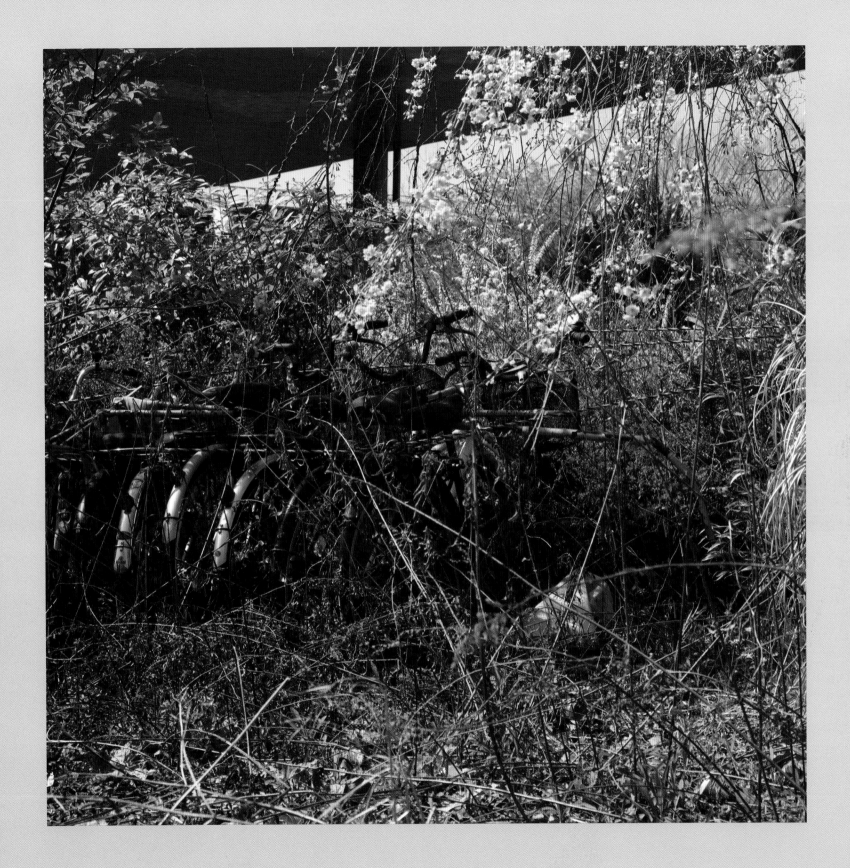

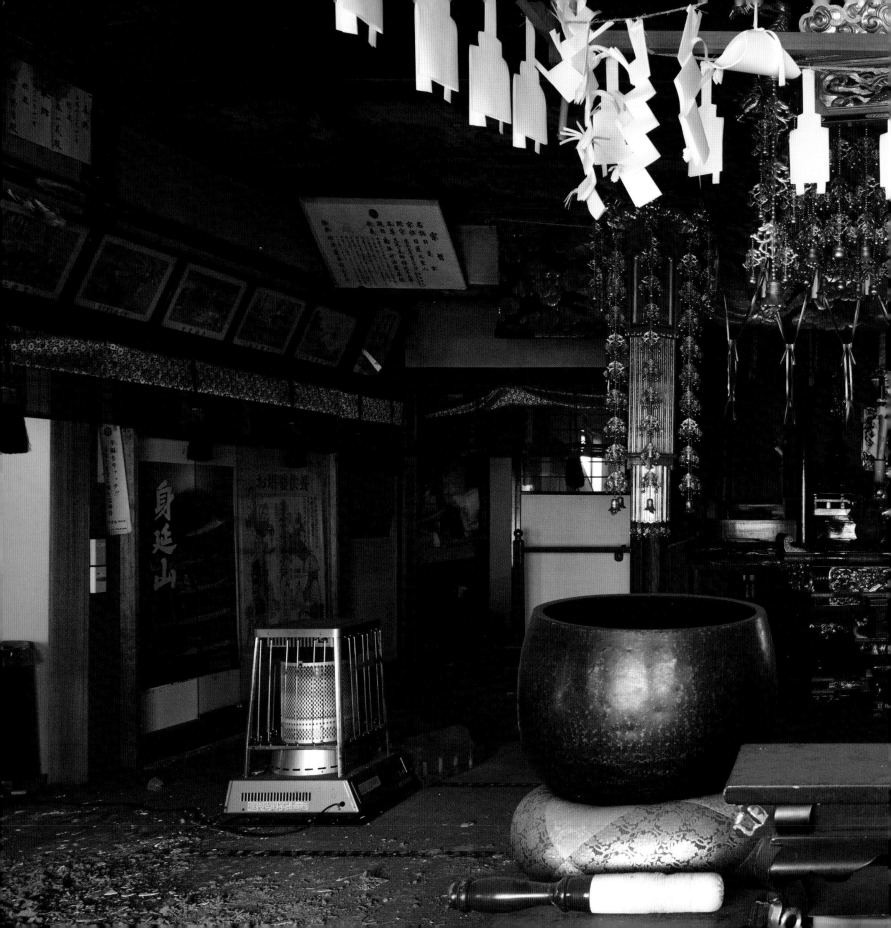

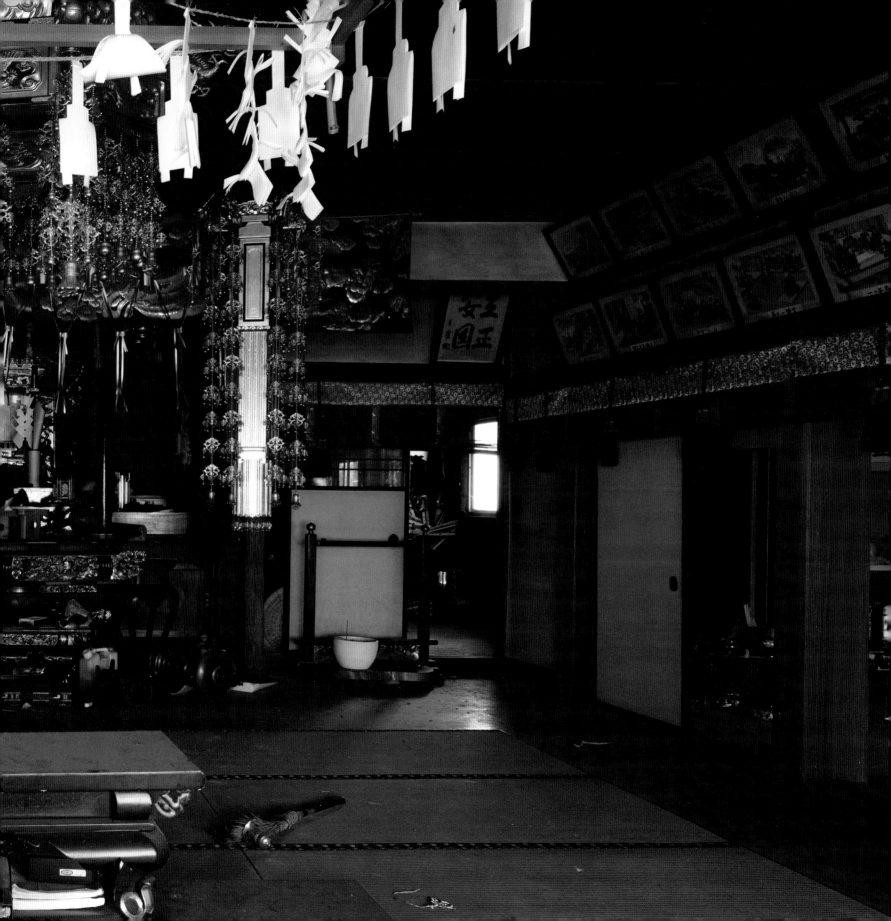

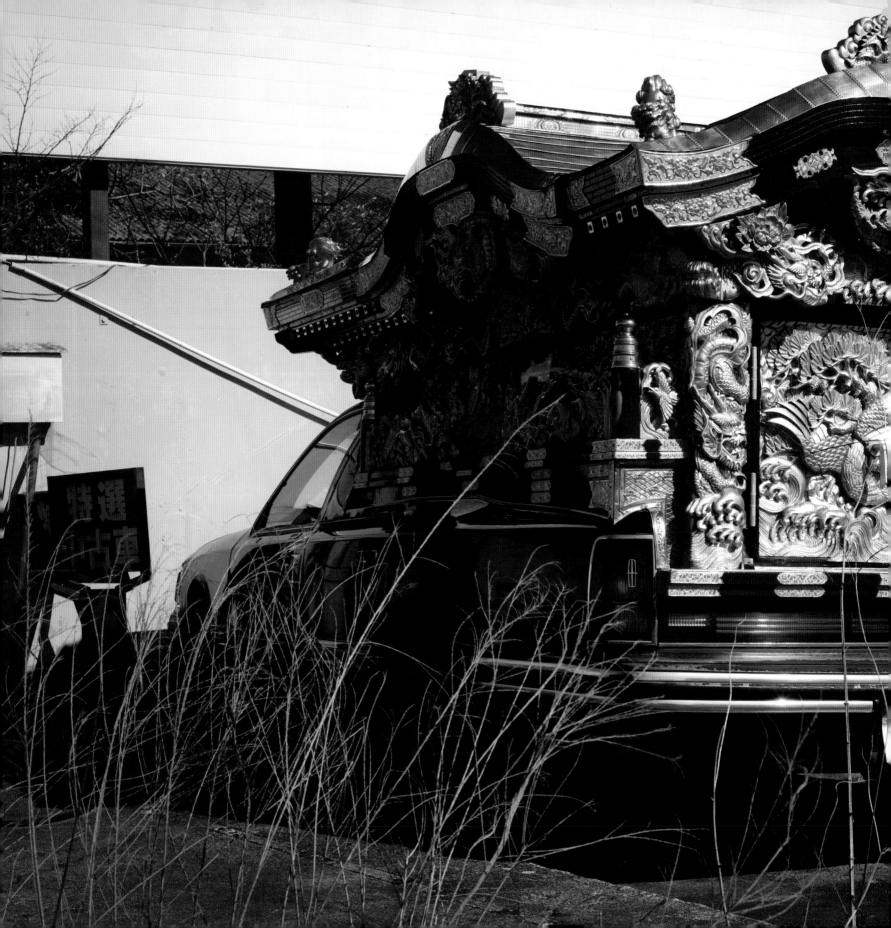

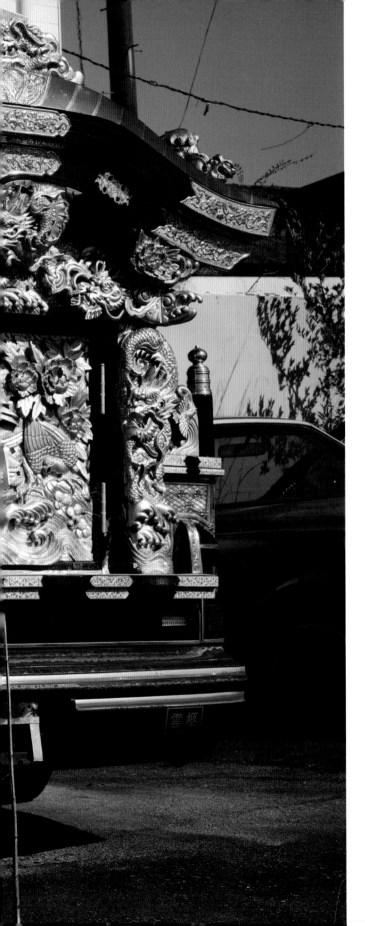

Fear is the killer

The psychological damage of fear of radiation sickness is a bigger killer than thyroid cancer. The life expectancy reduction following Chernobyl was attributed more to depression, alcoholism and suicide than to increased rates of Cancer. The stress of evacuation and displacement too has been estimated by some to have caused over a thousand deaths of Fukushima refugees.

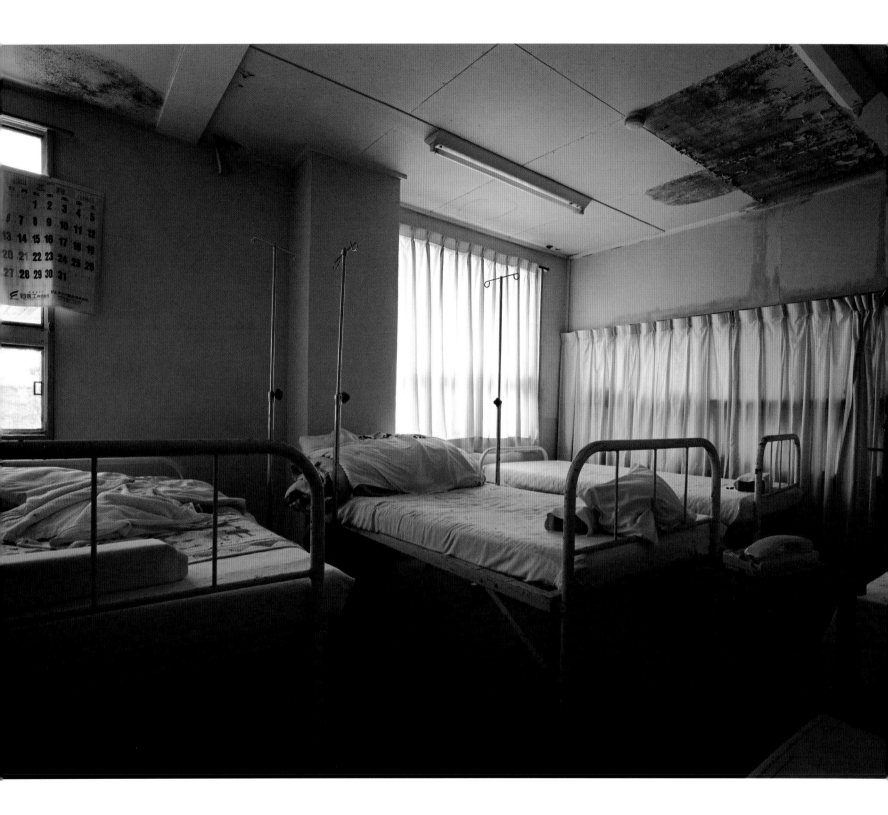

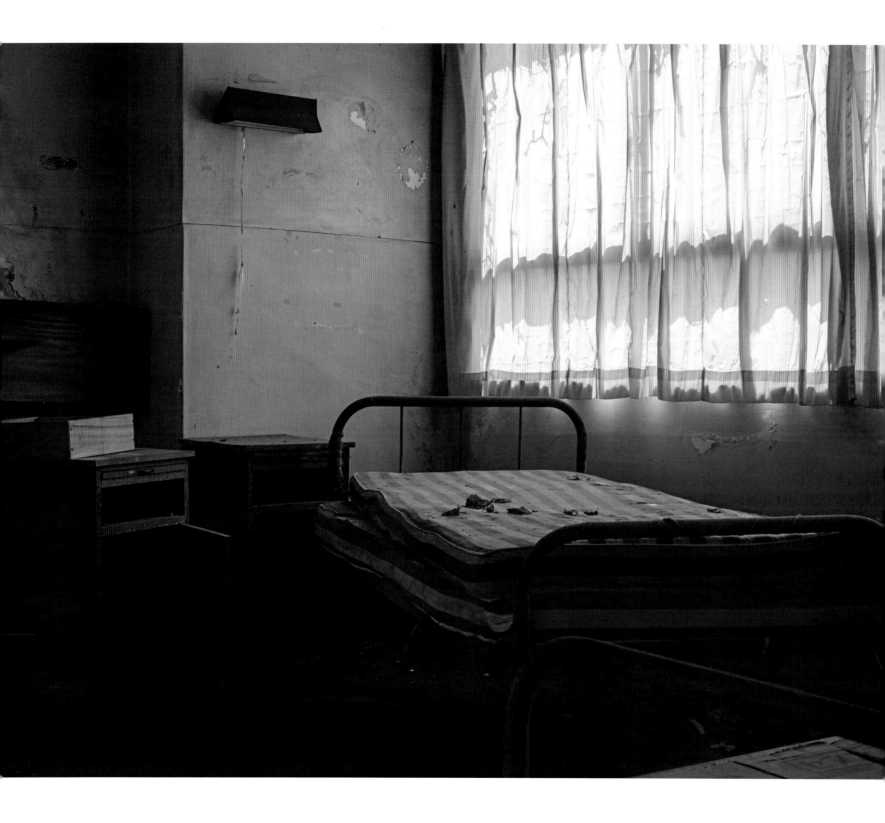

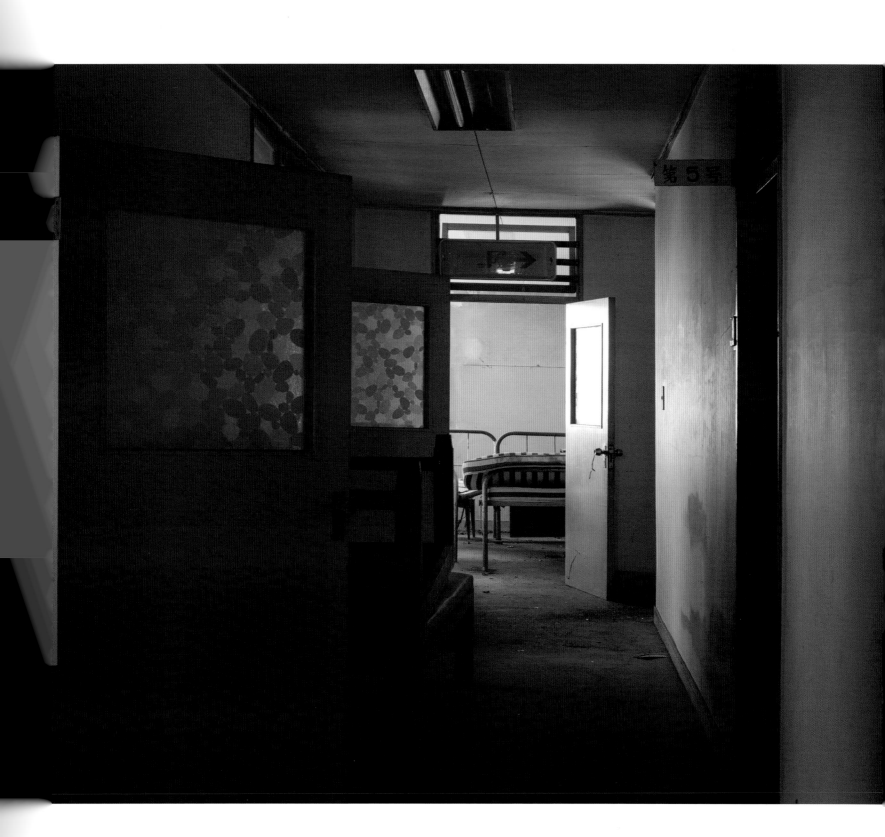

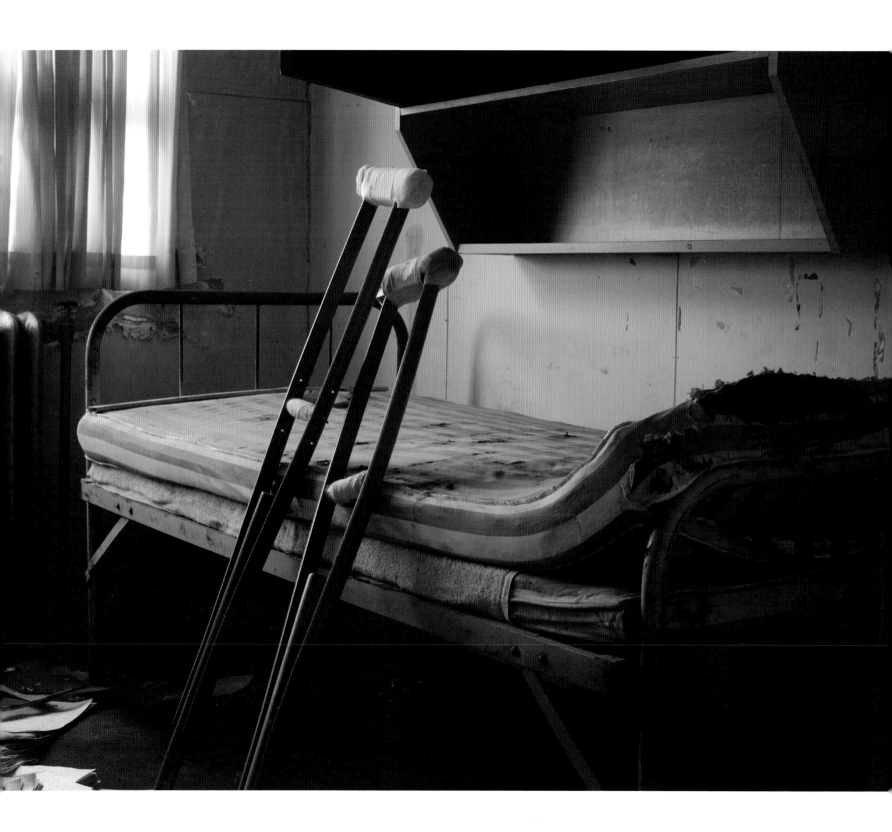

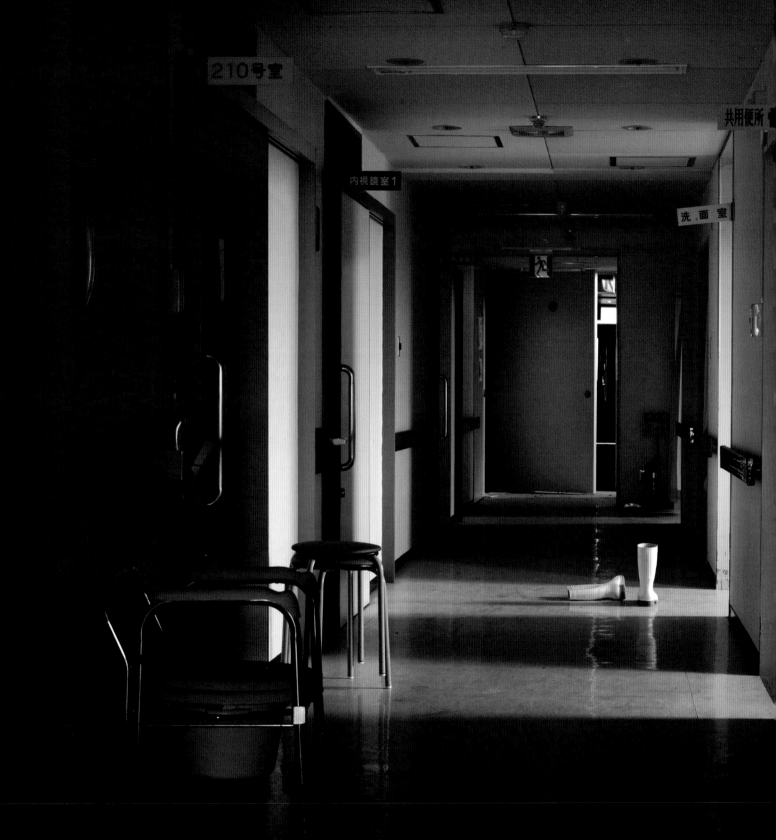

Millisieverts and Becquerels

Suddenly, everybody becomes an expert in isotopic radiation. The most damaging effects of contamination it seems are psychological stress - at least in the beginning. So much fear, so many confusing new concepts to take on board. New units of measurement must be learned. Everybody studies the science in the local newspapers, on blogs, on the TV. People begin to carry dosimeters and submit data to data collection projects. Solar powered dosimeters display the airborne contamination in public parks. The state begins the enormous task of monitoring the children of the region. Iodine tablets are distributed. Much argument about what constitutes safe levels of exposure takes place. Children are most at risk. Don't let them play outside too long. The stress on parents is immense. But people are determined to be rational and balanced in their response.

"Look at the data. Be objective. Don't get swayed by scaremongering."

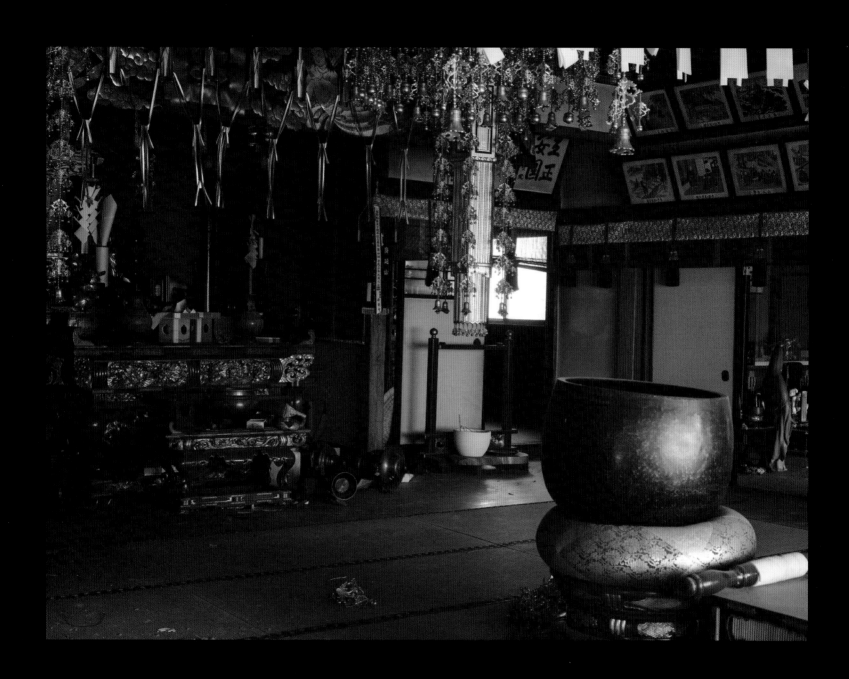

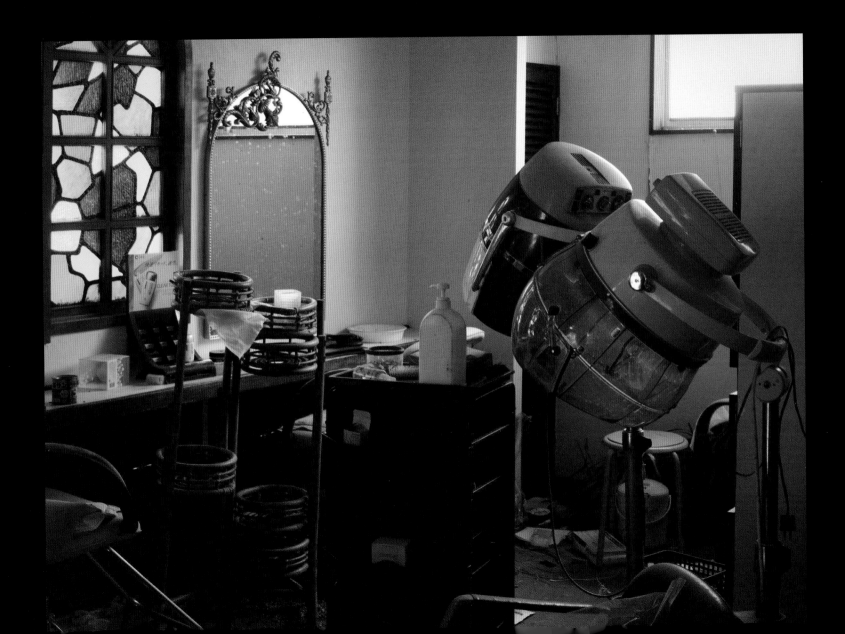

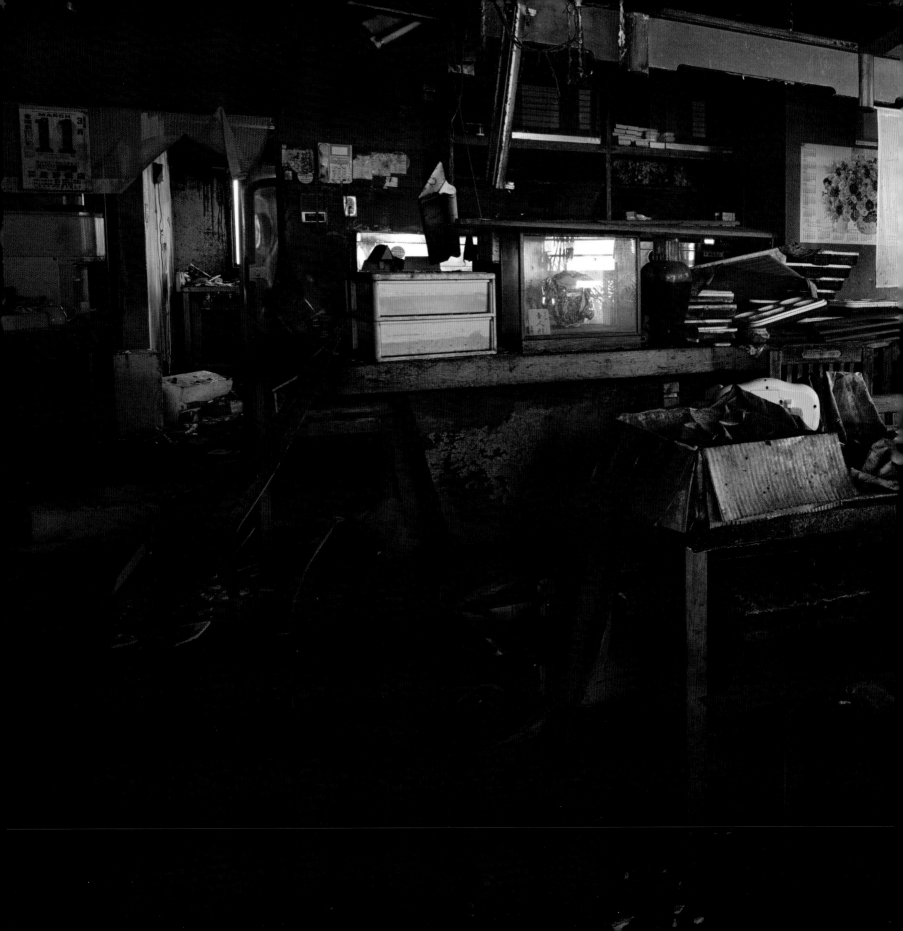

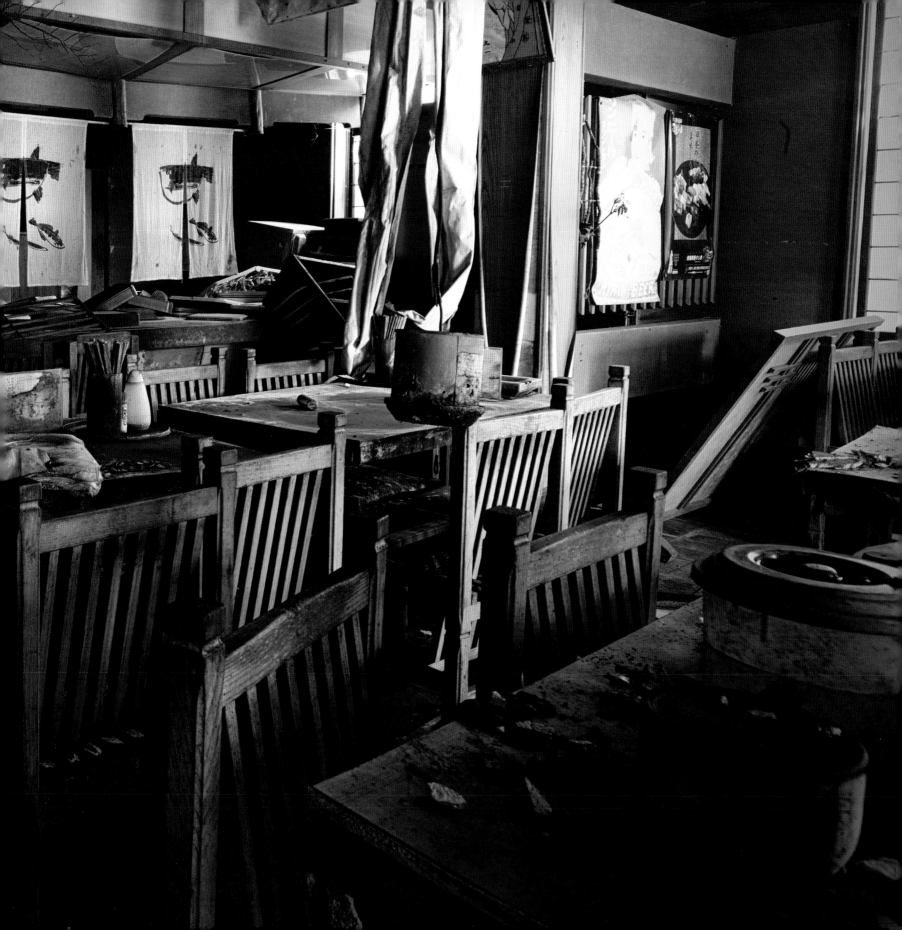

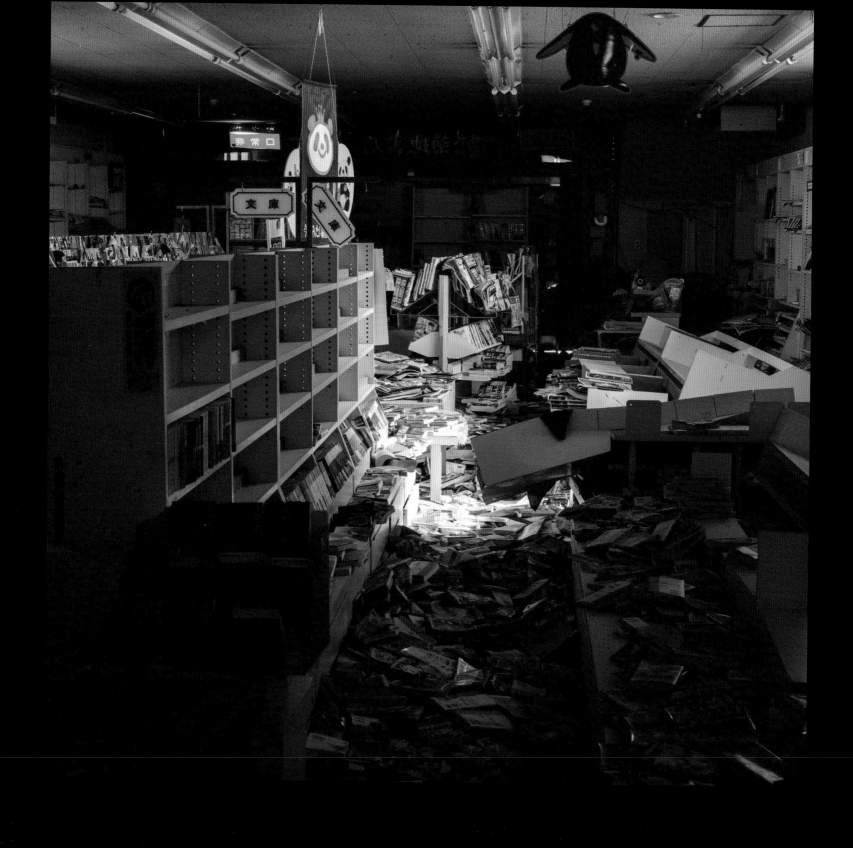

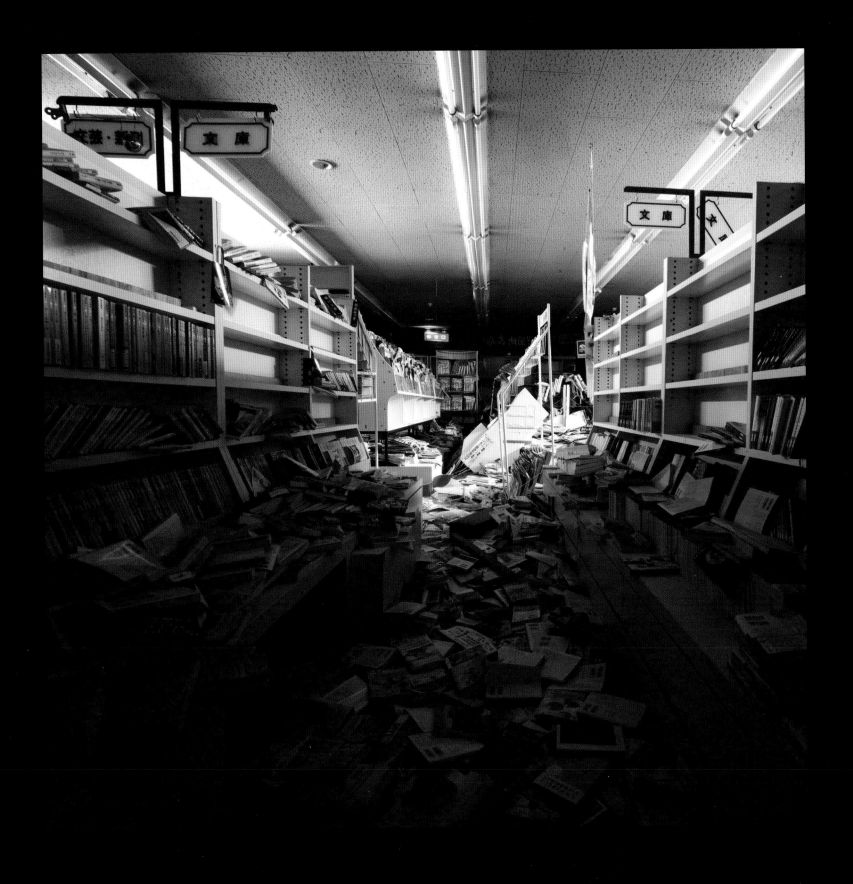

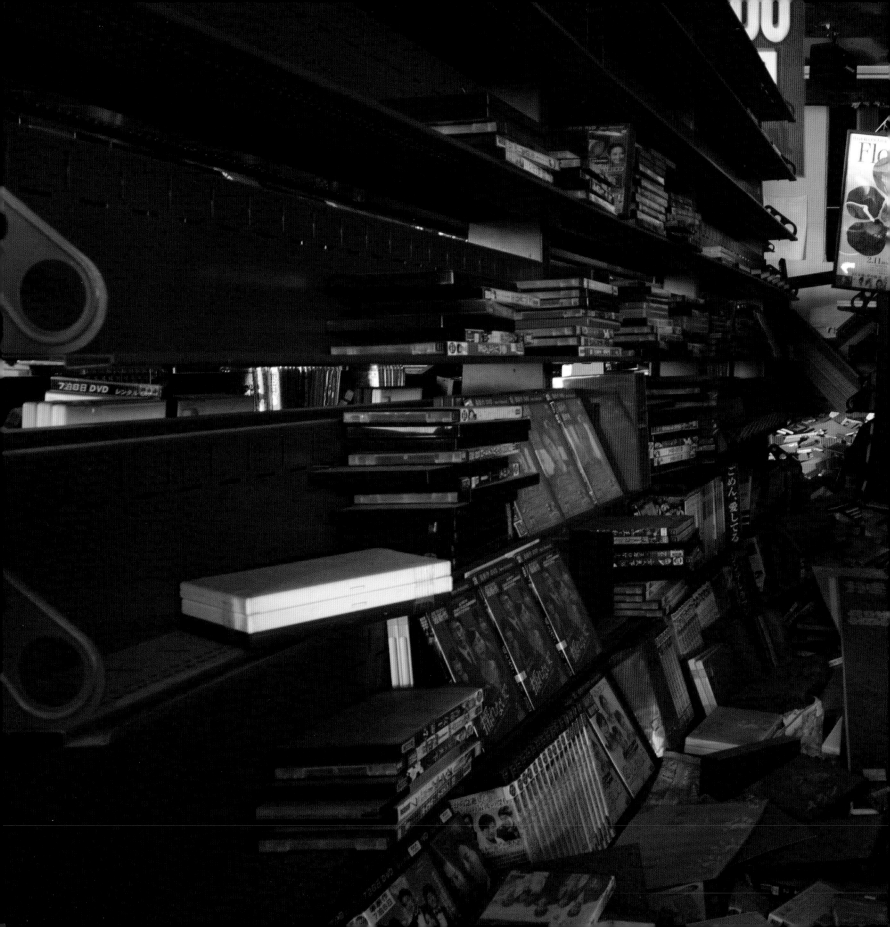

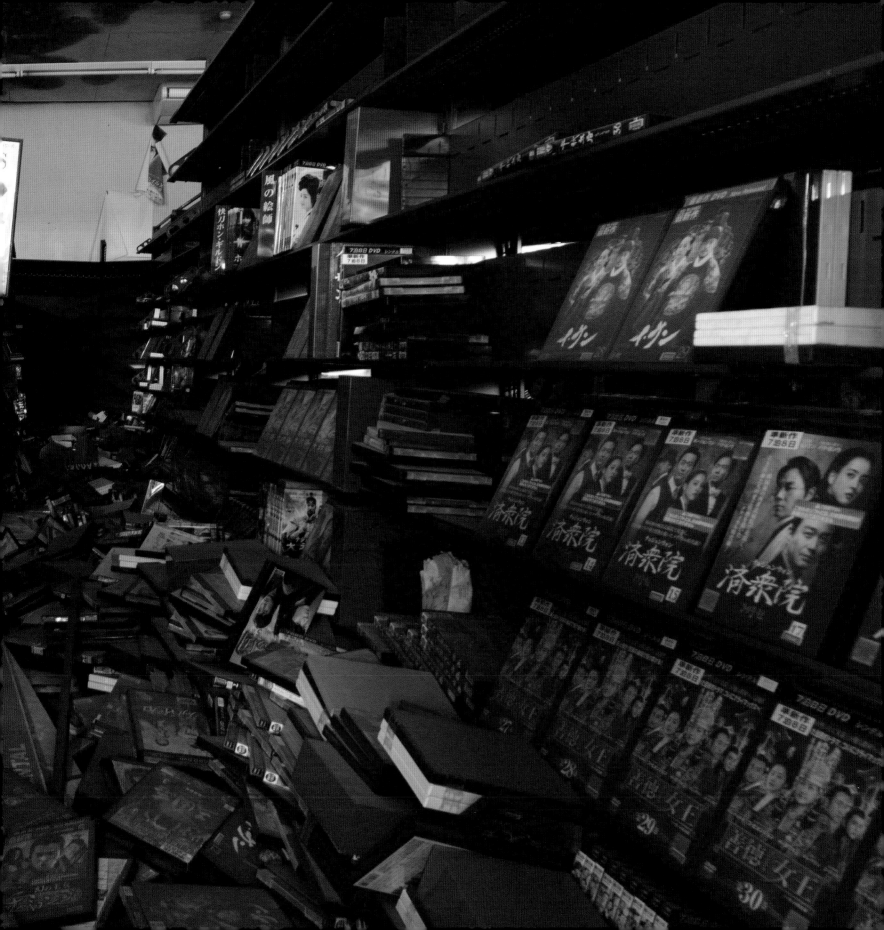

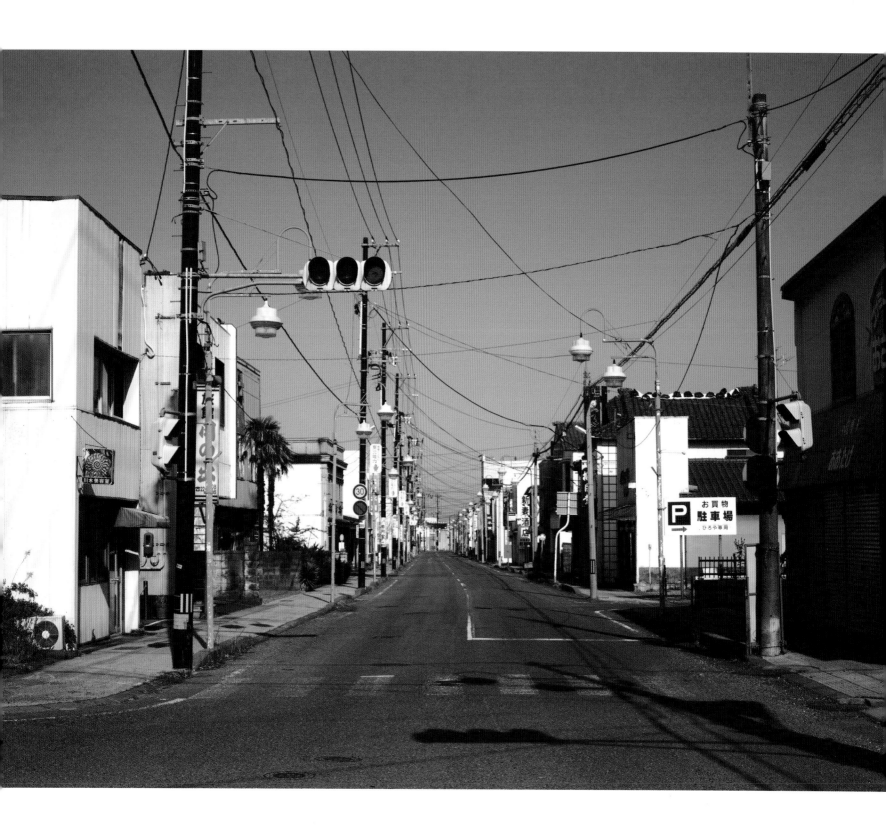

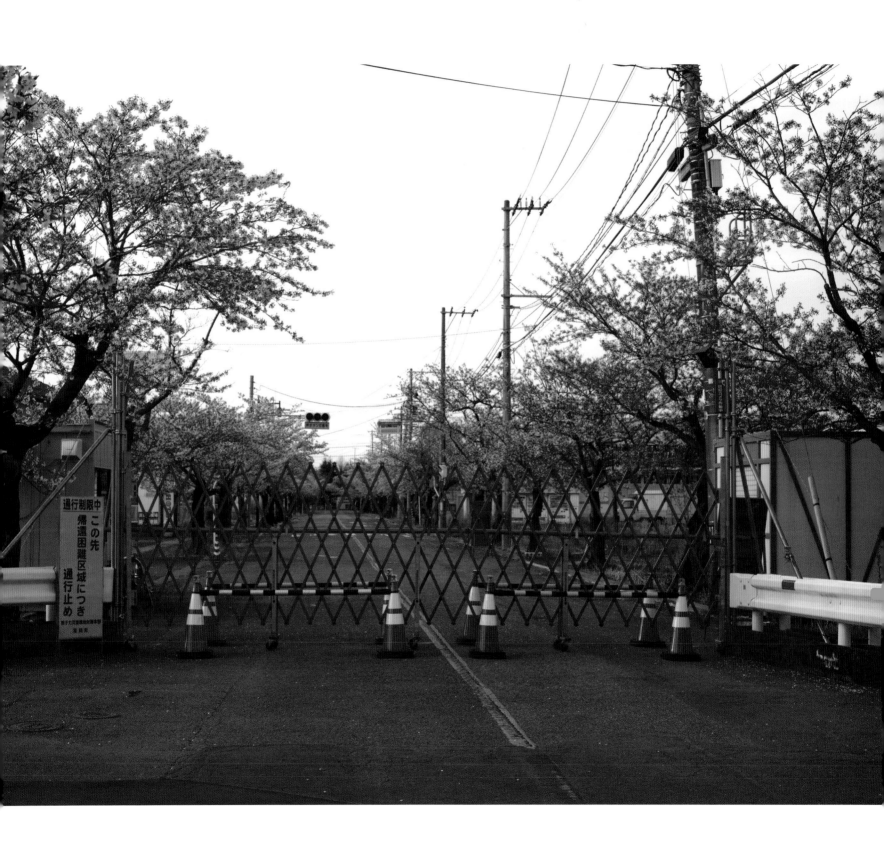

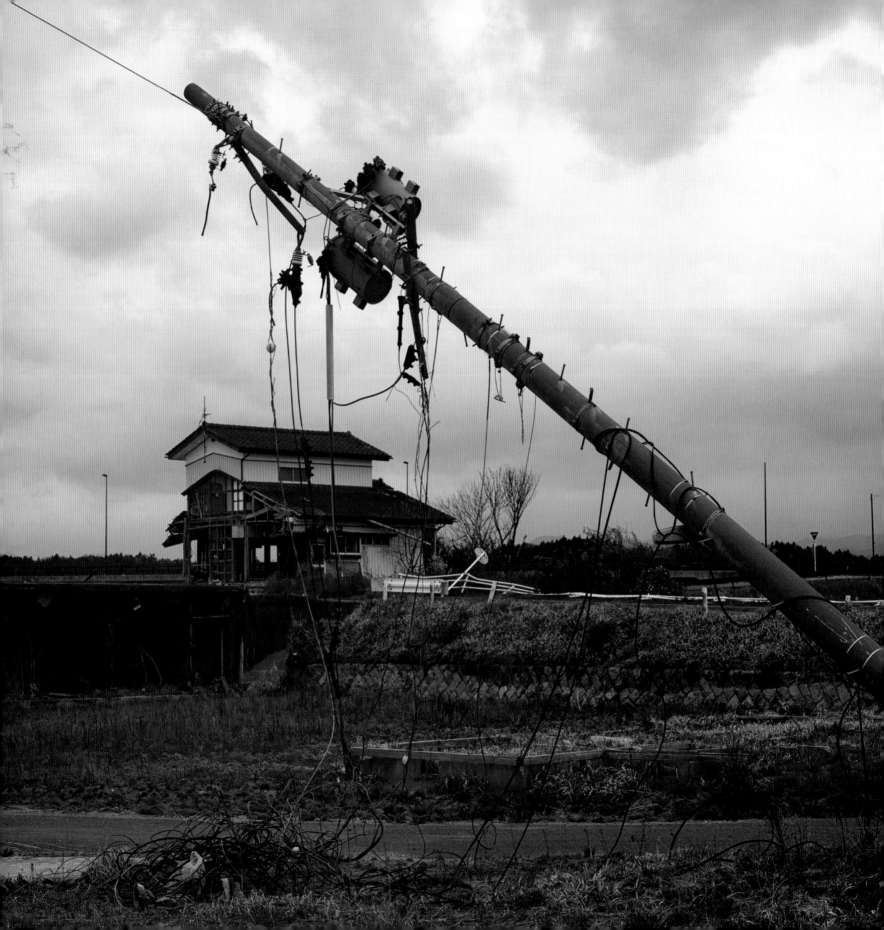

Earthquake sickness

When one has experienced several quakes in a day and one feels that the earth is still moving even when it has stopped. Aftershocks continued for years.

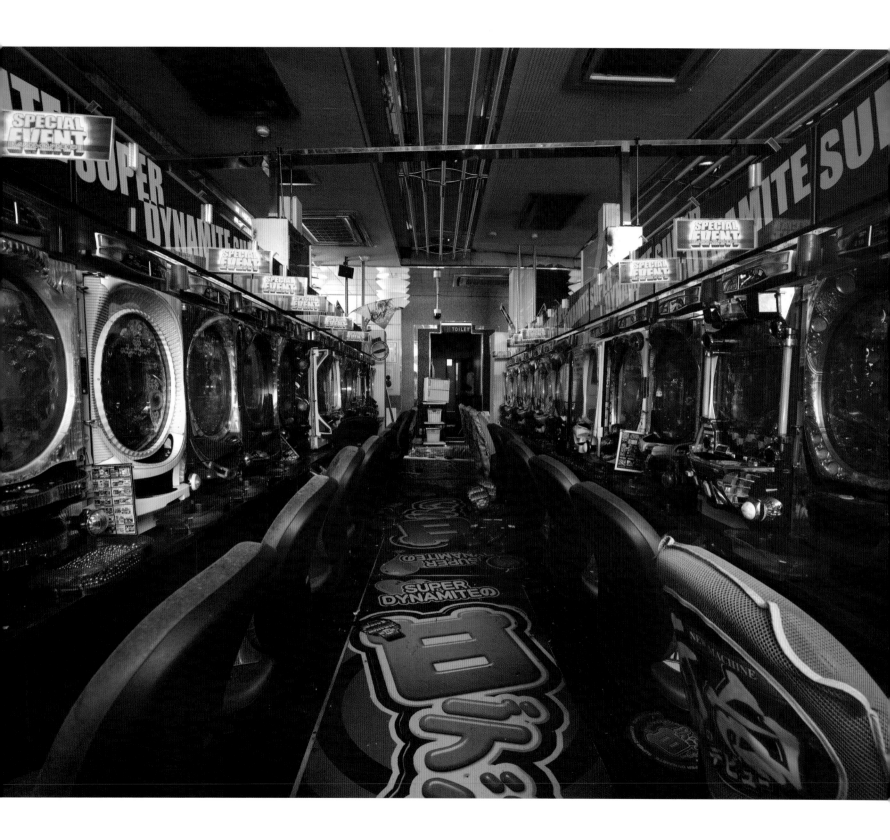

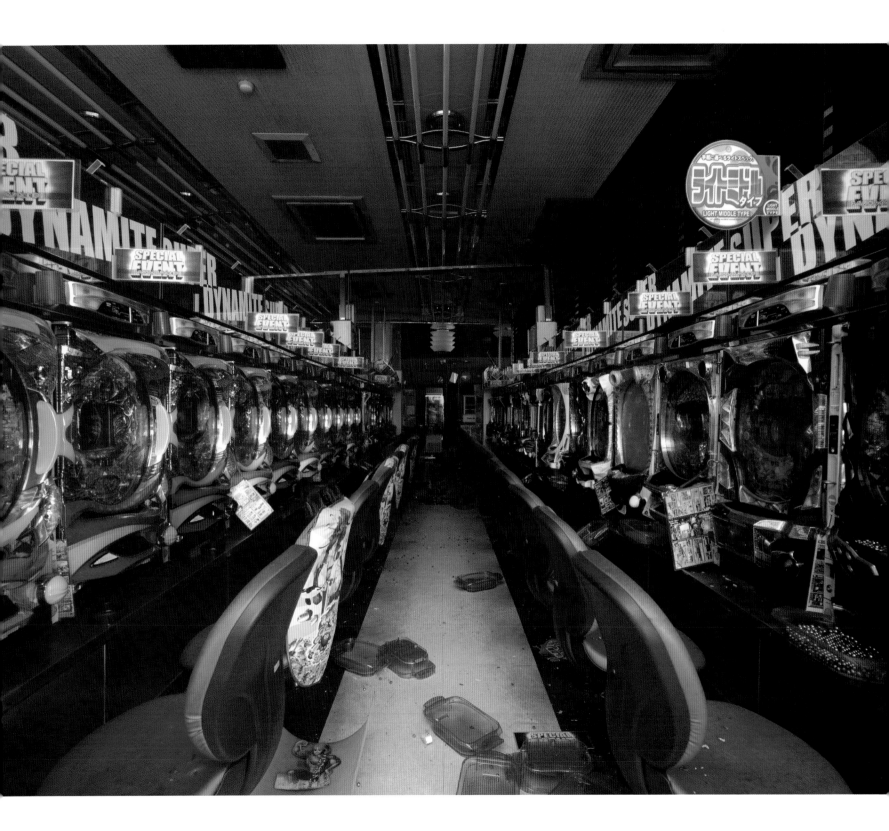

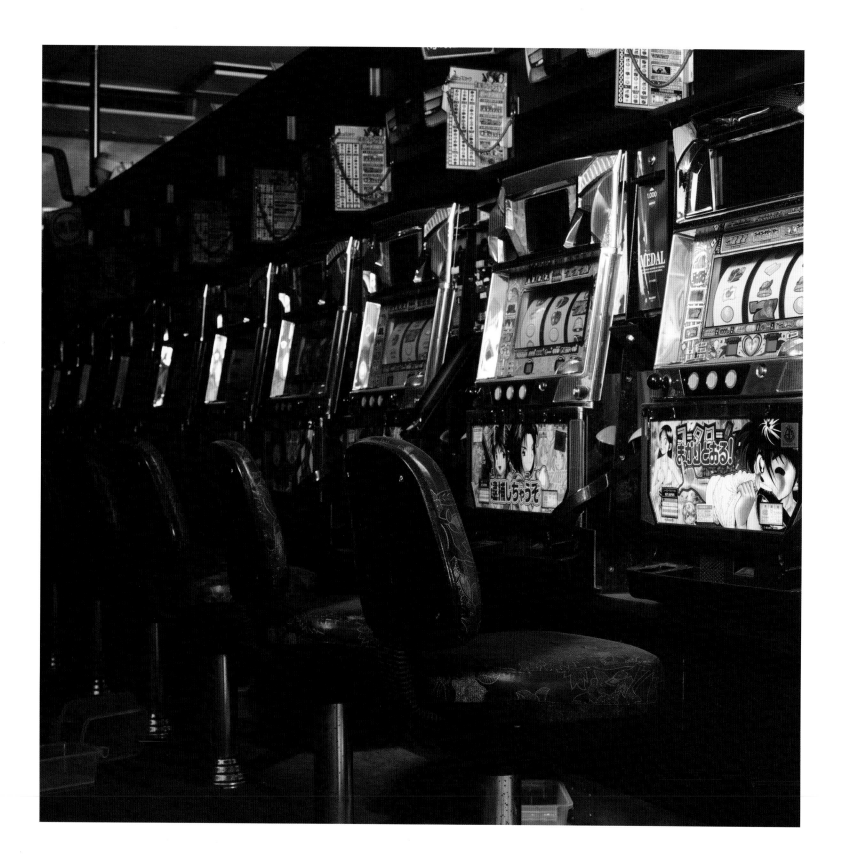

"I REMEMBER THE SMALL THINGS
WE DID TOGETHER BACK THEN.
WE PREPARED RICE BALLS
AND ATE TOGETHER,
CHATTING AND LAUGHING.
IT WAS FUN.
THINGS LIKE THAT BROUGHT
PEOPLE CLOSER TOGETHER."

- Kanai

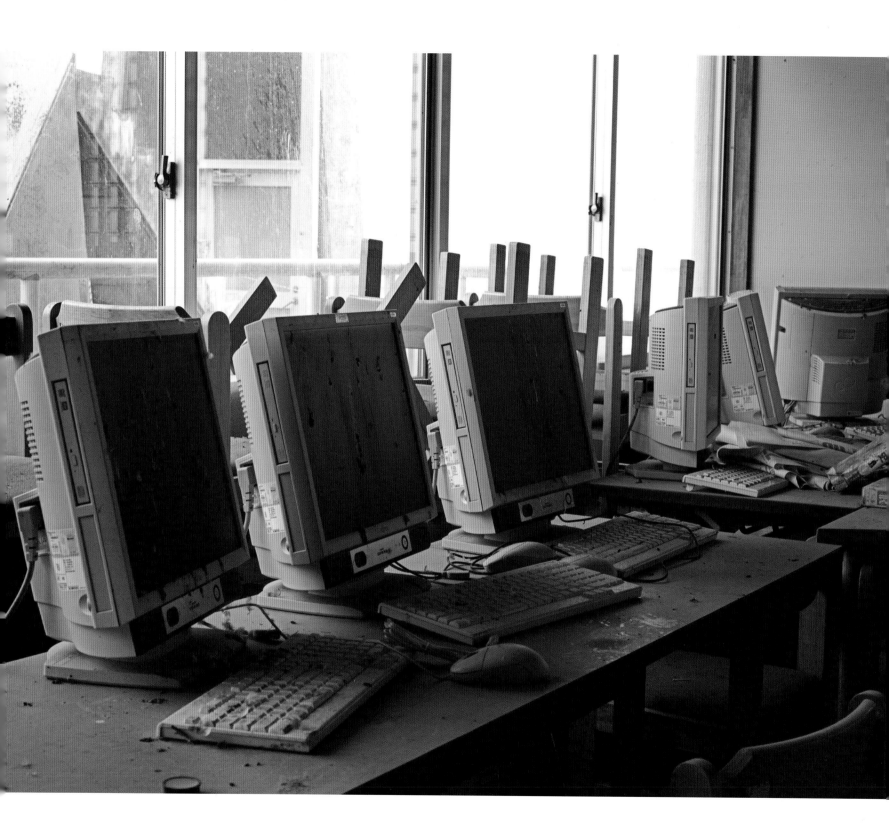

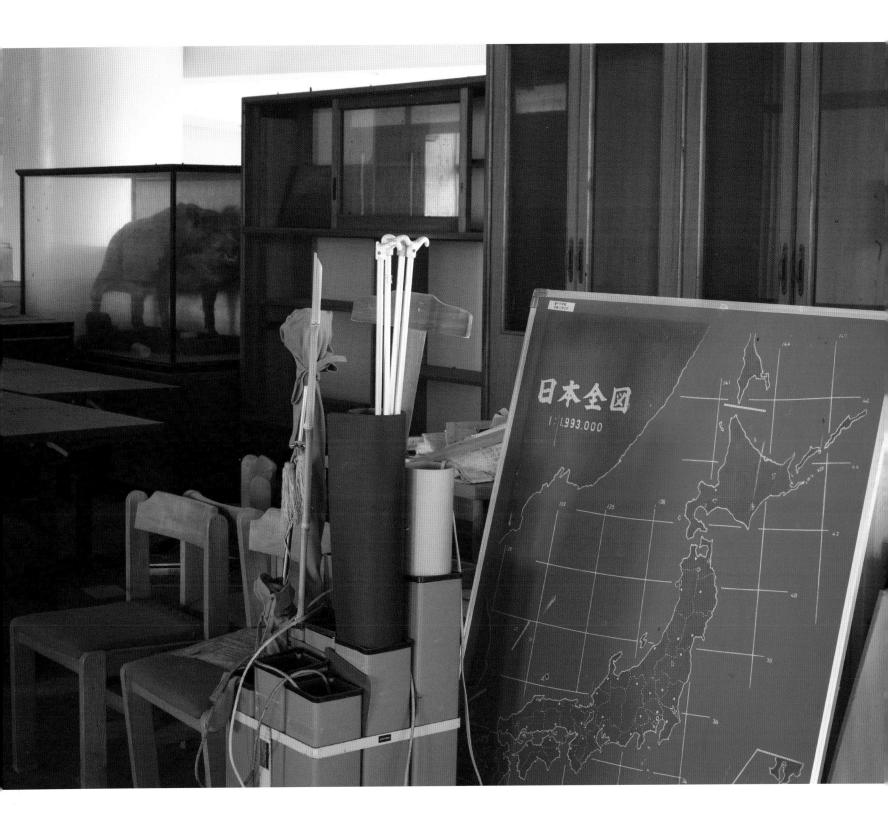

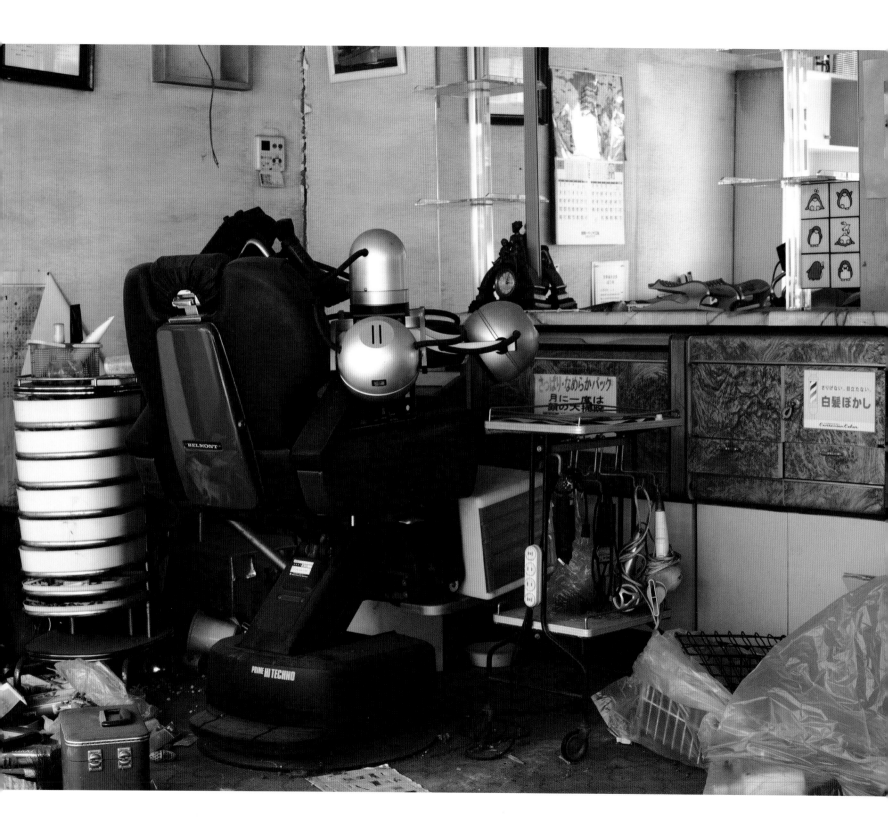

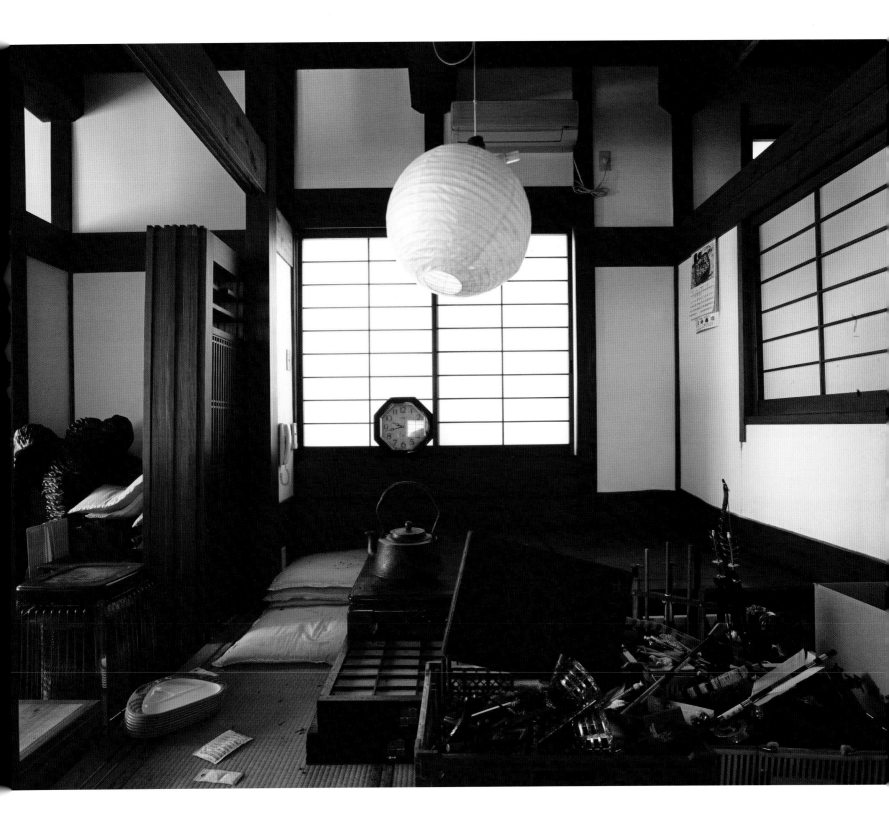

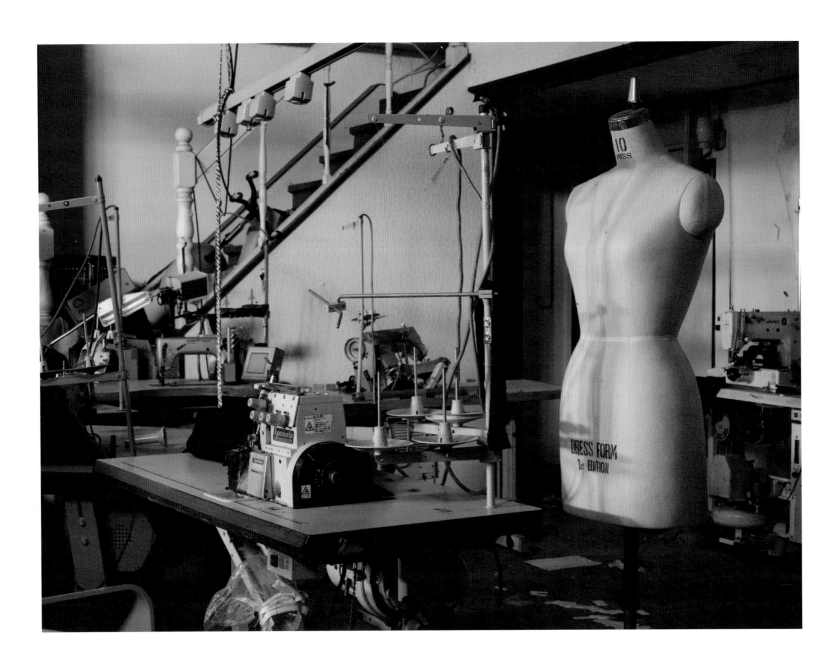

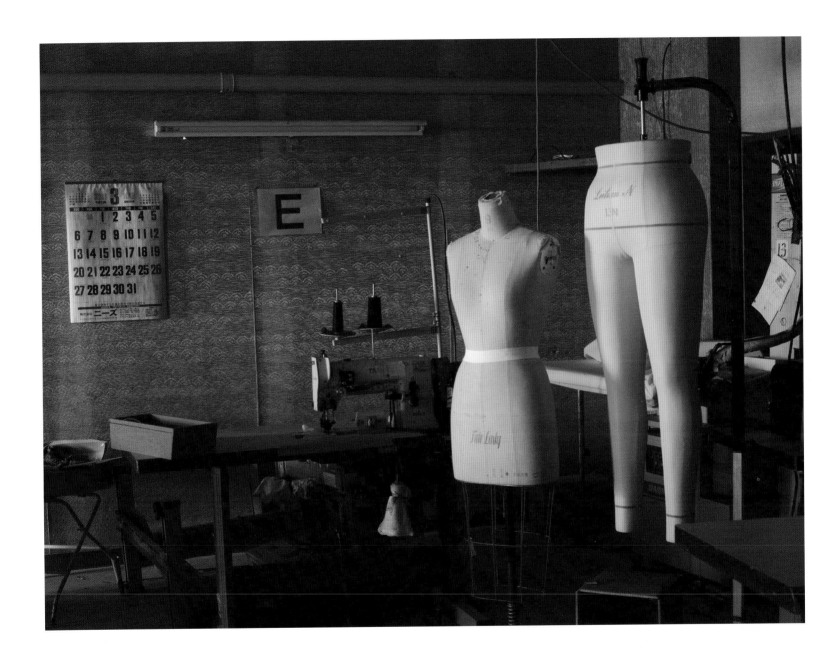

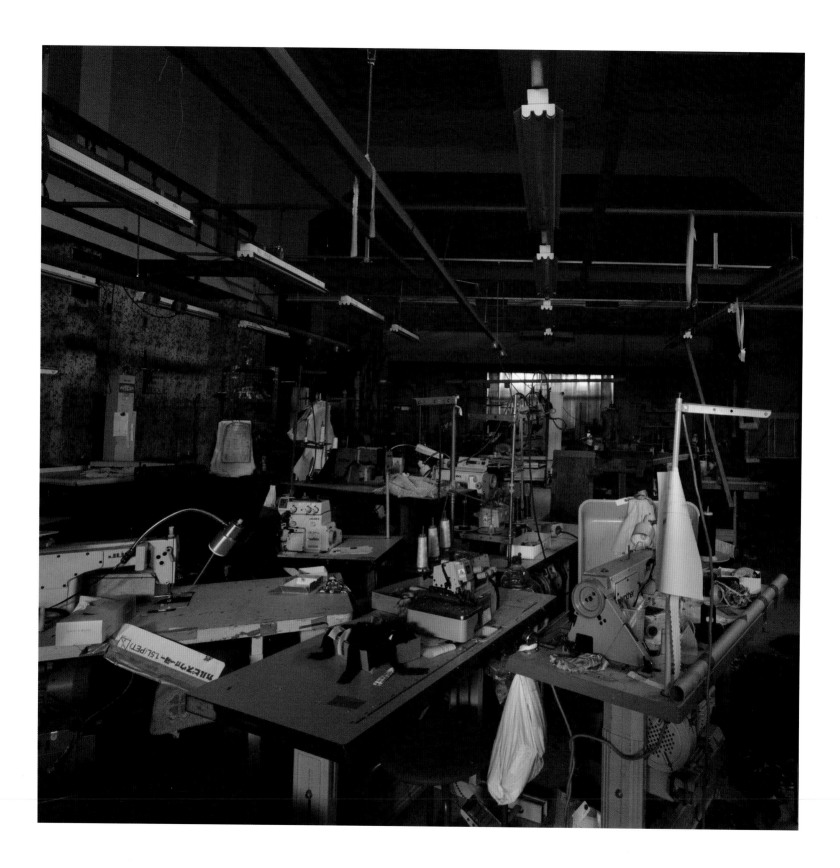

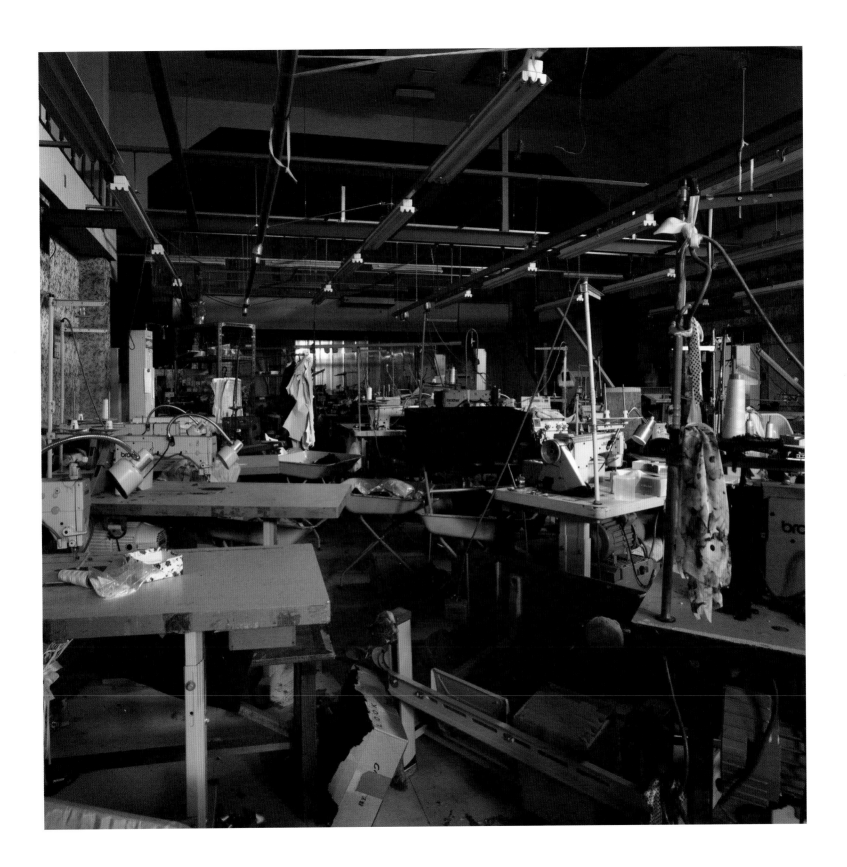

脱原発
DATSU GENPATSU

No More Nuclear!

Japan was one of the most nuclear dependent nations in the world when the disaster struck. Thirty percent of power came from the nation's fifty nuclear reactors. After the disaster, 80% of polled Japanese declared themselves anti-nuclear. All the reactors were shut down and measures to reduce energy use were taken. There has been intense political struggle over the reopening of reactors. However, the plans to reintroduce nuclear power have seemingly won out. The Sendai and Takahama plants are back online.

Many people take a nuanced view of nuclear power. There is little evidence that renewables can provide for 21st century energy demands. There is, however, no debate on the issue of responsibility for the disaster. TEPCO were found guilty of negligence. It was ruled that the Tsunami was a foreseeable event, and the accident itself was preventable. (Although the state shares a portion of the blame for inadequate monitoring). Any return to nuclear will need to radically overhaul safety measures, on an island that lies between not one but four fault lines between major tectonic plates. Another tsunami will happen.

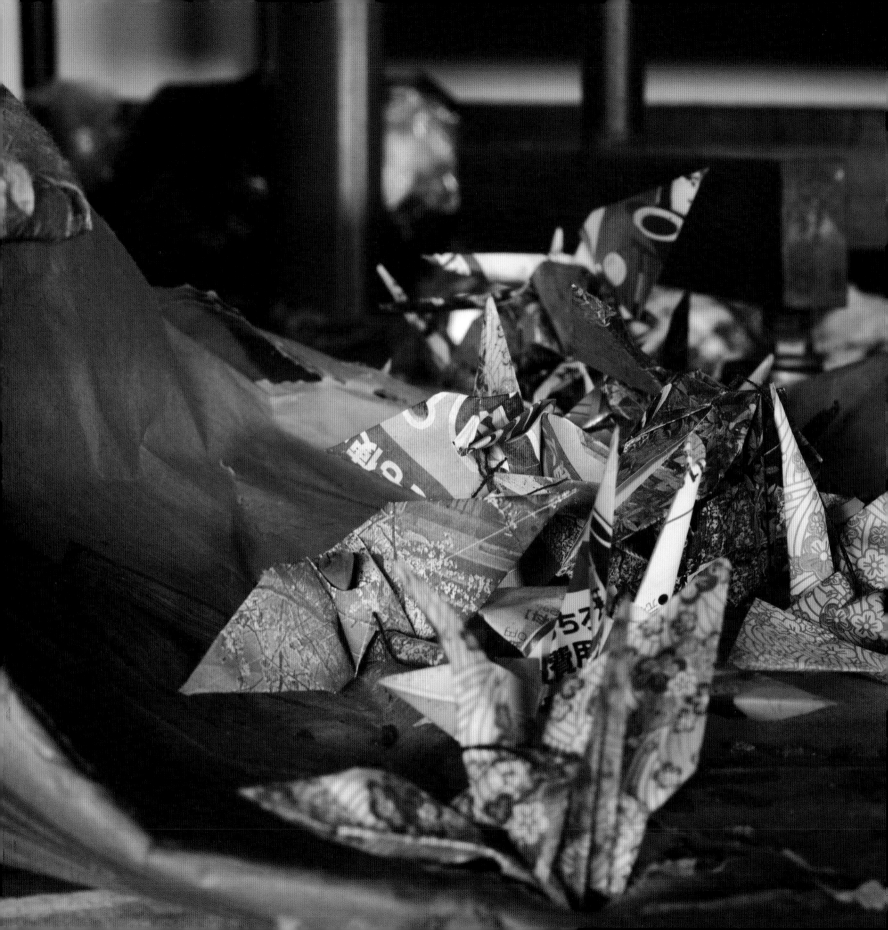

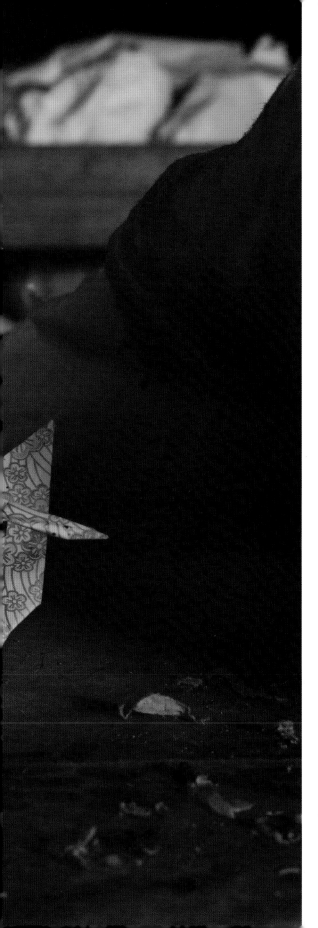

San-ten-ichi-ichi

Some Japanese journalists began referring to the catastrophe as san-ten-ichi-ichi which means 3/11 (11th March 2011). With deliberate echoes of the 9/11 attacks - the events of the that day for Japan must have felt similar. The sense of apocalypse, a disaster of multiple shocking events on a terrifying scale. The quake, the tsunami, the nuclear reactors, an old reality dying suddenly, replaced by a new one in the space of a single day.

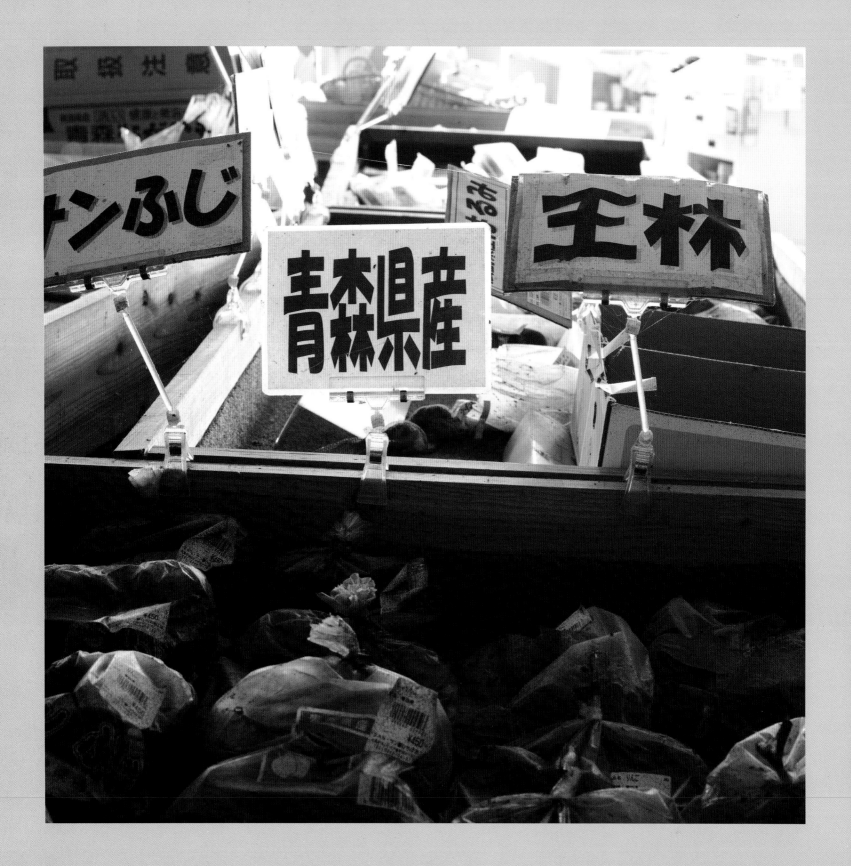

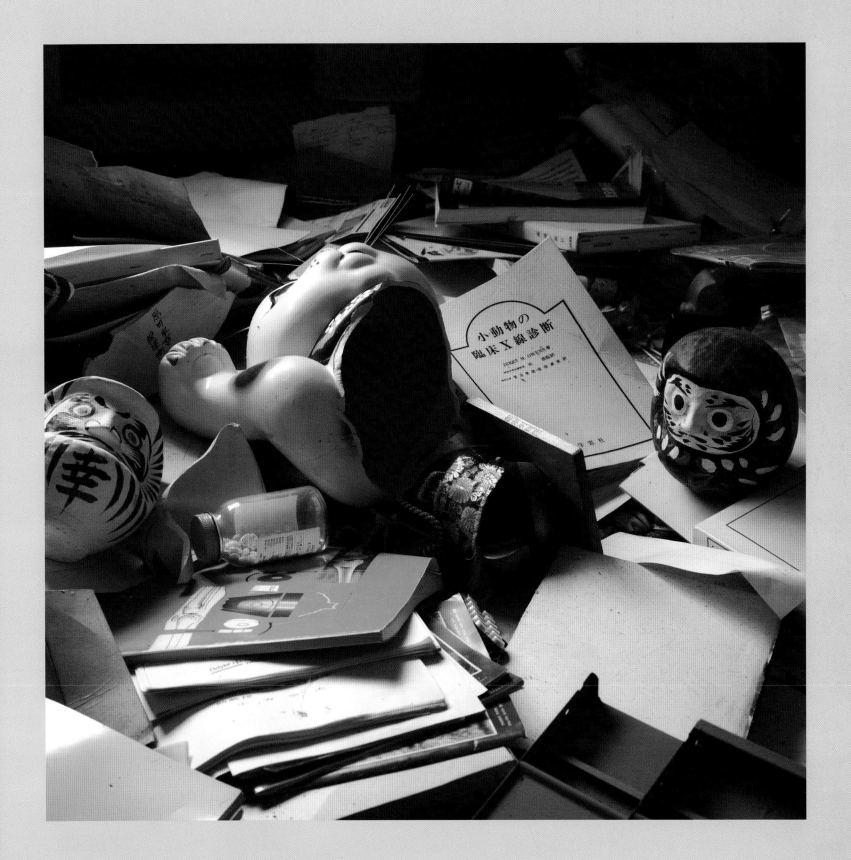

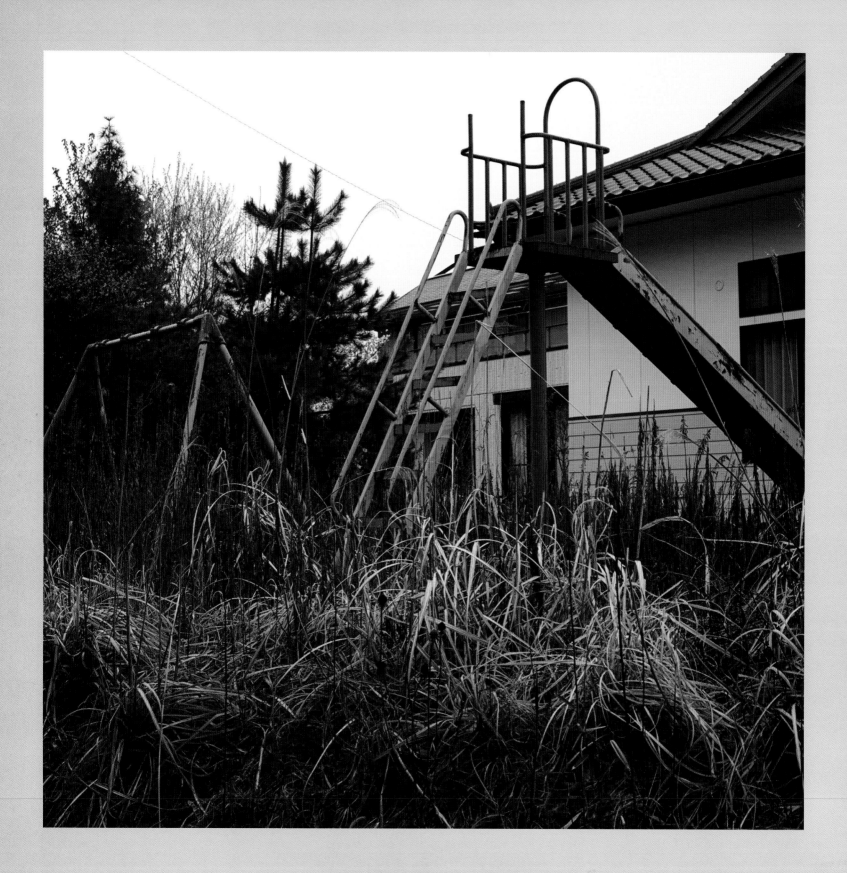

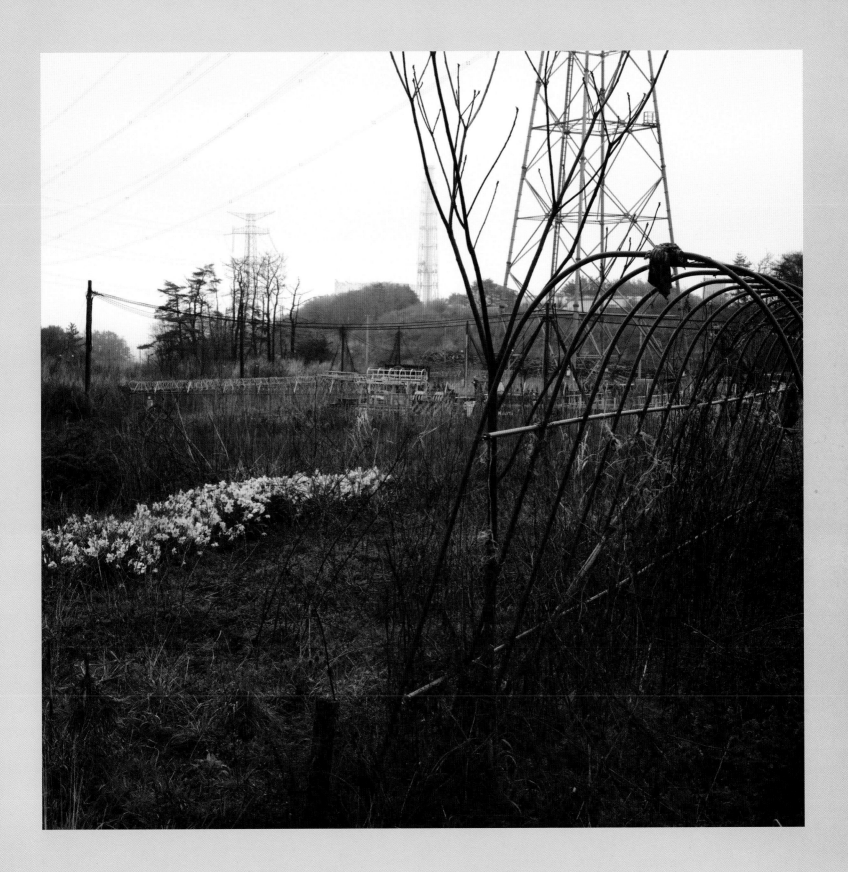

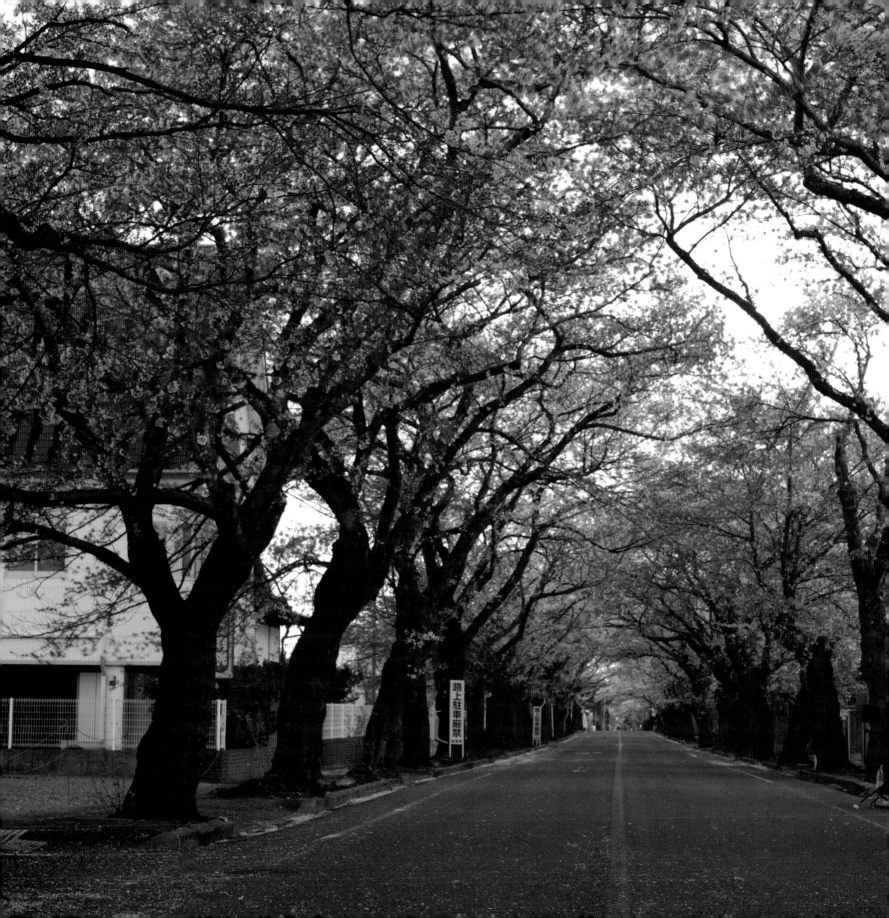

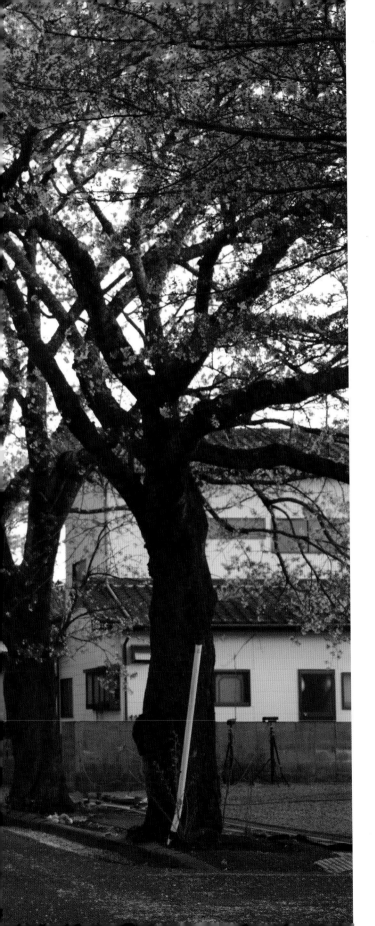

"Between our two lives there is also the life of the cherry blossom."

- Matsuo Bashō

東北地方

TŌHOKU

Matsuo Bashō wrote his 'Narrow Road to the Deep North' about this region of Japan in the late 17th Century. He was emulating the wanderings of even earlier poets who immortalised locations from the wild and remote northern parts of Honshu Island. Many of the sites continue to be tourist attractions today. Tohoku is far from the hyper-modernity of Tokyo, a tougher place to live where an older Japan continues to exist alongside the modern. It's a farming and fishing region with some heavy industry and of course, nuclear power plants. The population of the region was already in decline before the tsunami. Fukushima is one of six prefectures in the region. Sendai is the largest city. As time passes, people in Tokyo forget. The difficulty now is keeping the political will to reconstruct Tōhoku alive.

"It seems the rest of the country has moved on, but we are going nowhere."

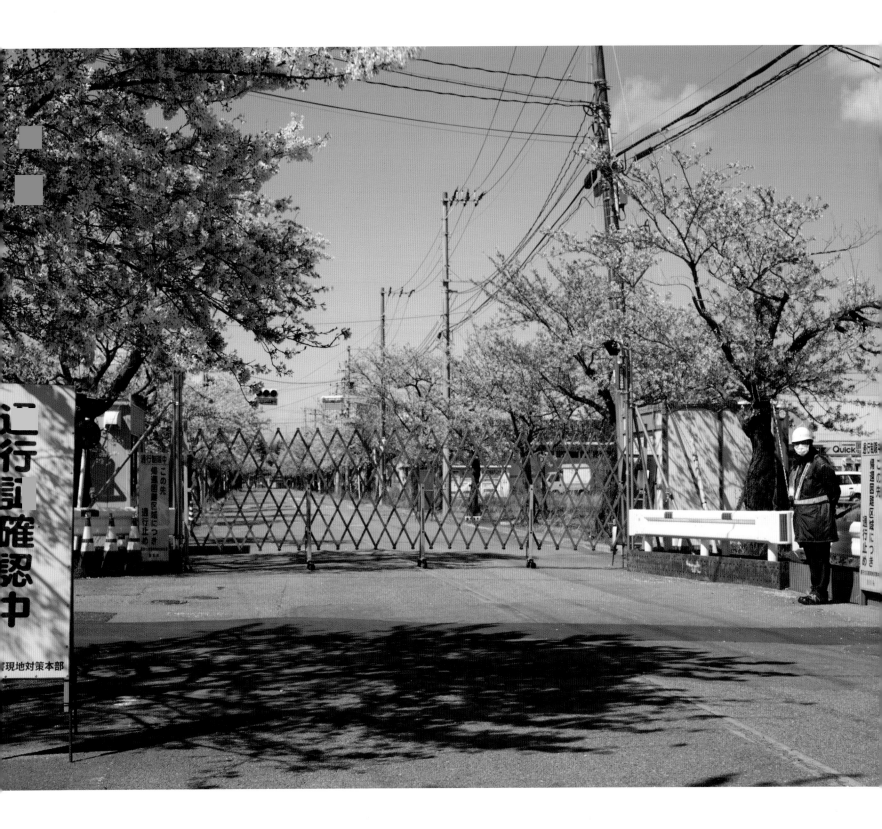

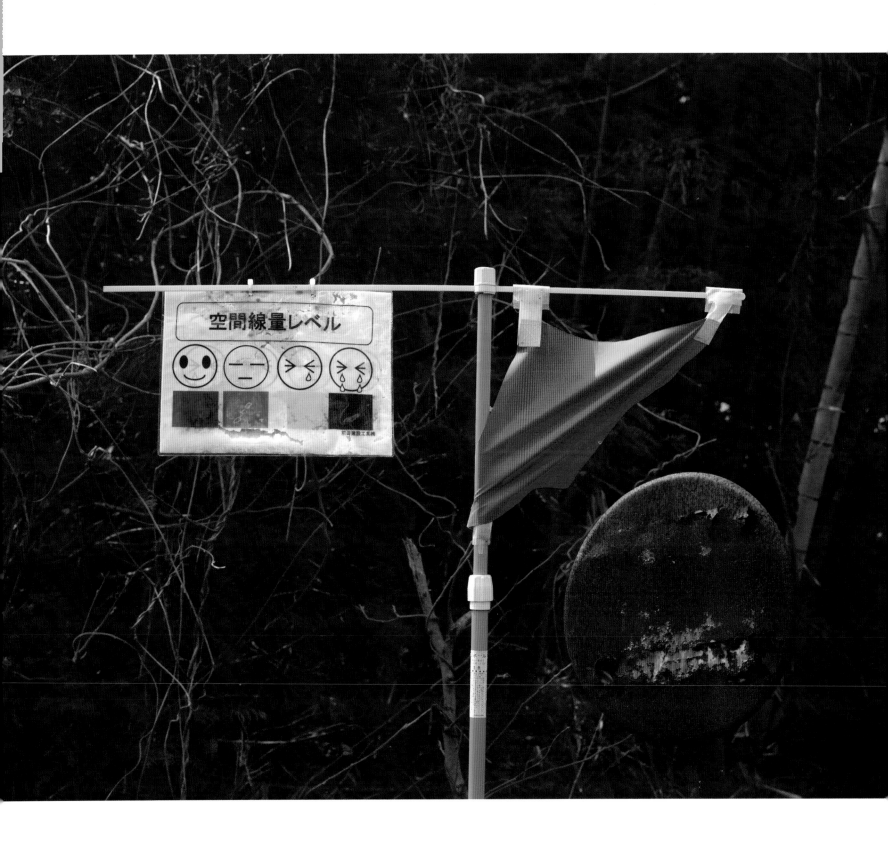

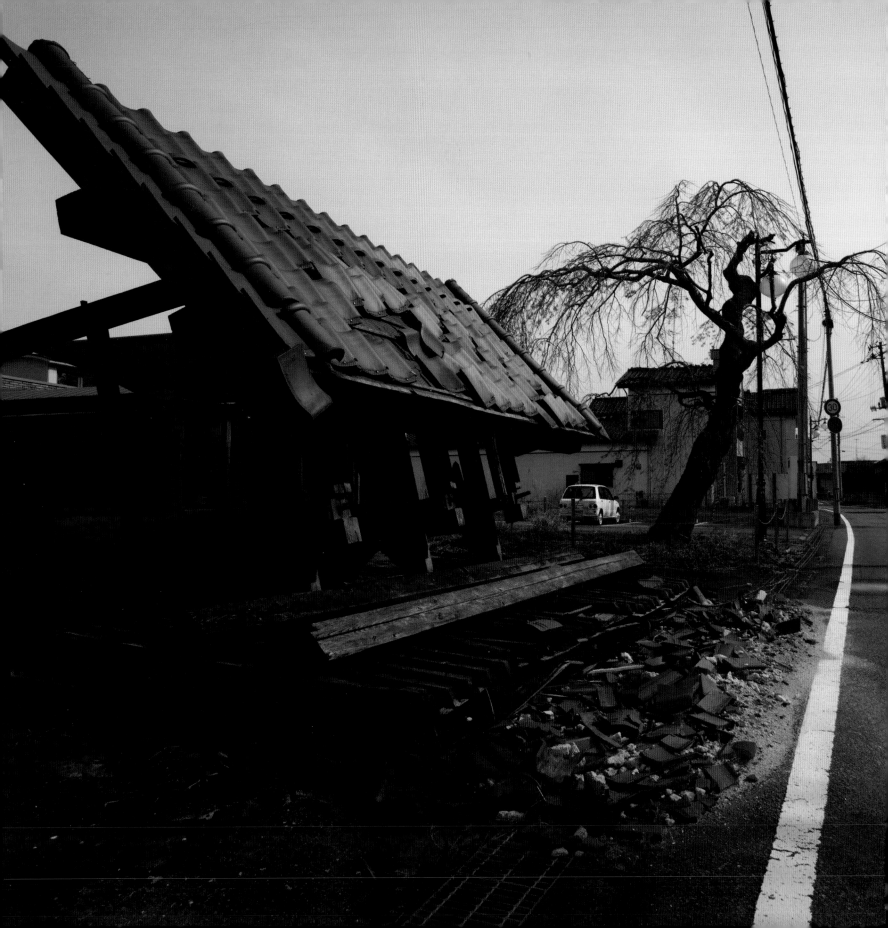

Gekijoo
- Fukushima Theatre

Darkly satirical. Gekijoo. The term for the relentlessly unfolding drama coming from Fukushima Daiichi. The accident did not simply happen. It happened in fits and starts over time, incidents and accidents going on for years. And always in the back of people's minds the possibility that it might get worse. Dozens of typhoons battered the region alongside the aftershocks in the years that followed. Deep snows and heat waves all contributed to the immense difficulty facing the workers at the plant, trying to limit the damage and work towards decommissioning. All the while, vast bodies of contaminated water sitting in makeshift vats, accidents waiting to happen. Political dramas. Corporate apologies. Sensationalised reporting. Gekijoo.

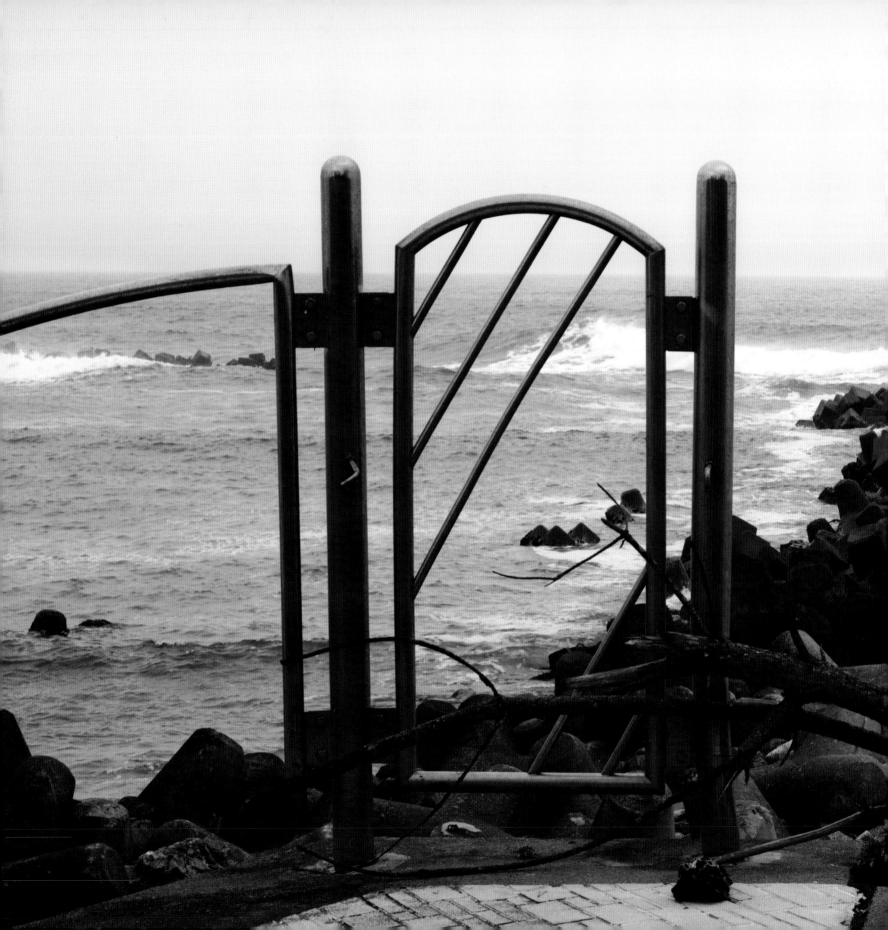

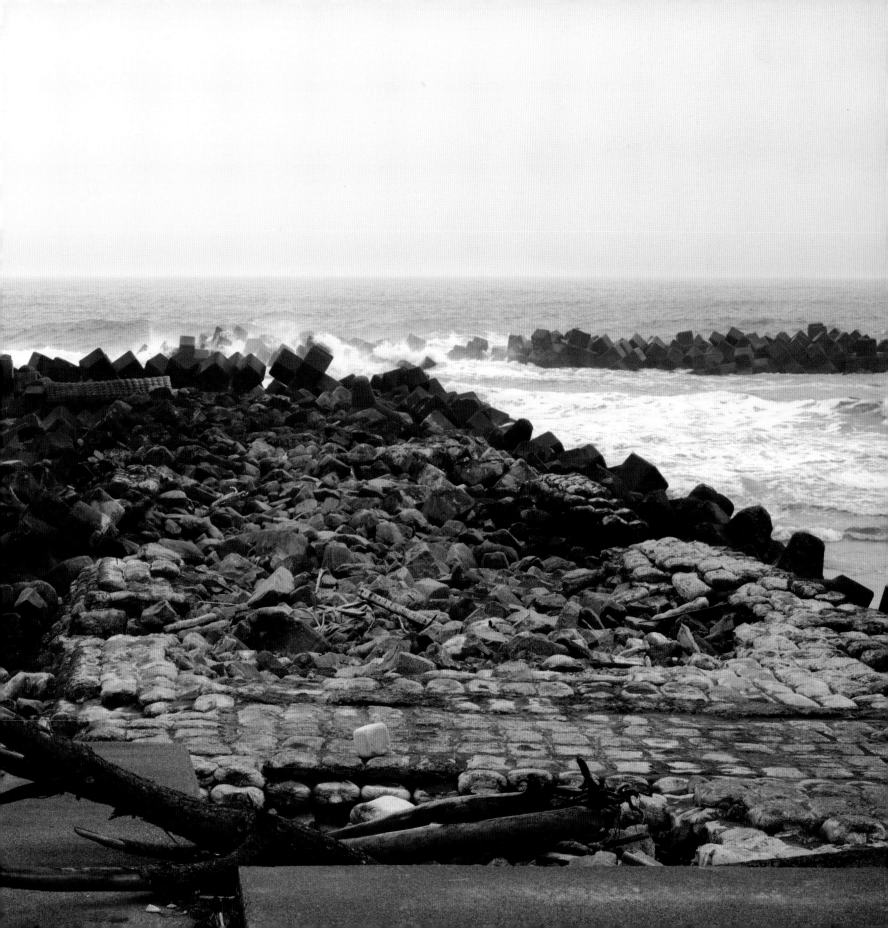

避難地域

HINAN CHIIKI

Exclusion zone

The Prime Minister Naoto Kan ordered a 20km evacuation zone around the Fukushima Daiichi Power plant shortly after the disaster struck. A further zone between 20-30 km was established where people were advised to seek shelter and remain indoors. Several districts to the north were also ordered to evacuate as a result of the predicted pattern of fallout. Recovery efforts are focussed on decontaminating and rebuilding towns like Tomioka for resettlement. Tomioka is the scene of the cherry blossoms featured in this book - a sign of the town's defiant optimism.

In some devastated villages you can see monuments decorated with yellow flags - these are a sign of a solemn vow to return. However, resettlement is not a simple matter for the people going home, when a ban is lifted on a town the relief payments to refugees are phased out. There are fears that the bans may be lifted too soon.

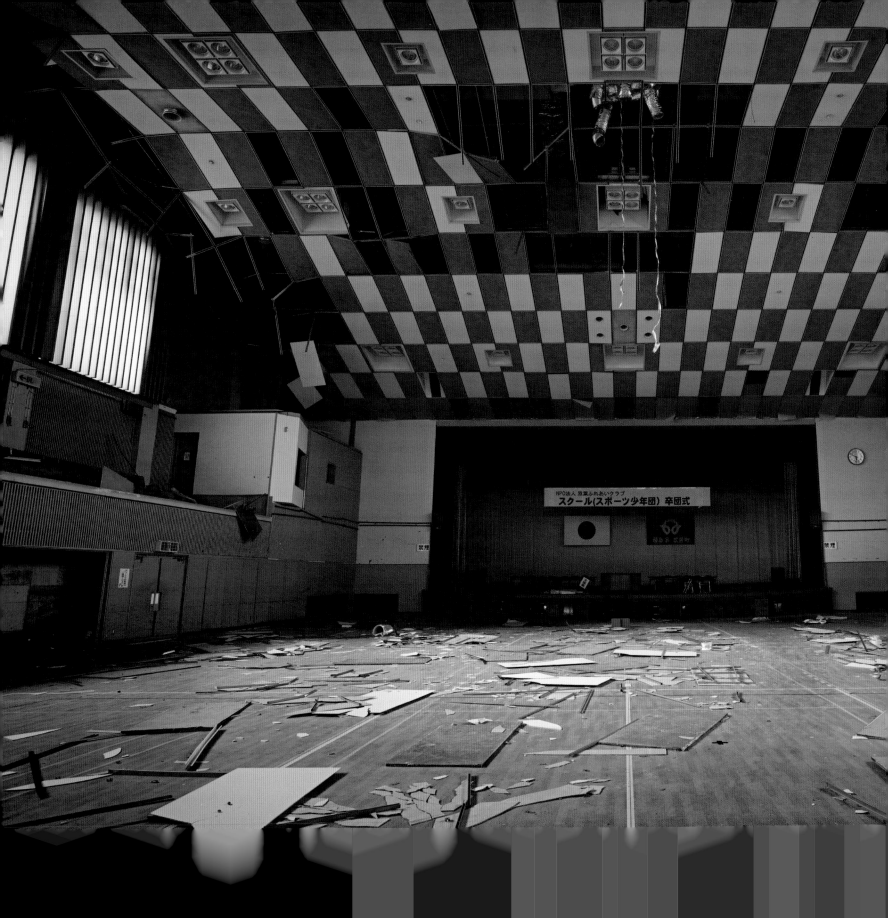

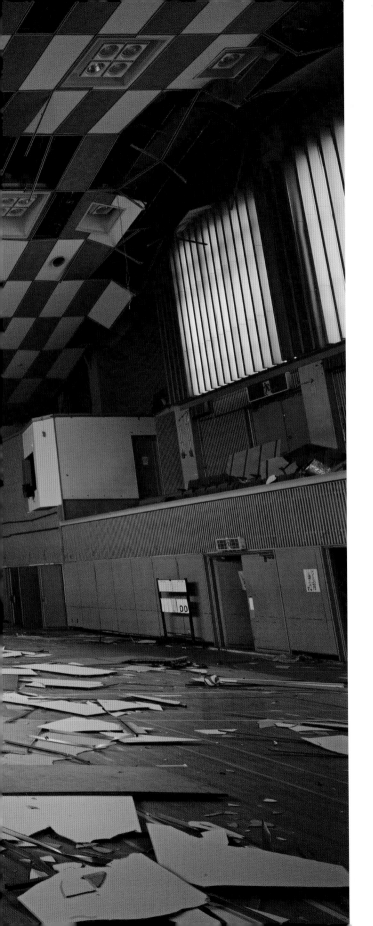

Black rain

Reports of black rain after the disaster. "I was soaked through with black rain," reported photographer Bin Ishikawa as he rode around Fukushima prefecture on a motorbike documenting the events. A painful echo. Deep in the cultural memory of Japan, the black rain that fell around Hiroshima and Nagasaki after the A-Bomb dropped. But did it really happen in Fukushima? In the panic of the aftermath, rumours abound.

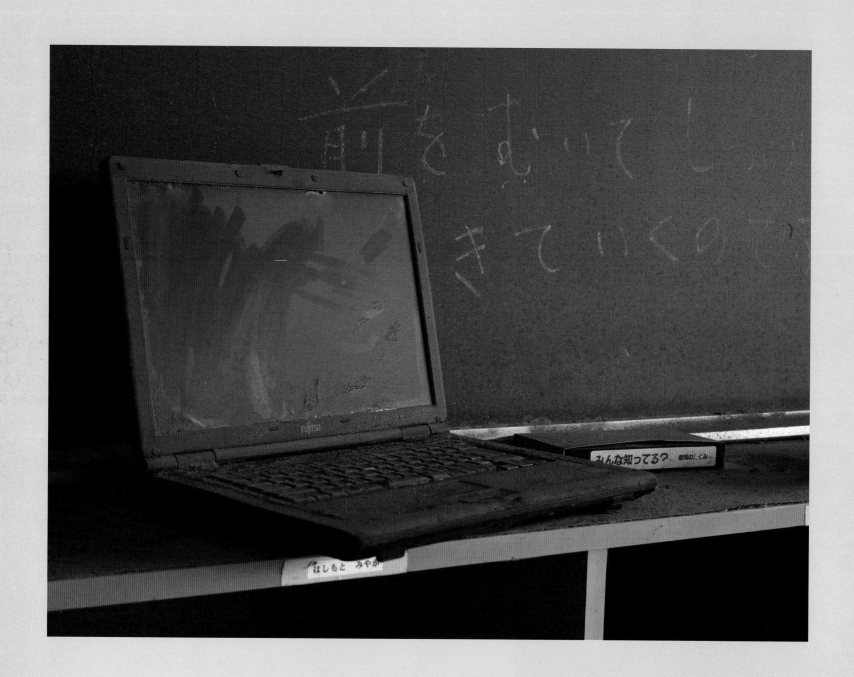

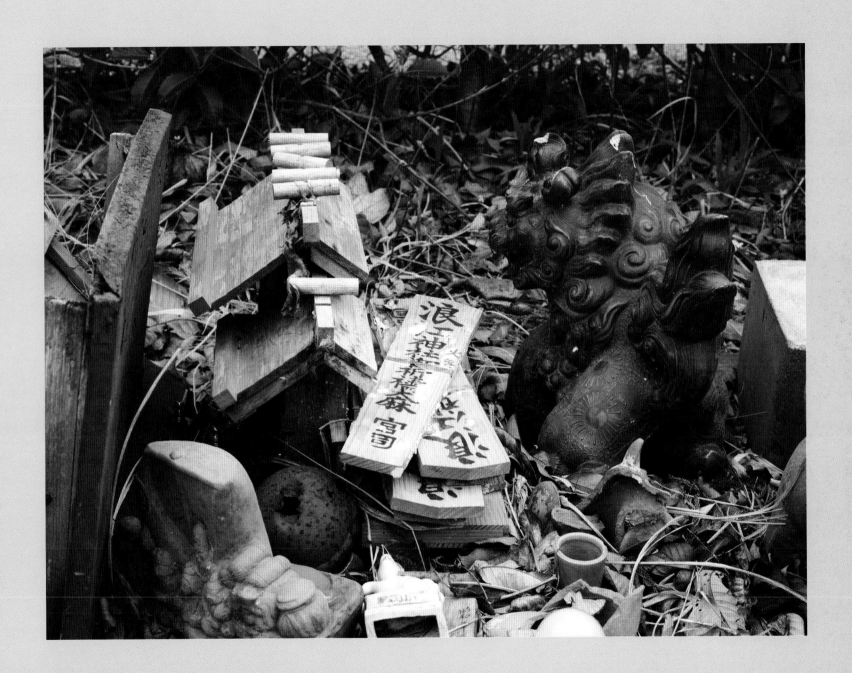

"IT IS UNREALISTIC
TO REBUILD THE TOWN
THE WAY IT WAS BEFORE
THE MARCH 11TH
DISASTER. WE THINK IT
IS NECESSARY TO SHOW
REALISTIC PLANS SUCH
AS CREATING A NEW
TOWN CENTER."

- Tamotsu Baba: Mayor, Namie Town

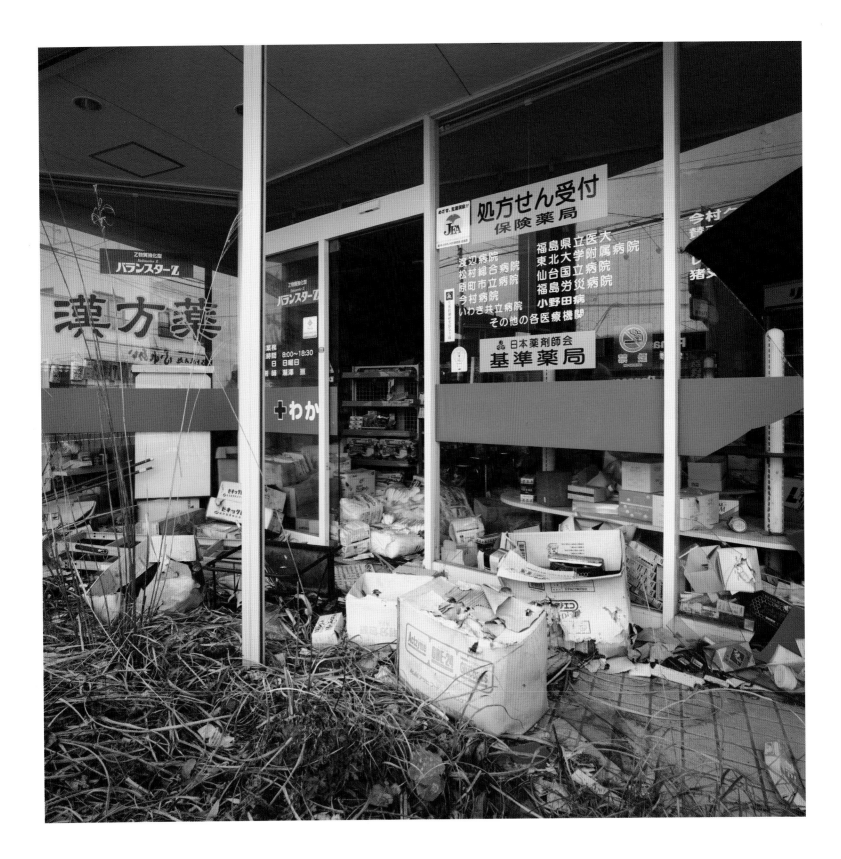

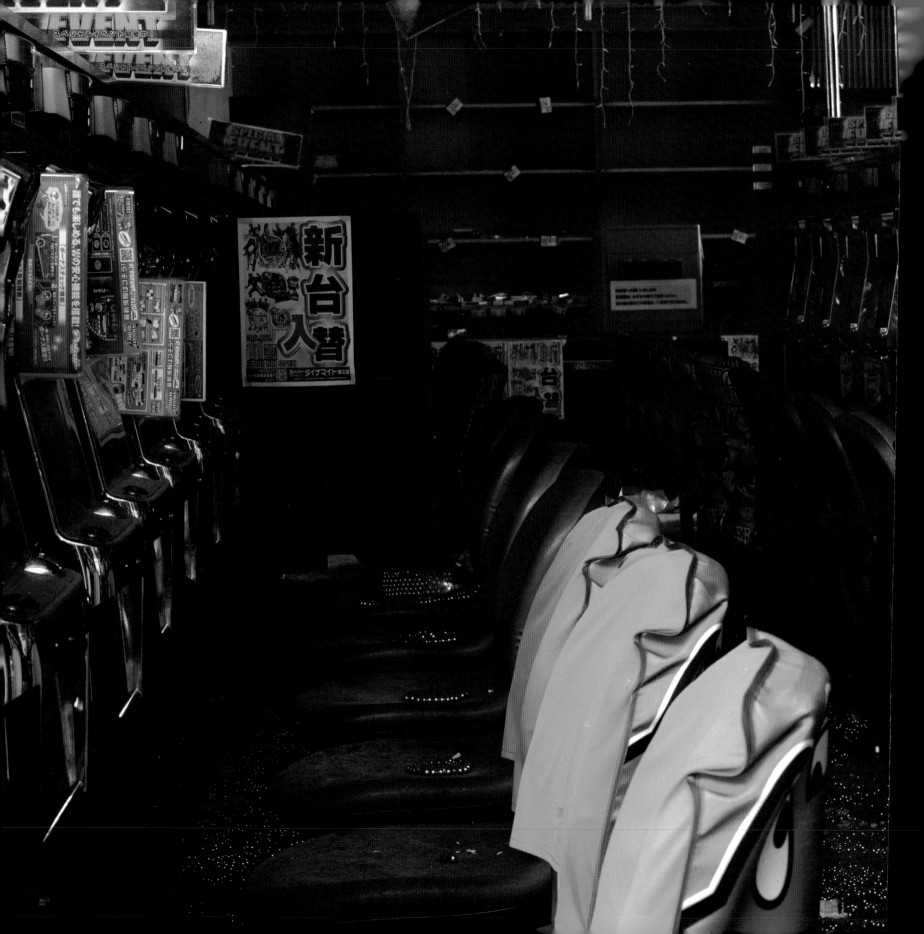

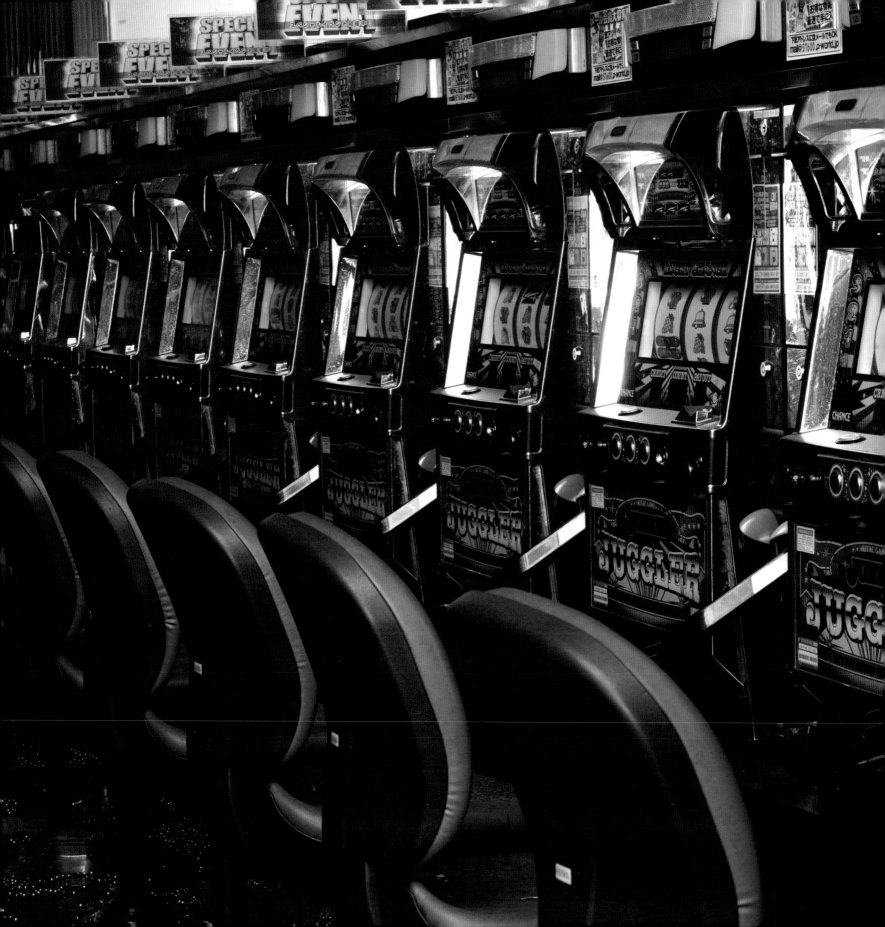

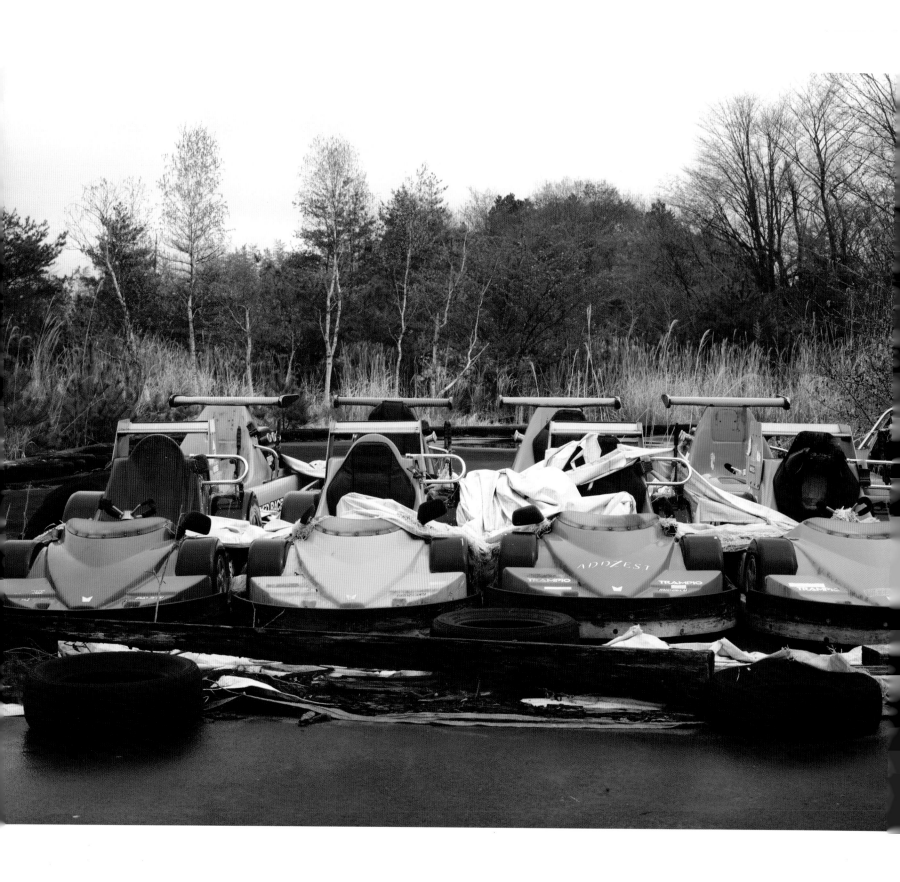

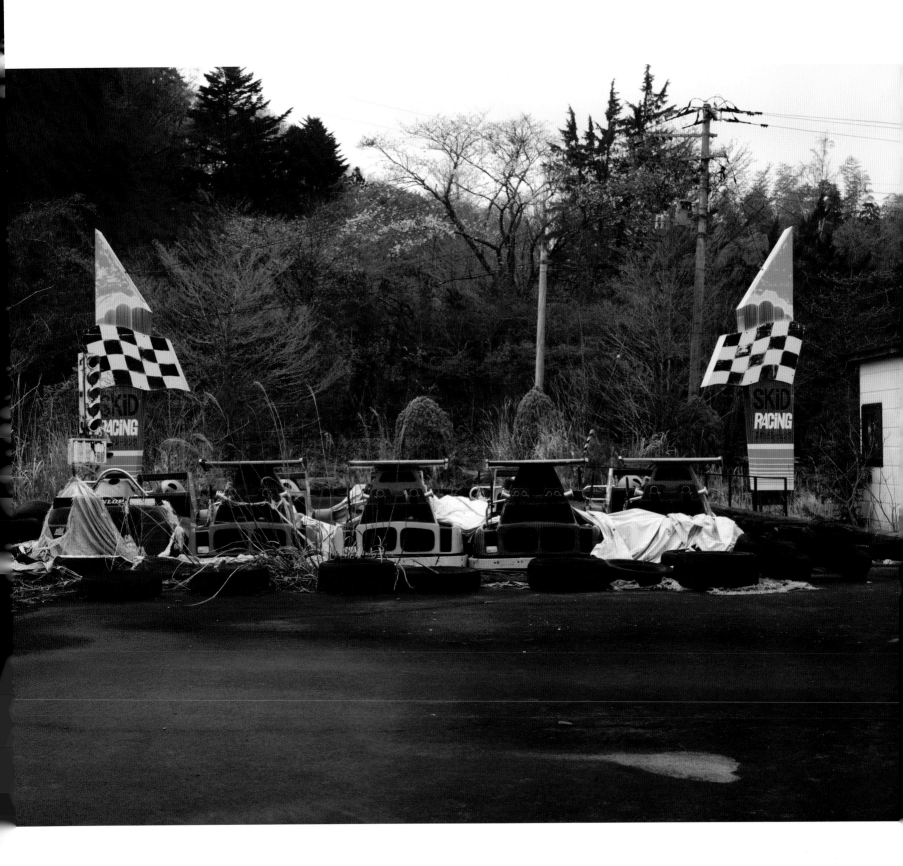

孤立死
KORITSUSHI

The exclusion zones represent, most of all, a mass exodus of human beings. 150,000 refugees initially fled the area. Many of them older people. Years later many are still housed in temporary accommodation. Efforts were made to shelter communities together, yet still some fall through the gaps in the system. Displaced people lack their networks of support. Two elderly people die alone without anyone knowing. This is koritsushi. It means 'to die alone'. Scandal. Especially for a people who honor their elders as a sacred duty.

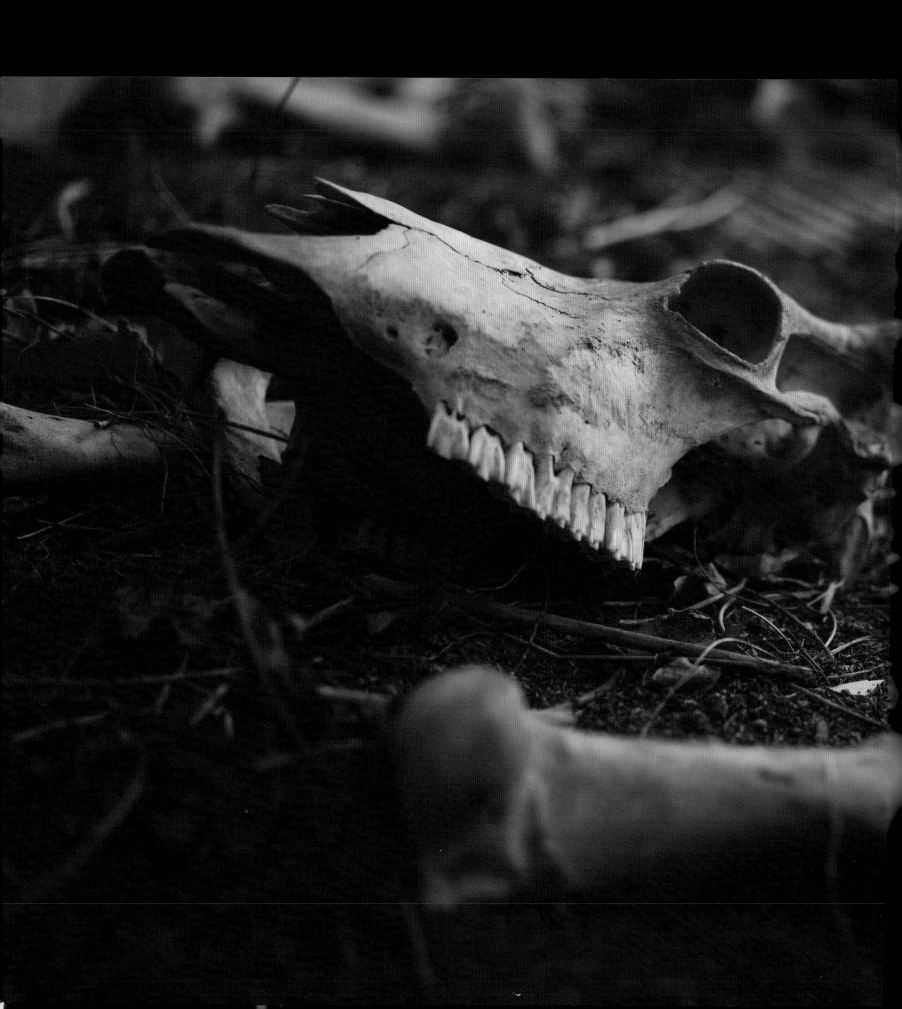

O-Bon

O-bon is the Japanese 'Day of the Dead', and like the Mexican version it is a joyful festival where the dead are welcomed back into their old homes and their lives are celebrated. After the disaster, special permissions were granted for relatives to travel back to areas in the semi-dangerous zones to visit graves. A sad, touching spectacle of families in white overalls and masks visiting their deserted towns to pay respects to the dead.

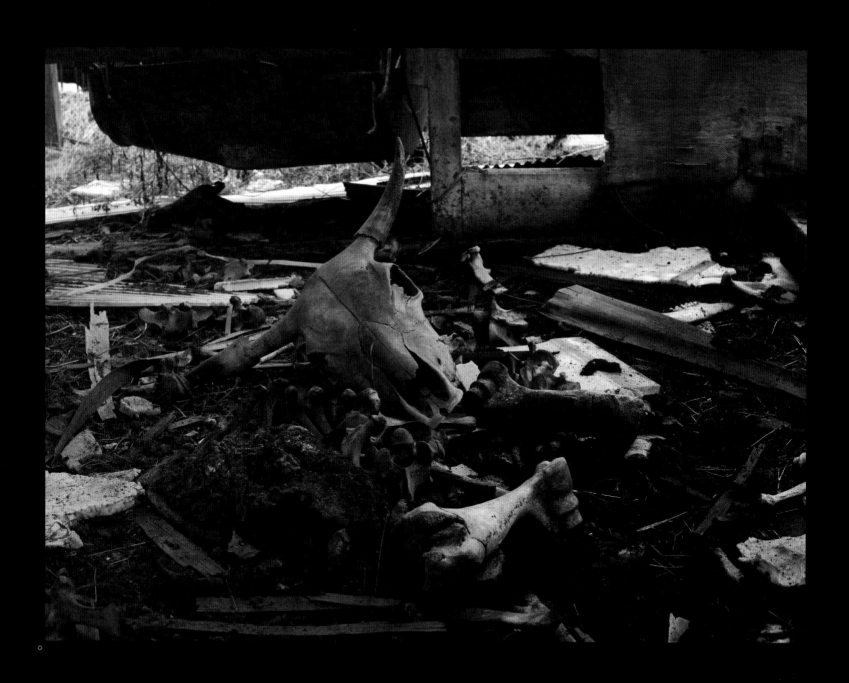

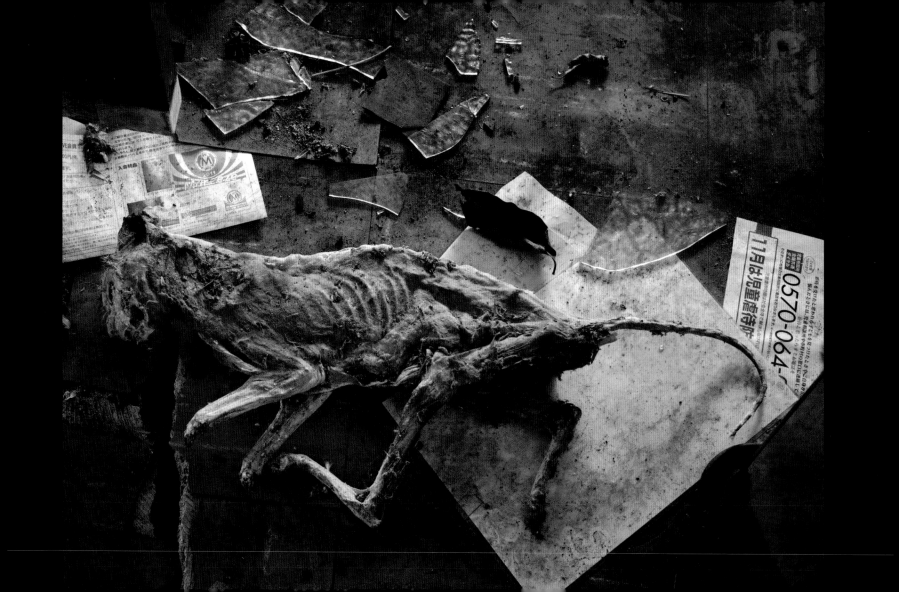

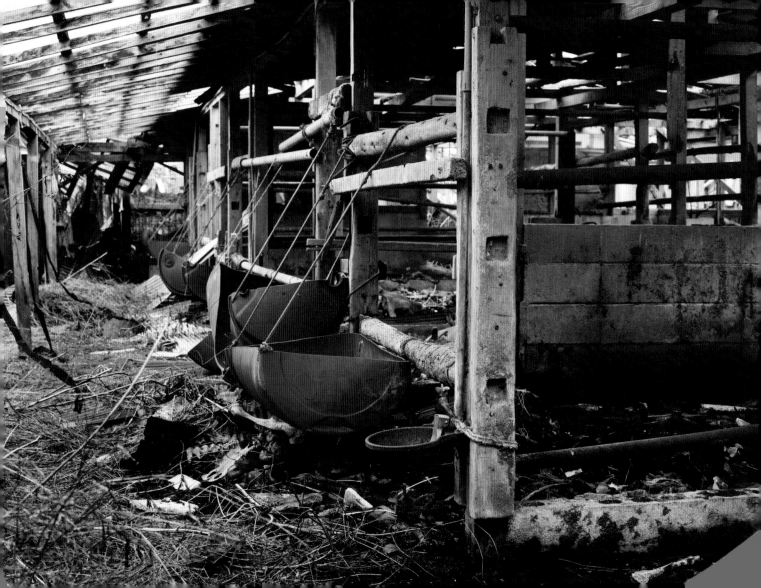

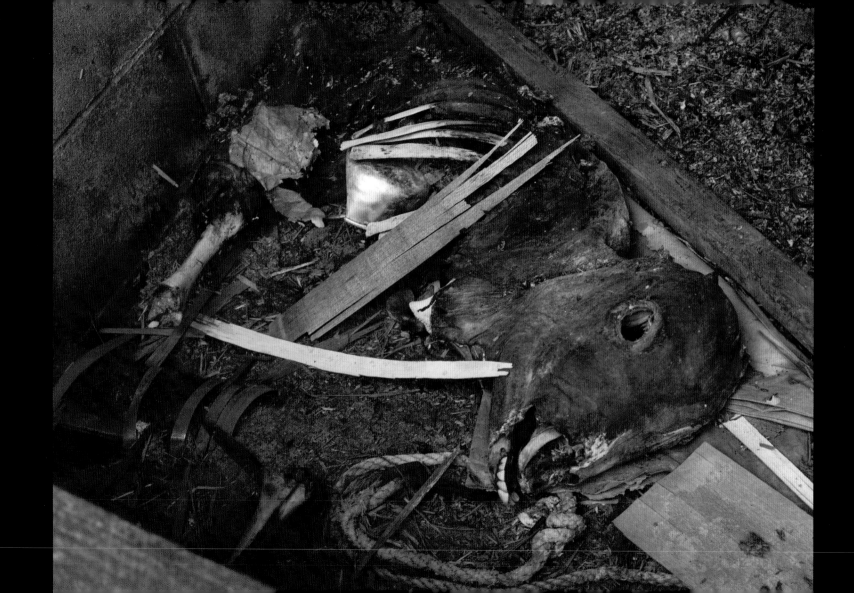

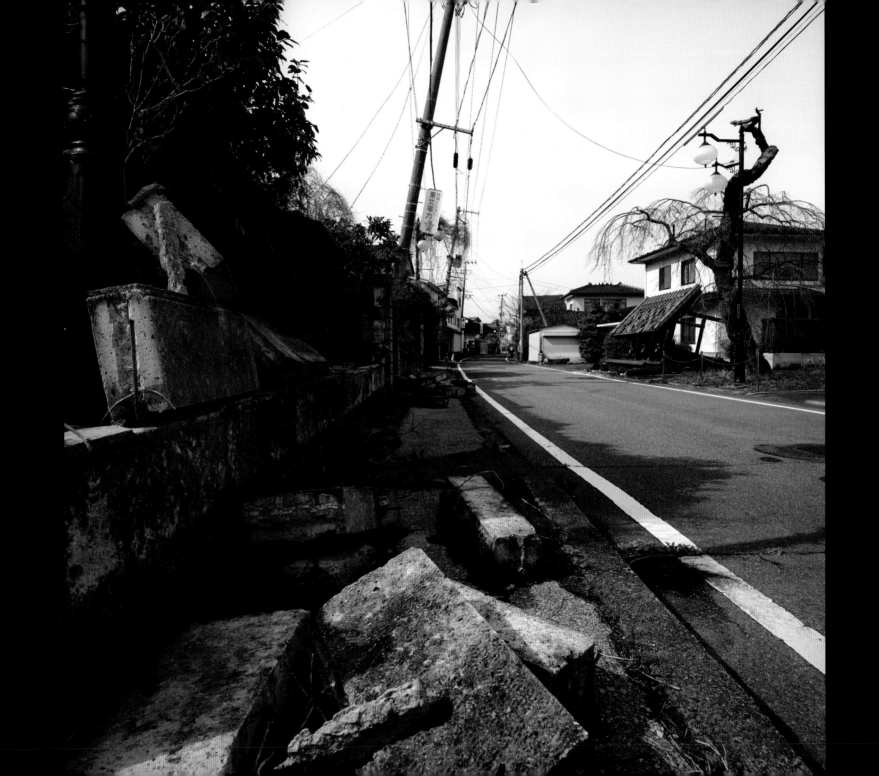

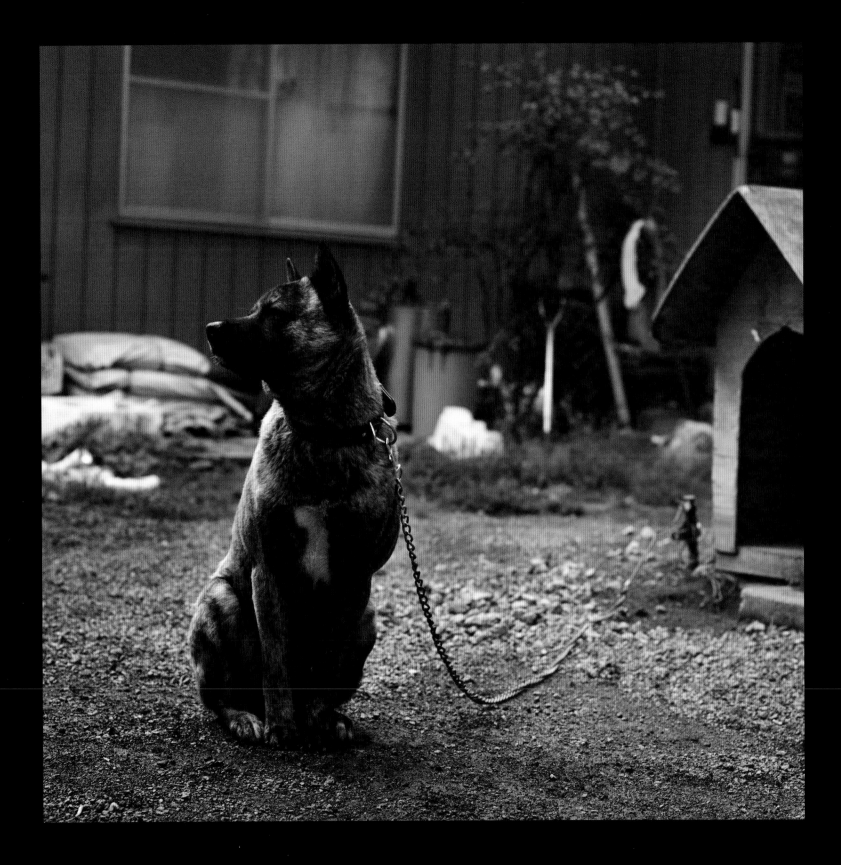

月命日
TSUKI MEINICHI

For years after the disaster there are tsuki meinichi 月命日 monthly anniversaries of the deaths of loved ones. In the beginning these were days for search parties, when there was still hope. More than 15,000 were eventually confirmed dead and a further 2,500 still listed as missing. Sudden, unexpected losses; trauma for those left behind.

"I THINK IT IS OUR DUTY AS SURVIVORS TO TELL THE WORLD HOW DEAR LIFE IS."

- Survivor, BBC Video

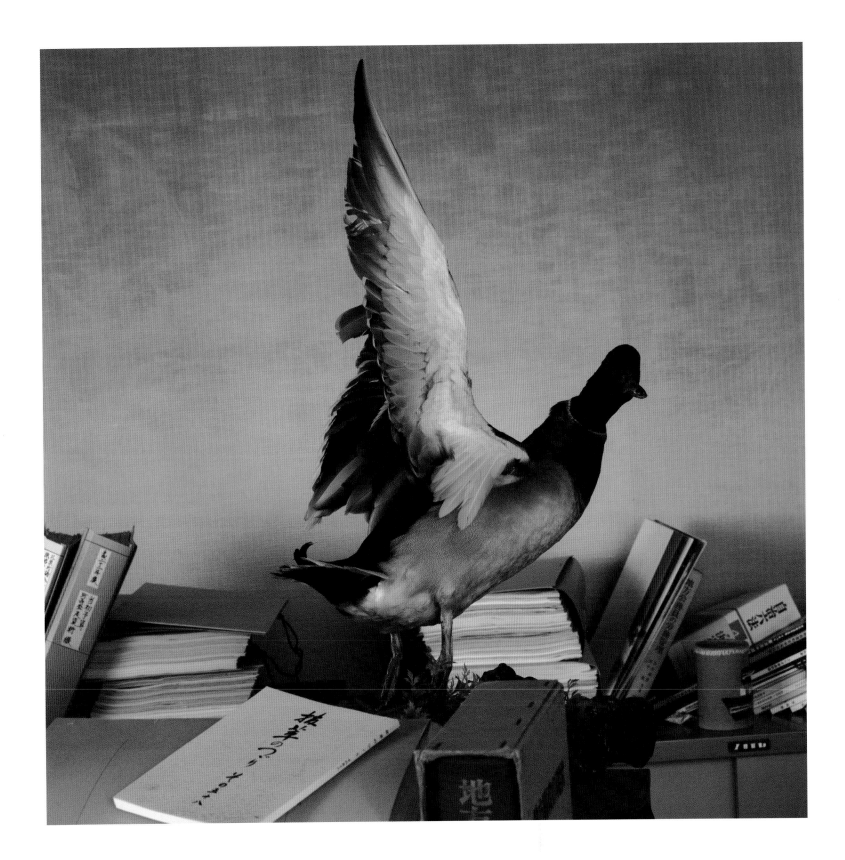

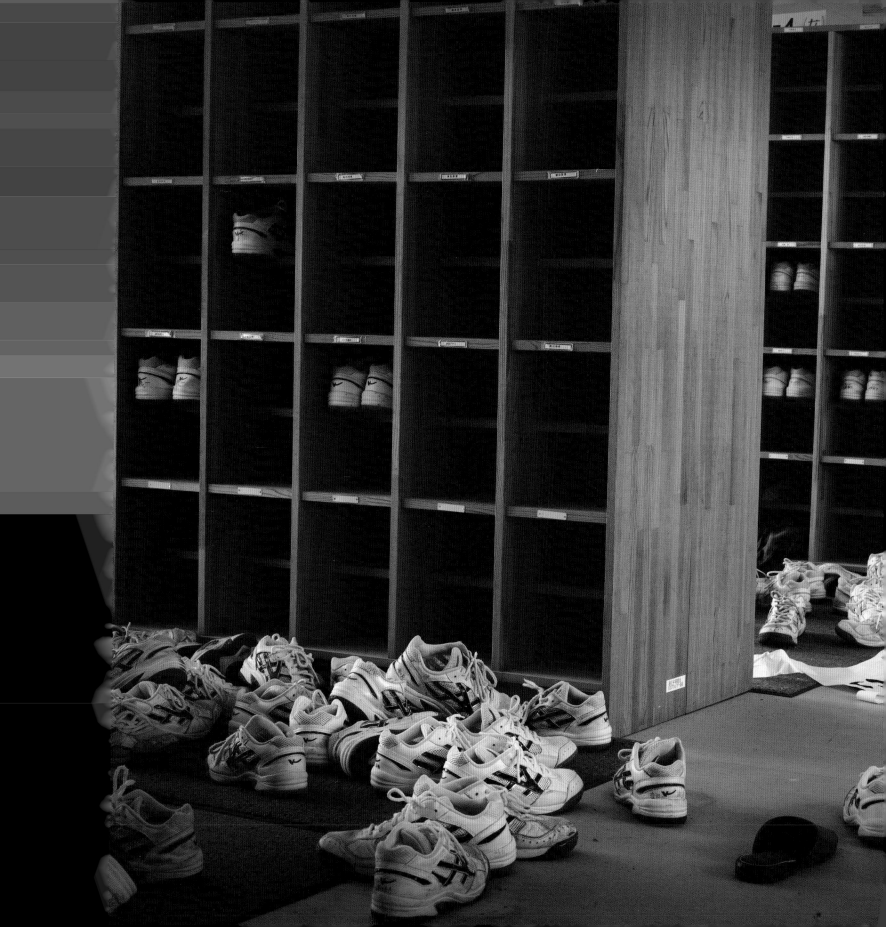

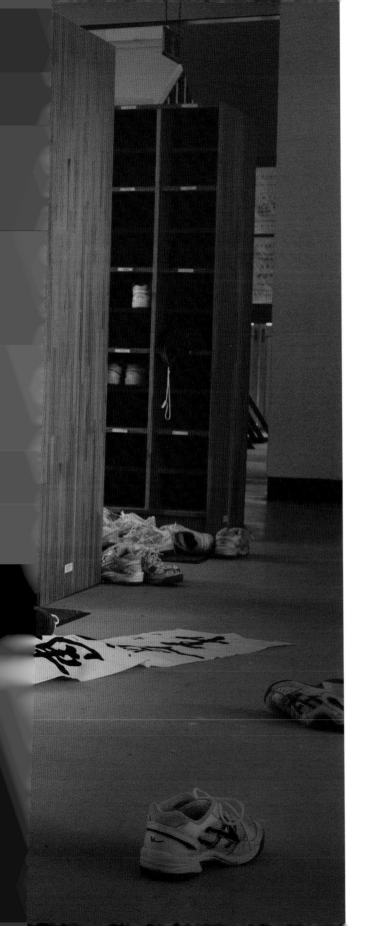

Emergency Backpack

Everything changes. Everything stays the same. Still thinking about work. Still worrying about money. Still berating yourself for not going to the gym. But there is something new in your closet. You have a backpack full of strange oddments ready to throw on your shoulders and evacuate with at a moment's notice. You keep your bathtub full of water. You keep a wind up radio and a solar flashlight. You have a stash of drinking water in sealed containers. Life goes on. But you are different. You no longer expect 'them' to do everything for you. You know finally, that it's the people around you that you will turn to, and them to you, when the unthinkable occurs.

THE ASSOCIATION OF DEATH
EDUCATION

"I use [the] term 'grief,' [but] some 15 years ago I don't even know that kind of term. And if I say 'grief' to quite well-educated people, [they say] 'What are you talking about? ... What is it?'" Yoshiko Suzuki, www.npr.org

The Japanese Government responded to the Tsunami disaster in 2011 with the provision of counselling for people who had lost loved ones. This was the first time ever that such provision had been made in Japan after a disaster. It was a sign of a deep, yet tentative shift in the Japanese attitude to suffering. The famous Japanese stoicism led many to comment on how impressively they appeared to cope with the tragedy, yet underneath this tough surface - traumatised people found themselves unable to express their emotions.

It is now generally accepted in psychotherapy that grieving is a process that requires people to acknowledge and talk about how they feel in order to move towards a functional acceptance. In a culture where many still feel deeply ashamed to show their emotions in public, this process stalls. People who don't talk about it get stuck, unable to find a new reconciliation with life.

Things are changing in Japan. Grief Counselling Associations are in operation and some 200 new counsellors were trained to deal specifically with traumatised children from the disaster zone. Almost 60 mental health care teams were deployed in the Tomioka region after the quake. It wasn't always like this.

Back in 1983 a Jesuit Priest and Philosopher from Germany set up the Japanese Association of Death Education, an institution that has quietly had a big impact on Japanese culture.

"At the time of the foundation of the association, death was still considered a taboo in Japan. Consequently, there was practically no education about death, dying, bereavement and grief. I consider grief education as an essential part of death education." - Alfons Deeken

Deeken is something of a cult figure in Japan having published many books on the subject of dealing with death in Japanese. This and the increasing globalisation of culture is perhaps softening Japanese attitudes to grief. Maybe the necessity of dealing with such widespread trauma is itself teaching the Japanese to grieve.

"There is no other way that we can survive than we say to each other like a prayer, 'Gambare' - go for it, go for it, be positive, be positive," - Yoko Kumagai, www.npr.org

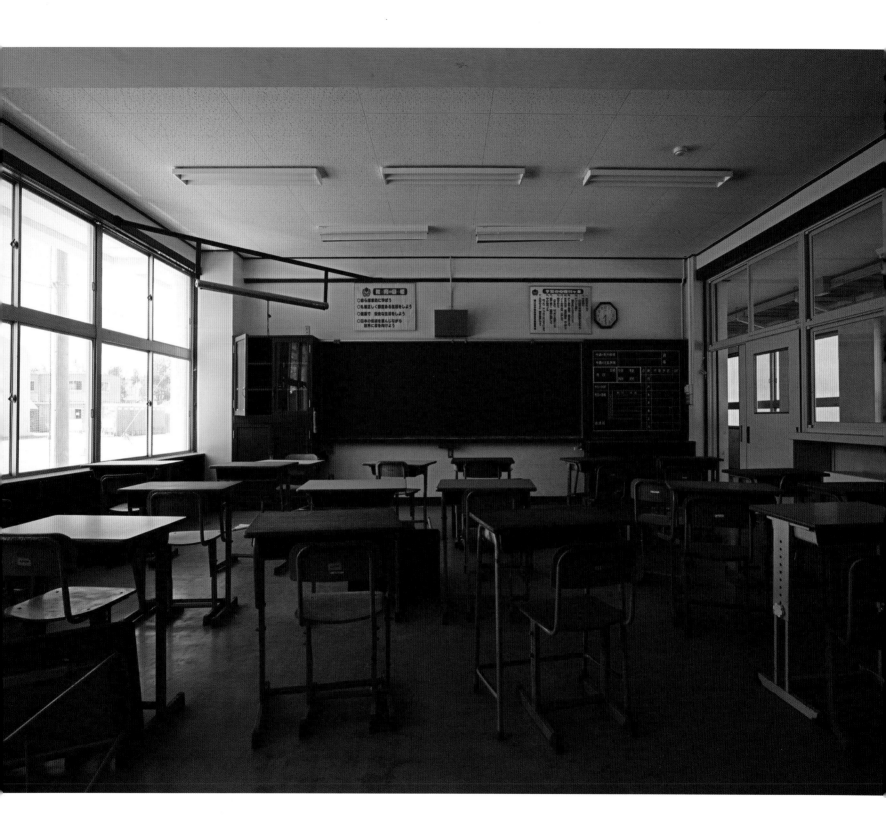

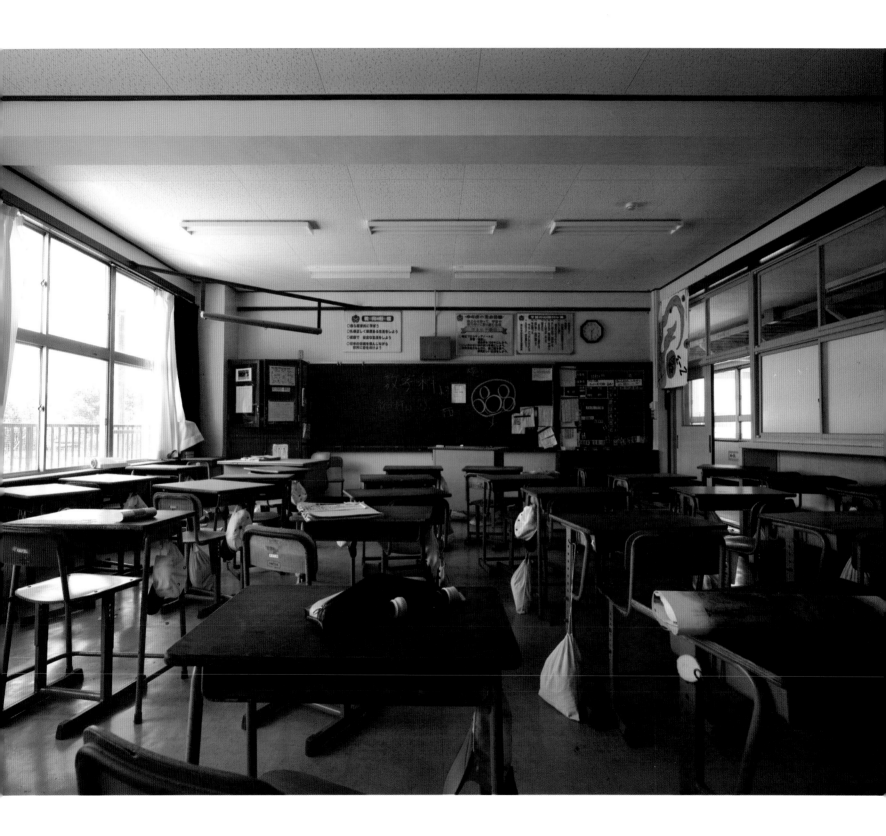

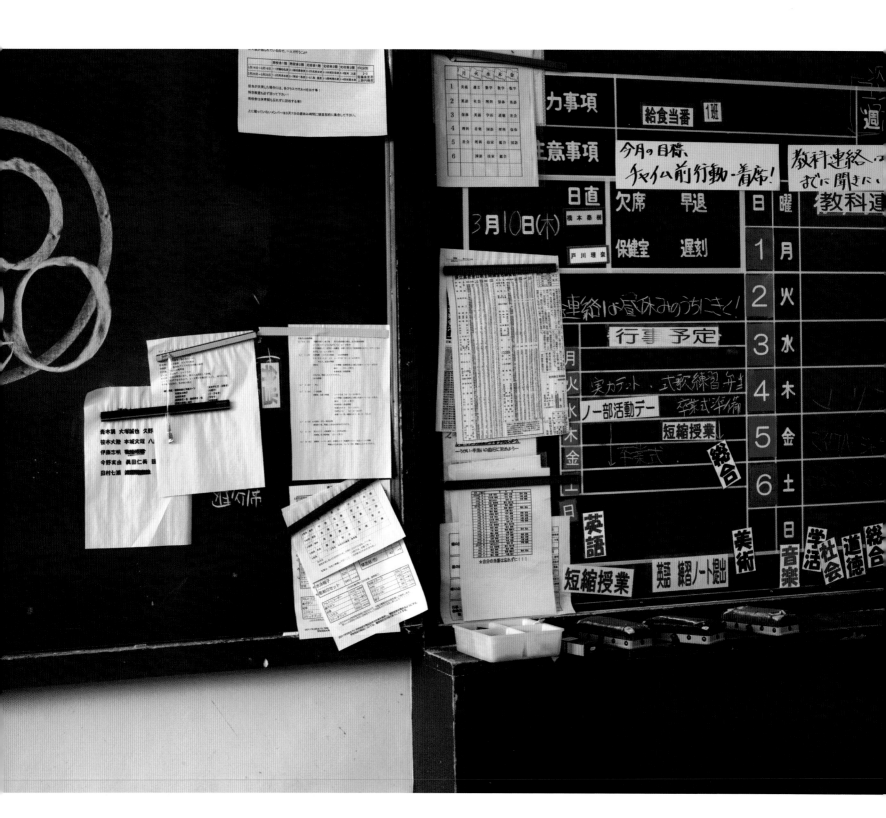

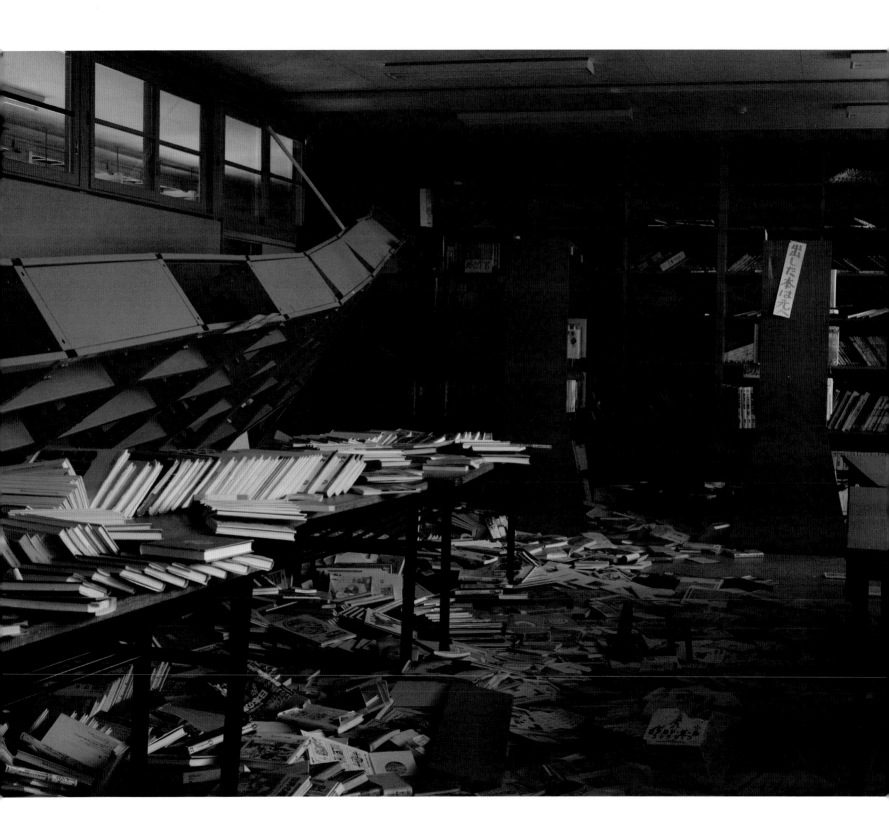

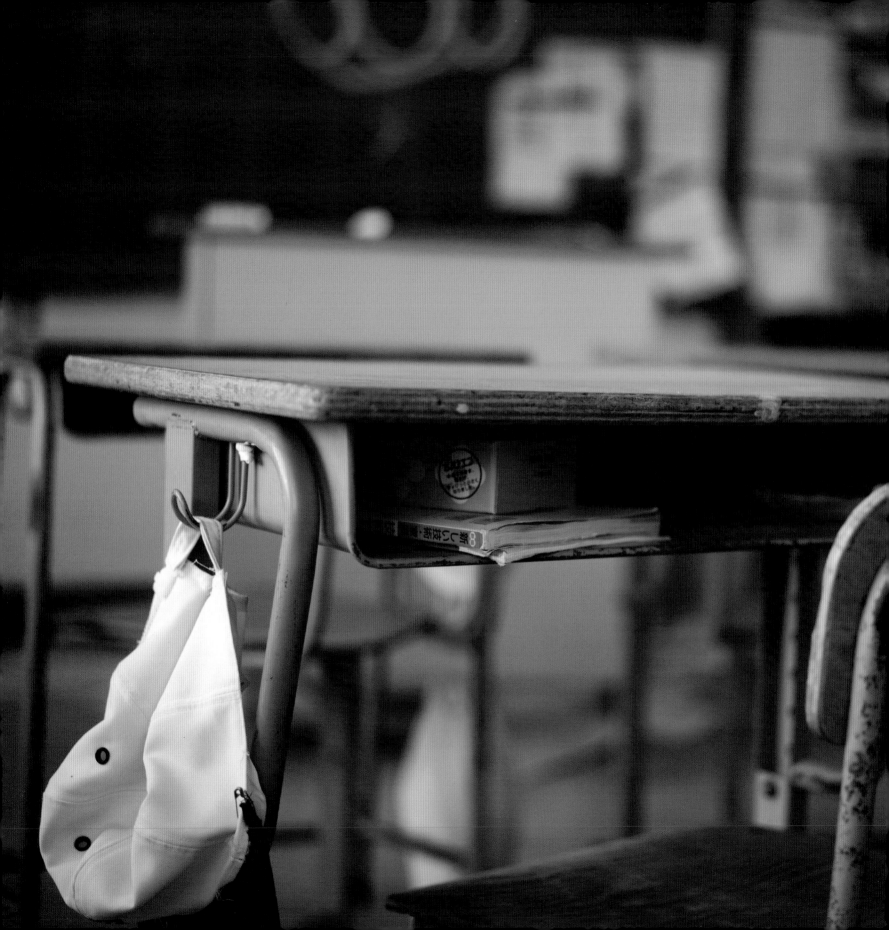

Trauma

The children who lost a loved one in the flood do not talk about it. The experts say this is bad for them in the long term. People try to find ways to help them engage with their loss. They draw pictures. They make photographs. They write essays at school. Trauma is a silent thing.

"If we talk about it, I feel down, so I avoid talking about it. I sometimes want to know what my friends went through but I don't ask. I'm worried that I may not be able to help them."
- Survivor, BBC Interview

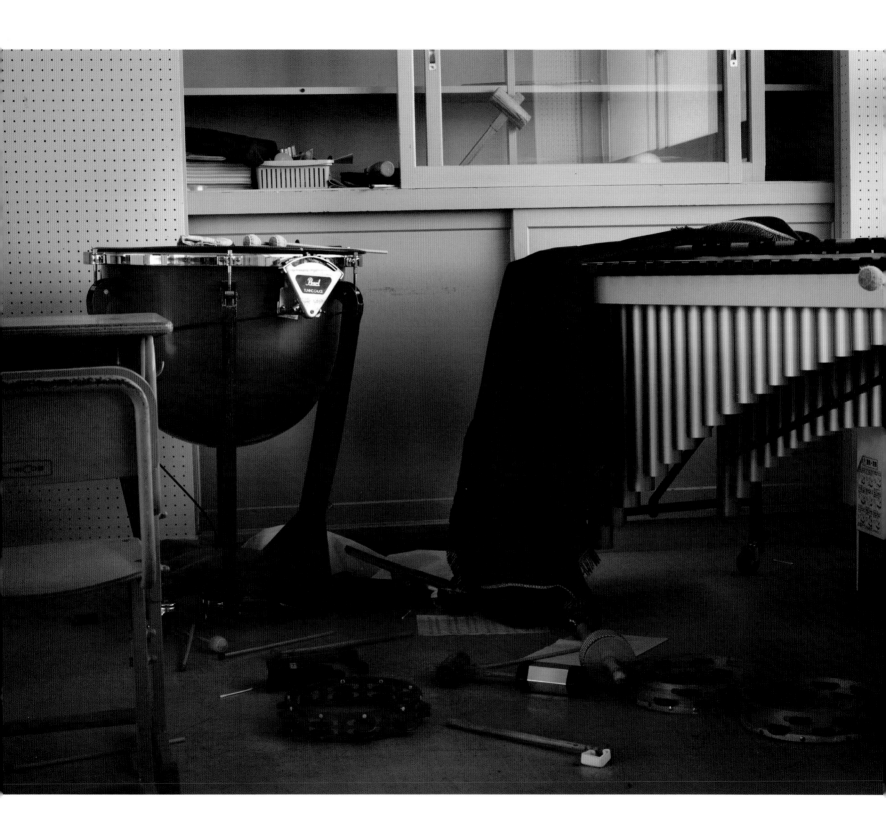

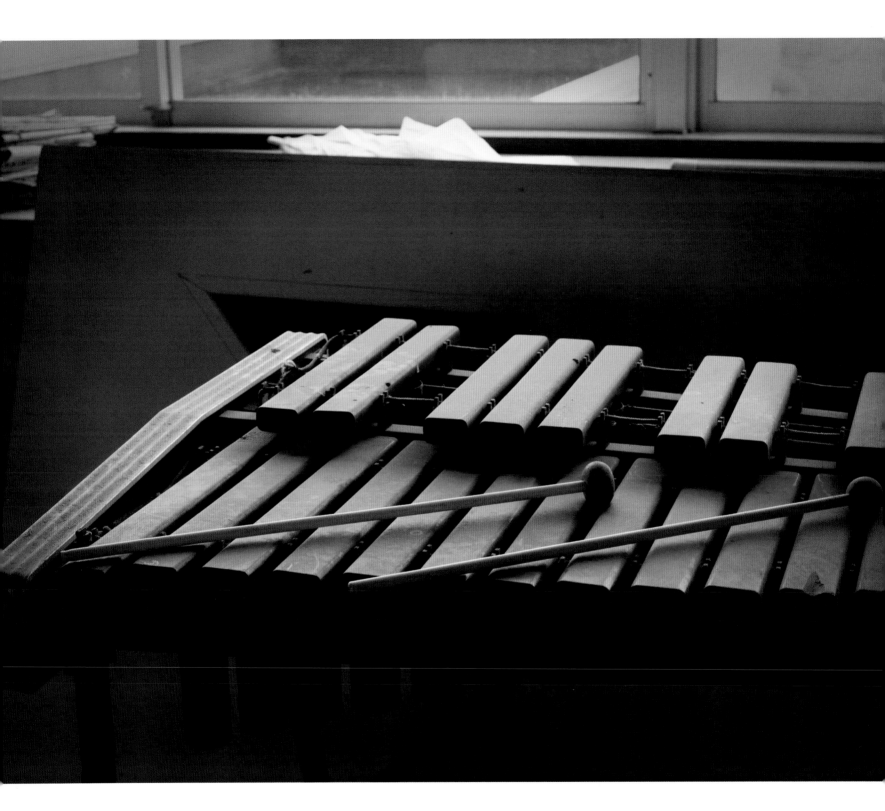

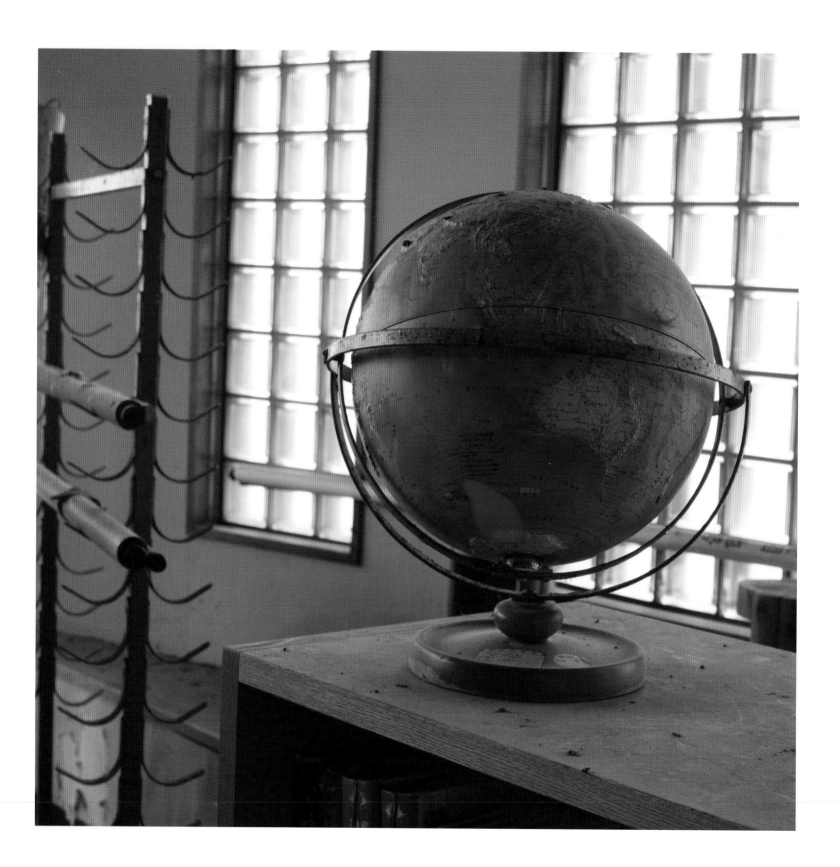

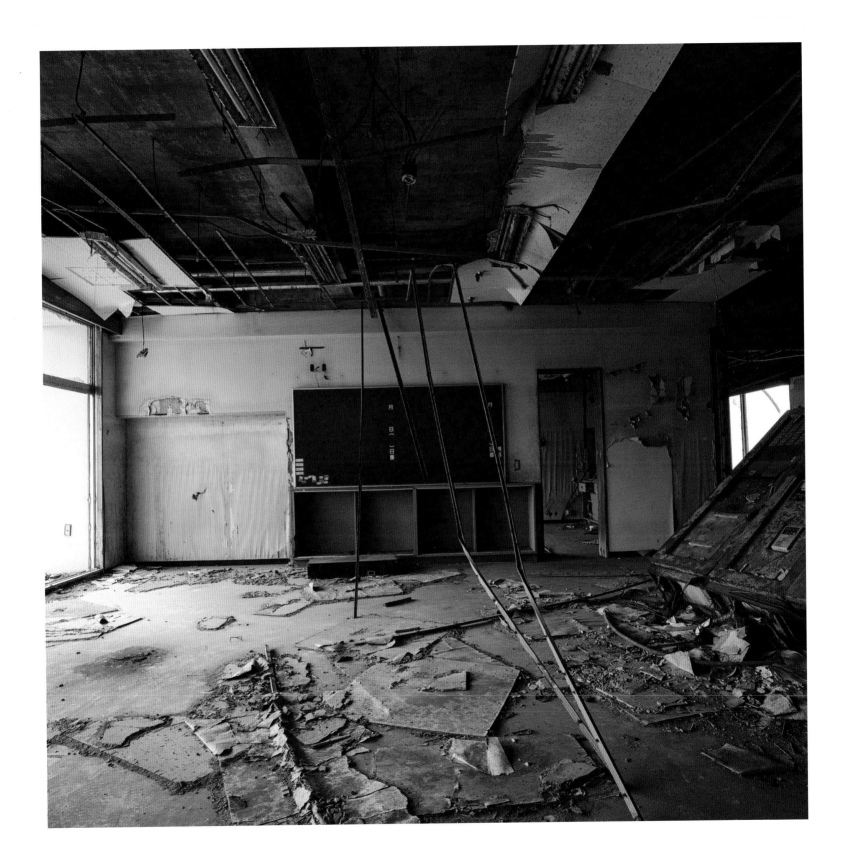

内部被爆

NAIBU HIBAKU

Food

Fukushima is an agricultural district. Panic about the contamination of food from the regions around the power plant has damaged the industry. Much has been done to counteract the fears. The emperor and empress, among others, are photographed tucking into fruit and vegetables with the Fukushima regional stamp. Some supermarkets offer free food testing. People worry about 'internal exposure' but the recovery of the region depends upon the recovery of the Fukushima brand. Scientists assure us that the food is safe to eat. Exports slowly recover.

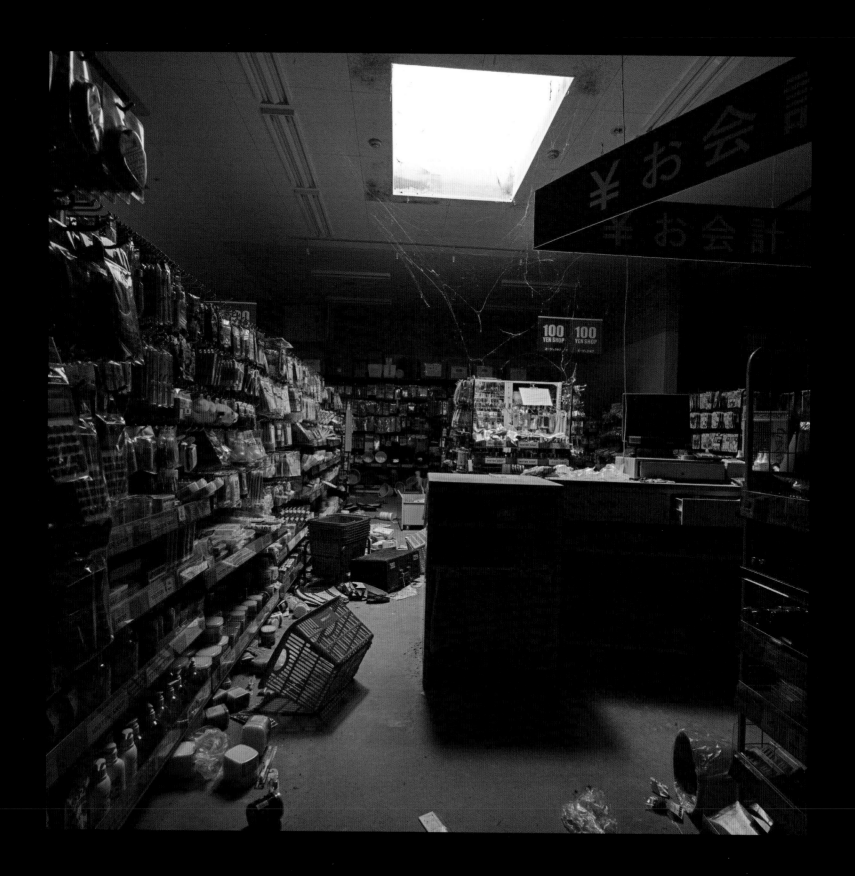

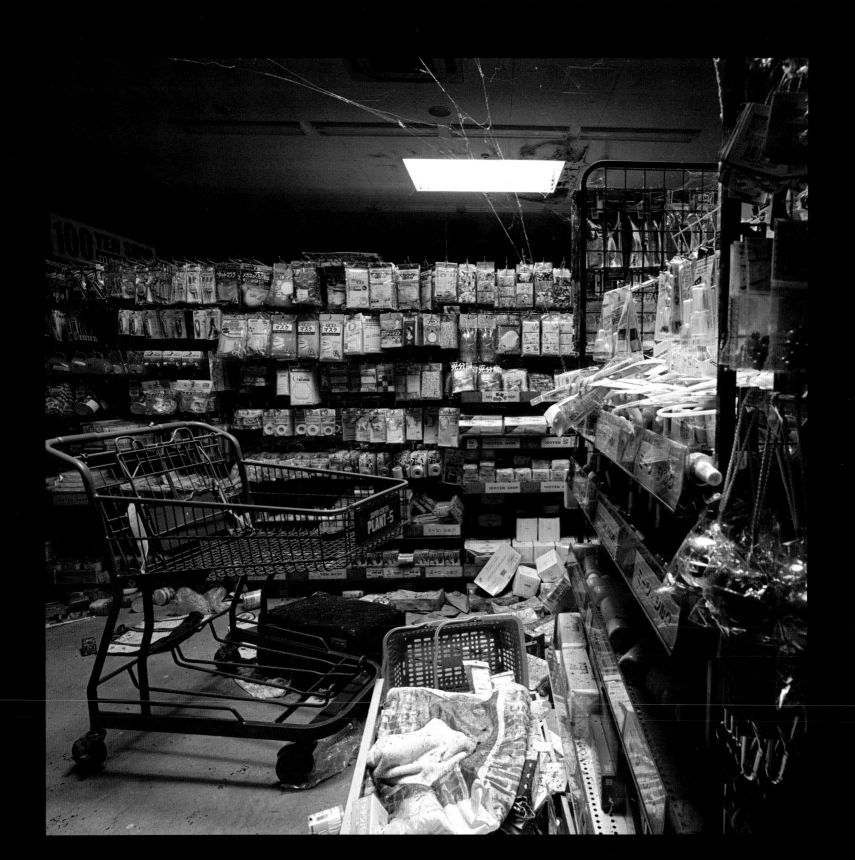

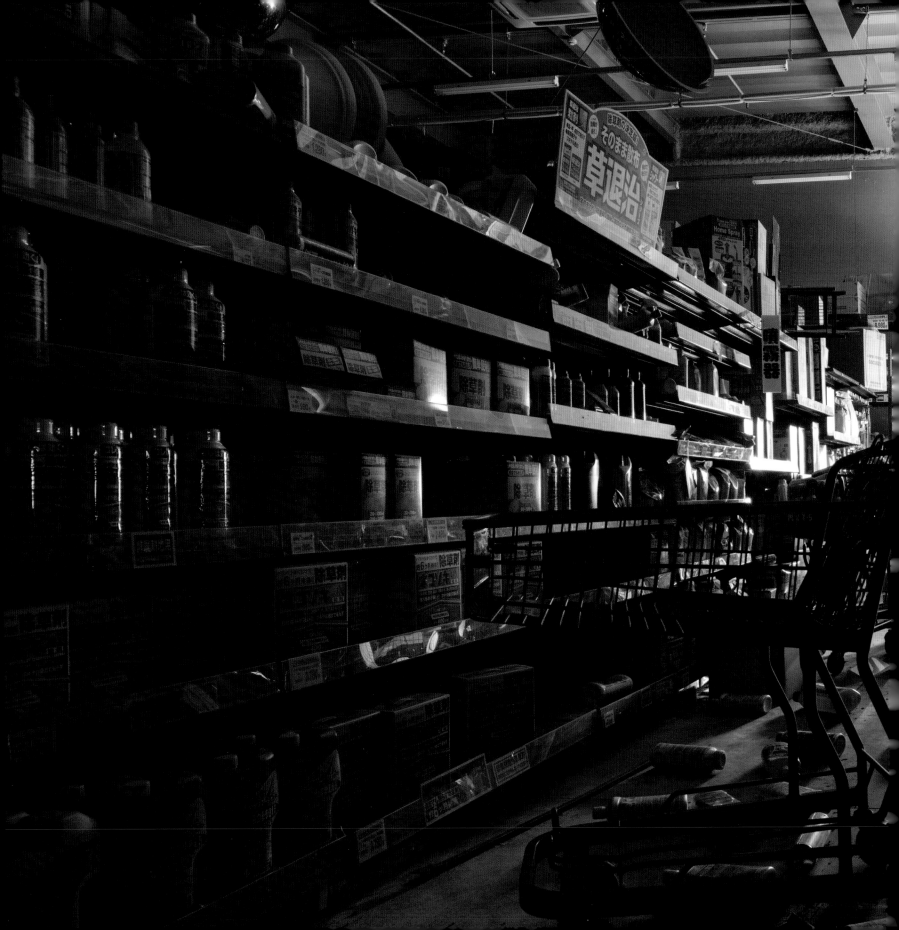

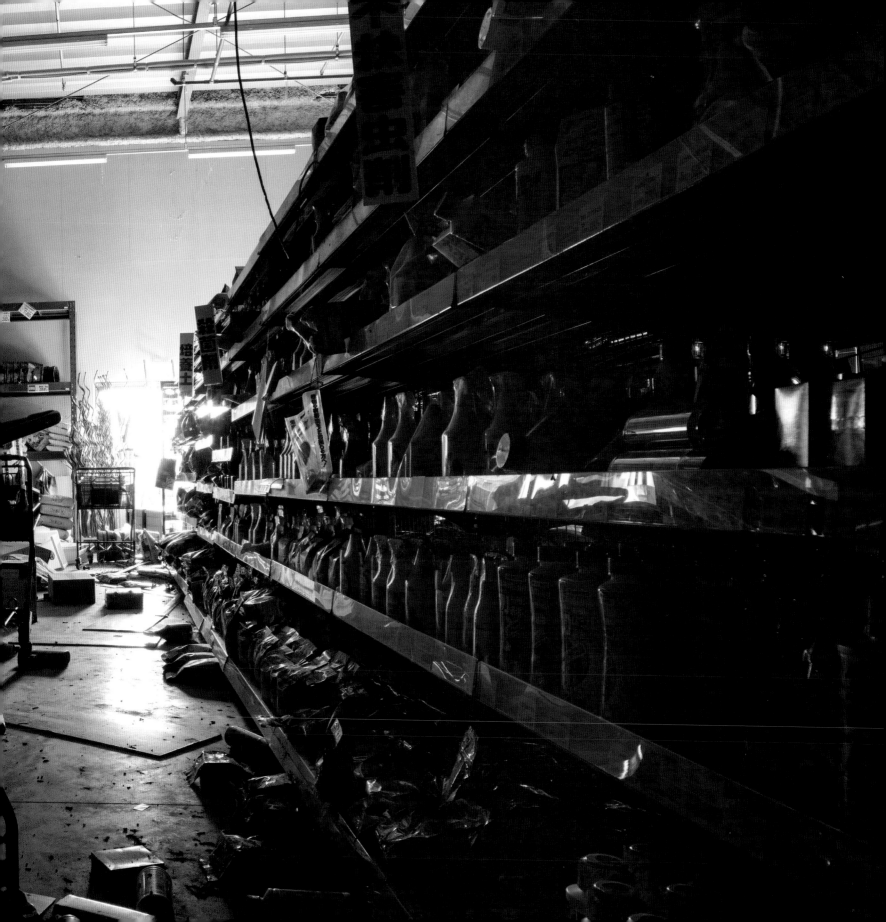

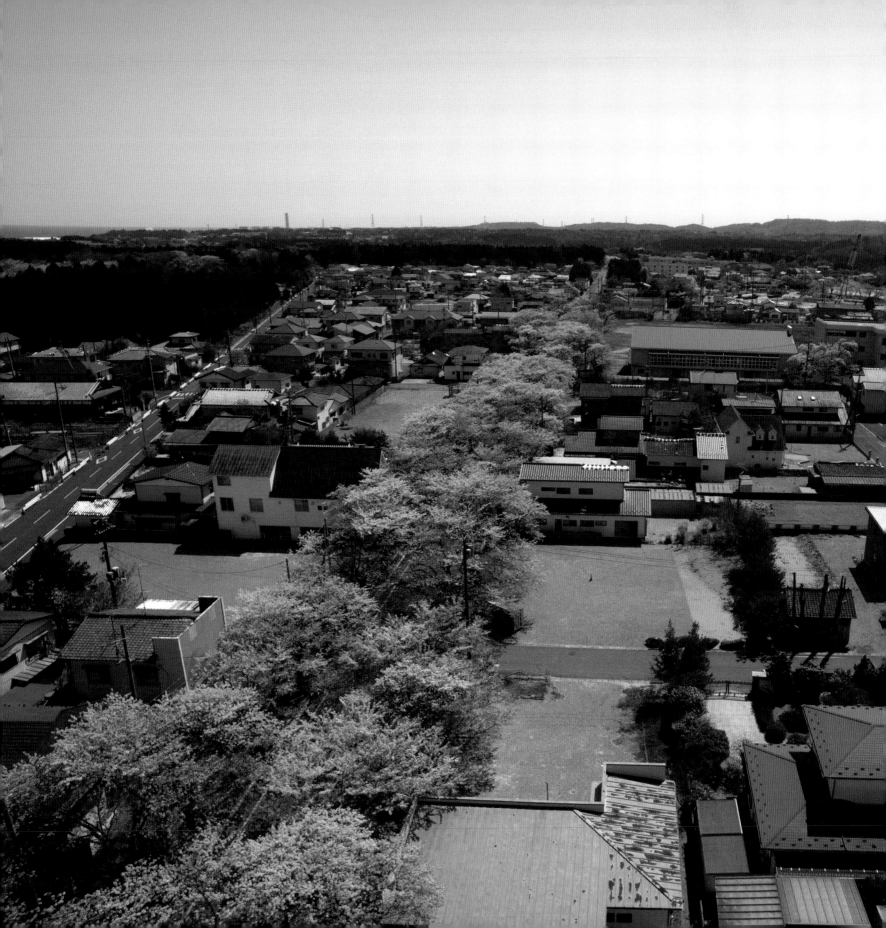

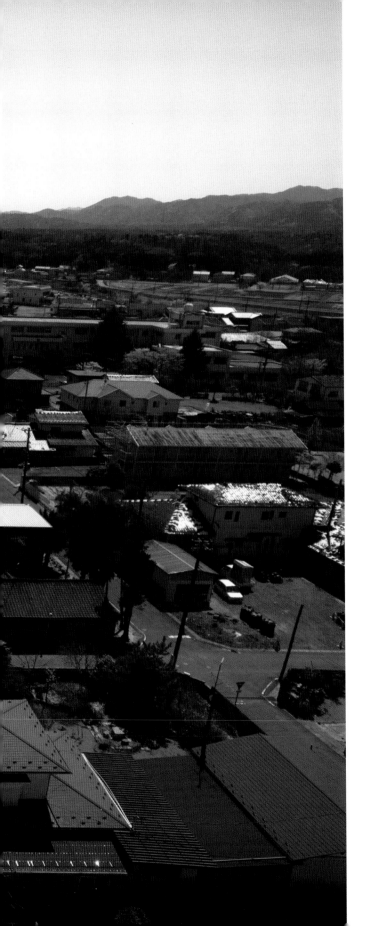

"I'm touched by
this chrysanthemum
it weathered
the typhoon"

- Matsuo Bashō

産総研

SANSOHKEN

Renewables

One of the silver linings of the disaster was a huge upsurge in political will to back renewable energy sources. The government now pays high tariffs to renewable energy producers to encourage growth of solar, wind, hydroelectric and geothermal electricity. They have also deregulated the industry allowing more renewable power plants to be built more easily. The target is to get 20% of national energy from renewables by 2020.

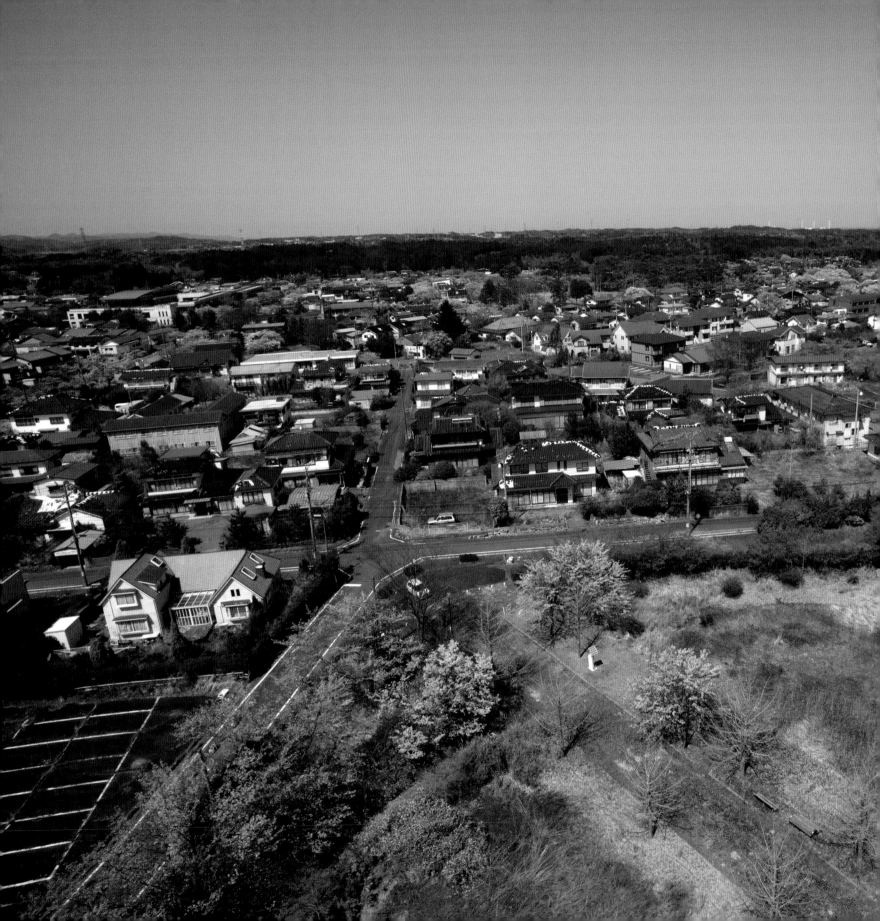

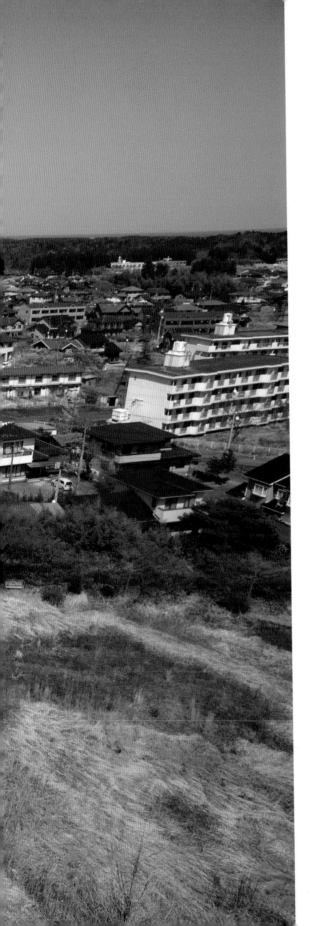

"I came to think that the safest way is to build a society that does not have to depend on nuclear power plants, and that this is possible"

- Naoto Kan, Prime Minister of Japan during the Fukushima nuclear crisis.

THE BLAME GAME

July 2015 a Citizen's Panel - equivalent in status to a Grand Jury in the US system - voted to indict three TEPCO executives for failing to prevent the nuclear disaster at Fukushima. They found that the executives had known in advance of the risks and had failed to take adequate action.

Three years earlier, an investigative committee found that the political culture surrounding the nuclear industry could have precipitated the accident. The government had written a carte blanche to TEPCO by assuring non-interference in their operations. There was an insufficient legal framework in place for monitoring.

Some have even suggested that the Japanese culture of 'saving face' was partially to blame. Executives are supposedly less likely to report problems 'up the ladder' in Japan.

Anyway you look at it - the pursuit of profit is a clear systemic condition of these types of disaster. Companies that are always looking at the bottom line will always be driven to cut costs by delaying infrastructural improvements.

But perhaps nuclear power and it's disasters are a responsibility that we collectively own. As long as we have an insatiable desire for cheap energy - industry will seek to satisfy that demand. Politicians and executives may be motivated by greed or noble impulses, but the result is the same - produce more energy, cheaper, faster, forever.

It's a game that invites the occasional disaster.

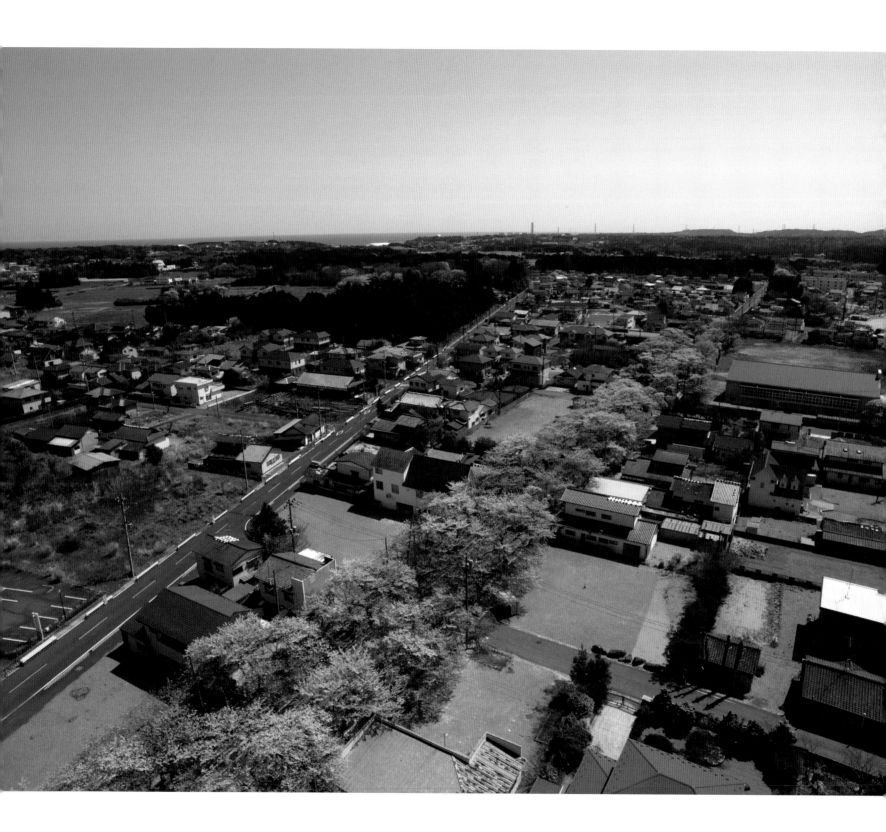

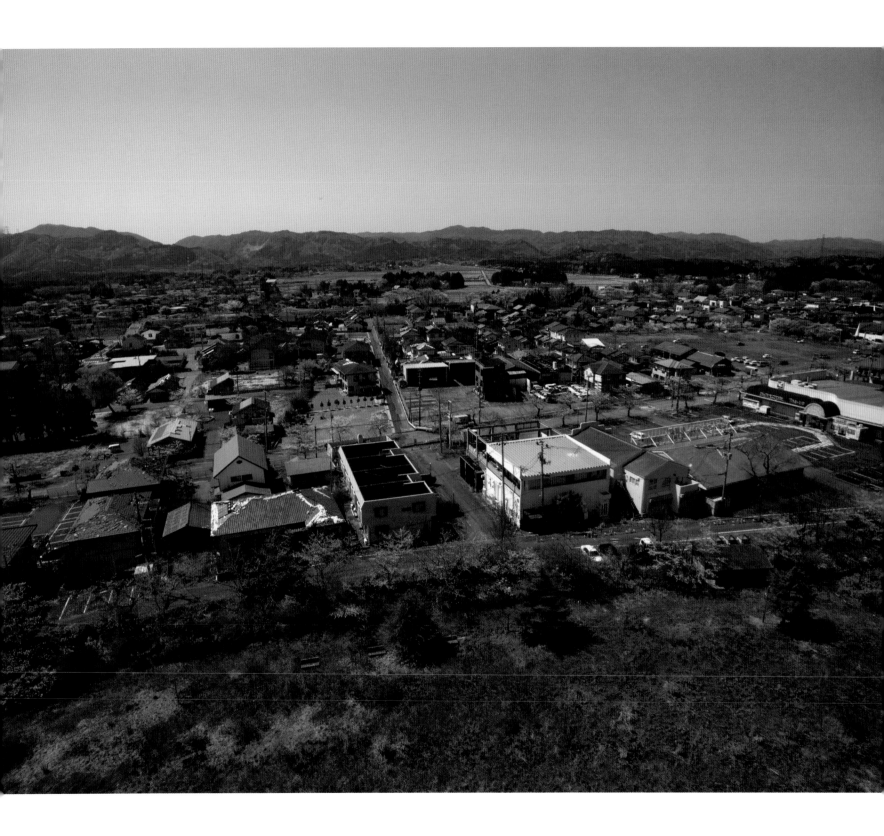

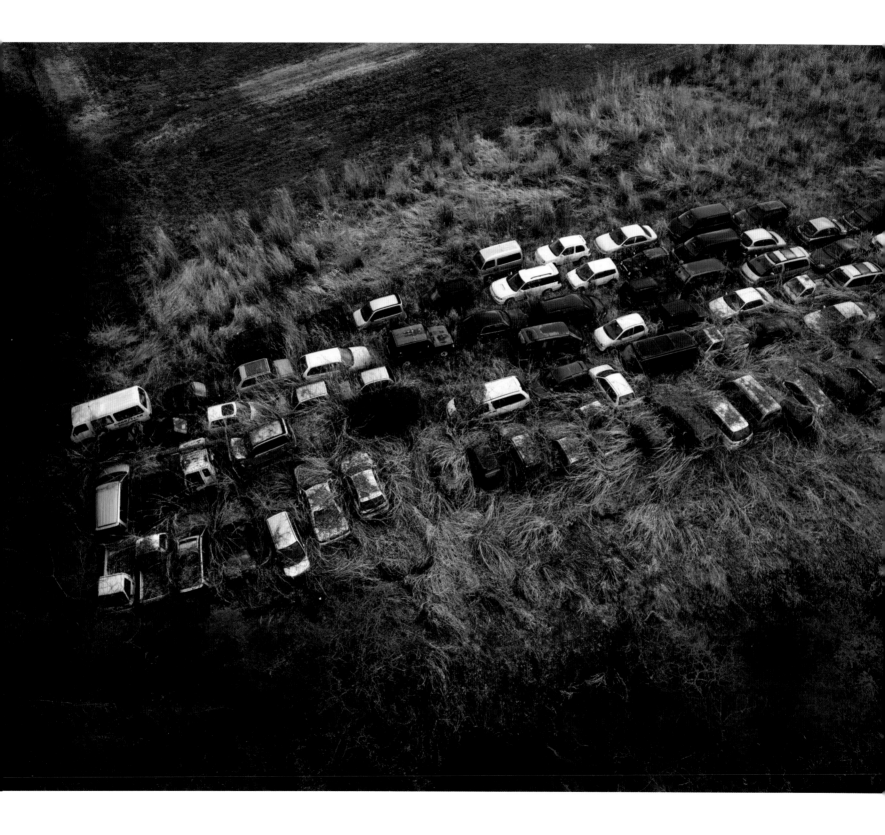

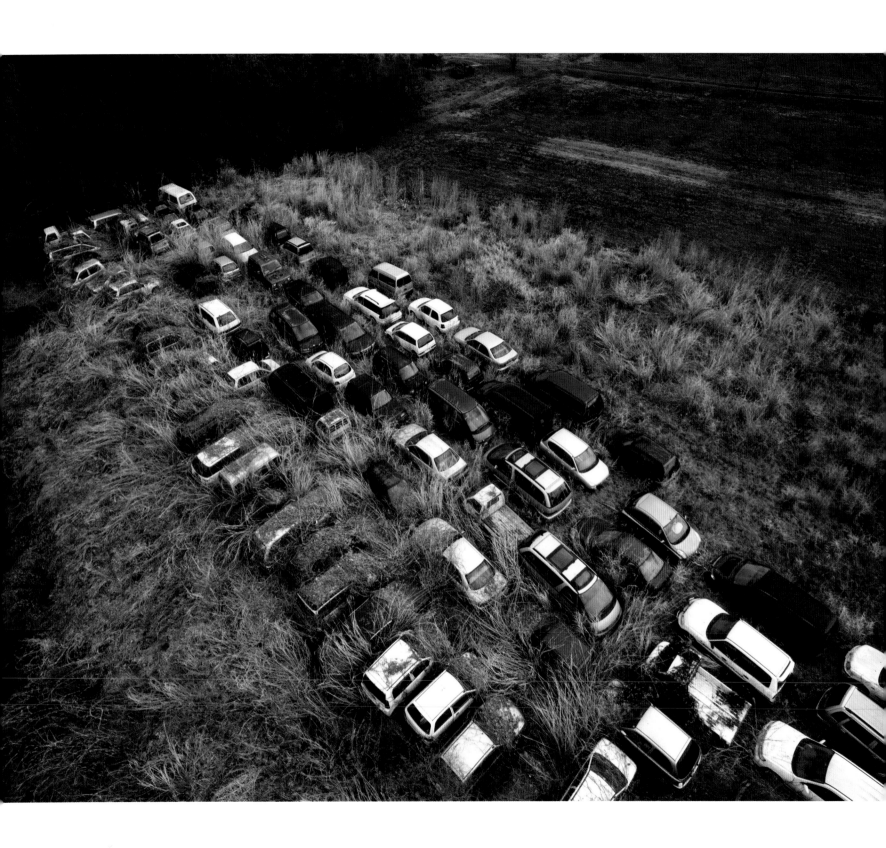

"IN TOMIOKA, IN THE SUMMER,
I COULD HEAR THE SOUND OF THE WAVES.
HERE IN KORIYAMA THERE ARE ONLY CARS
AND THE NOISE OF TRAFFIC.
MY RELATIVES LIVED IN THE SAME VILLAGE.
NOW THEY ARE SCATTERED.
THERE ARE NO PHOTOGRAPHS.
EVERYTHING WAS WASHED AWAY."

- Refugee, http://annekaneko.blogspot.co.uk/

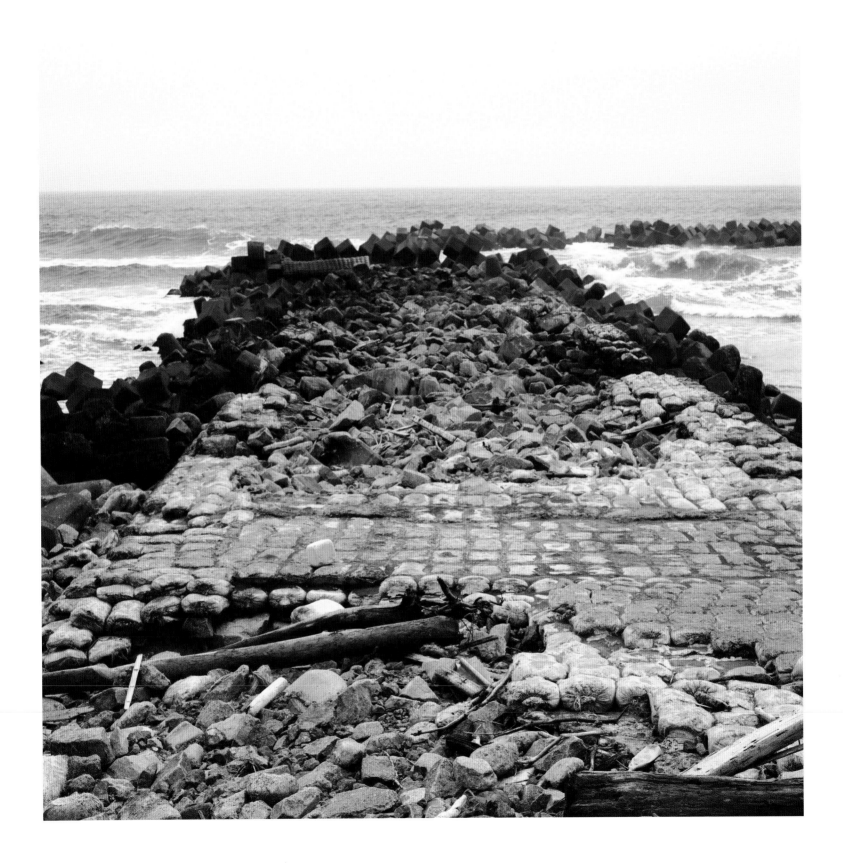

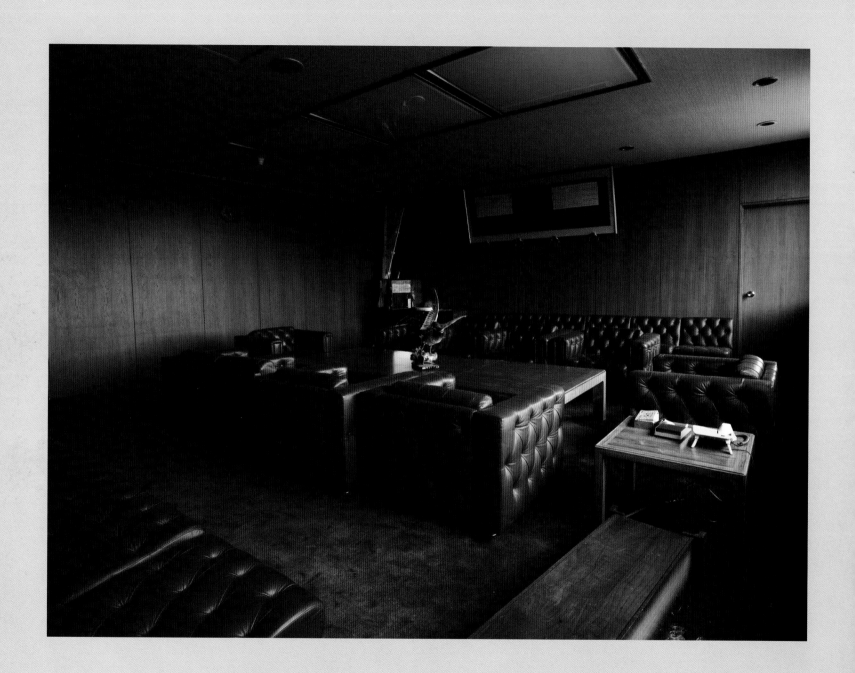

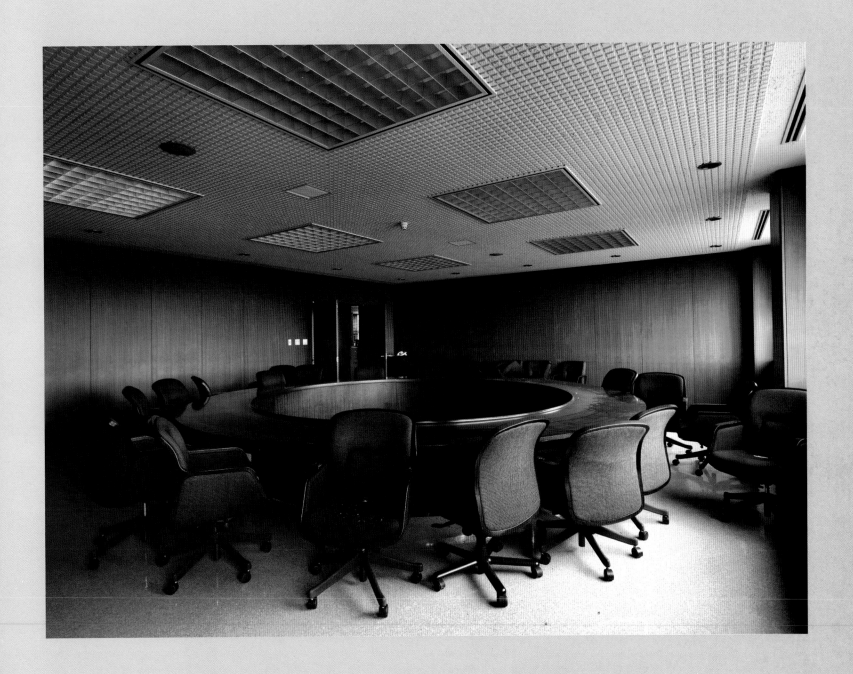

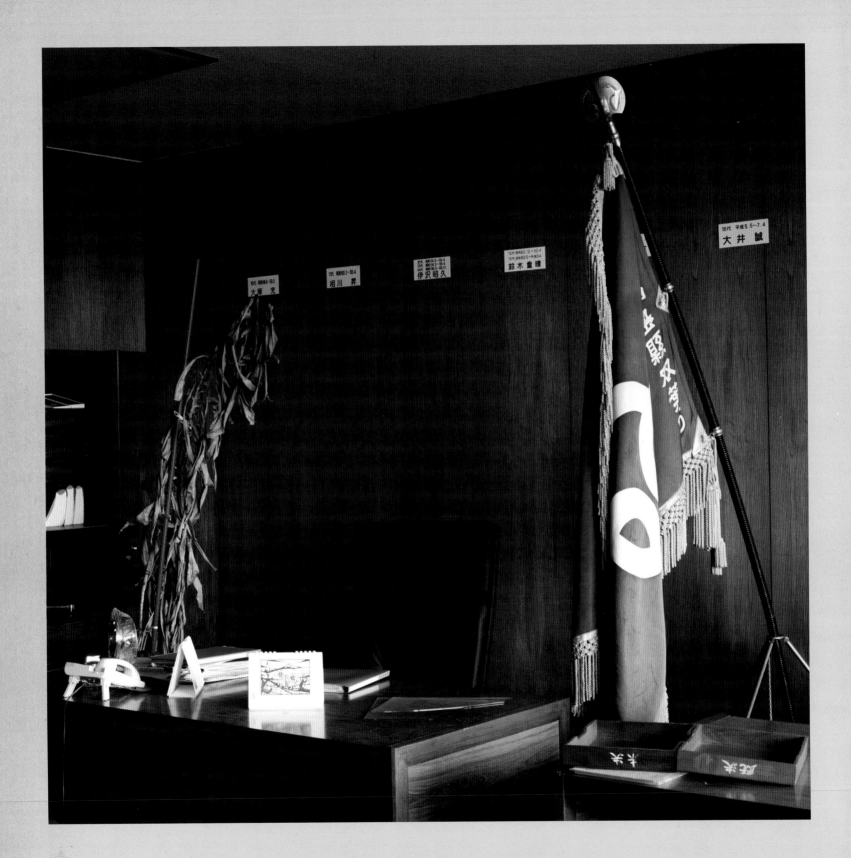

BE BRAVE, BUT NOT
RECKLESS

Friday, 11th March 2011

2.46pm Earthquake of Magnitude 9.0 occurs off Eastern Coast at Honshu Island

3.27pm The first tsunami hits the Dai-Ichi Nuclear Power Plant.

3.30pm A 46ft Tsunami hits, breaching the 19ft seawall and disabling all but one of the back-up generators.

7.30pm Prime Minister Naoto Kan declares a nuclear emergency status.

9.00pm An evacuation order is issued for persons within 3 km of the plant.

Saturday, 12th March 2011

Fuel rods in reactor 3 are exposed. The core of reactor 1 melts.

3.30pm Evacuation of Residents within 10 km of Fukushima 1 begins.

3.36pm Hydrogen explosion in the outer structure of unit 1.

9.40pm The evacuation zone is extended to 20km around Fukushima 1.

Sunday, 13th March 2011

5.10am Fukushima Unit 1 is declared INES Level-4 'accident with local consequences' event on the International Nuclear and Radiological Event Scale (INES)

9.00am Core damage occurs in Reactor 3.

Monday, 14th March 2011

11.01am A hydrogen explosion occurs at unit 3 exposing the spent fuel pool to the atmosphere.

Tuesday, 15th March 2011

11.00am Explosion damages reactor 4. Further explosions take place in unit 3 and 2.

Wednesday, 16th March 2011

Fire is reported in unit 4-reactor building. Evacuation of 20km zone is completed.

Thursday, 17th March 2011

Helicopters are used to drop seawater on spent fuel pools in units 3 and 4. Emergency crews spray water into unit 3.

Friday, 18th March 2011

INES rating at unit 1 upgraded to level 5. Unit 4 is upgraded to level 3.

Saturday, 19th March 2011

High levels of radioactive iodine are registered in tap water in the Fukushima area.

Saturday, 2nd April 2011

Contaminated water from Reactor 2 is found to be flowing into the sea.

Thursday, 7th April 2011

A 7.1 magnitude aftershock strikes.

Tuesday, 12th April 2011

Fukushima incident is raised to an INES level of 7 – the same as Chernobyl.

Saturday, 8th October 2011

Radioactive particles are found beyond the 30km evacuation zone.

December 2011

A decommissioning timetable is announced for the Fukushima reactors. The anticipated completion date is 2052.

October 2014

Japanese government narrows the size of the evacuation zone allowing 275 people from 138 households to return to their homes.

POSTSCRIPT

160,000 people were evacuated from their homes as a result of the disaster. 26,000 people are working on the clean-up.

2016

While the government pushes to lift evacuation orders on some Fukushima communities, a poll published at the time of the fifth anniversary of the disaster shows that two thirds of the nuclear evacuees had given up any hope of ever returning to their homes.

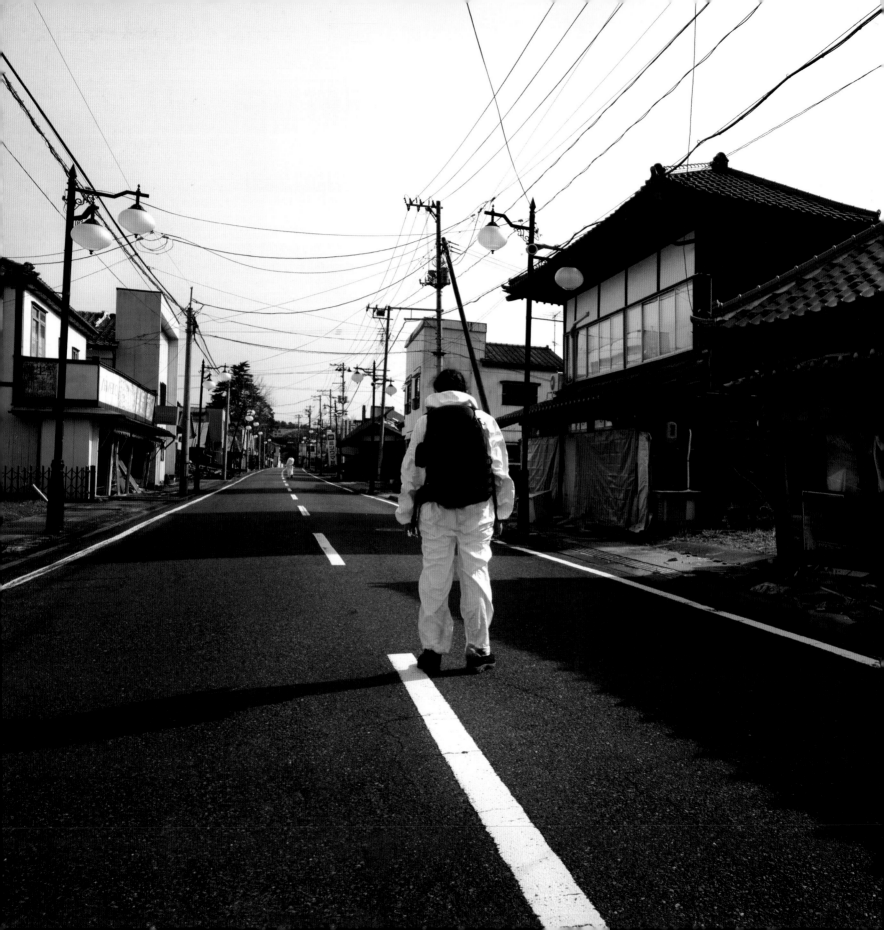

ACKNOWLEDGEMENTS

To my amazing supporting family whom I could not do this without you, those still with me and those that are not.

Philip Parkes, Fiona Peaty, Malcolm Peaty, Caroline Crawford, Howard Parkes, Chrissie Parkes, Leo Parkes, Elias Parkes, Noah Parkes, Niece to Be, Maddie Williams, Derek Williams, Natasha Scanlon, Rhodri Scanlon, Harry Scanlon, Annalise Beedell, Anthony Beedell, Nick Beedell, Stewart Williams, Dee Cook, Paul Cook, Nathan Cook, Dean Cook, Carla Kemp, Dan Kemp, Stanley Kemp, Dan Barsby, Katrina Kemlow Cook, Rex Johnston, Diana Johnston, Tom Cook, Leonard Parkes, Kathleen Parkes, Betty Knappett.

To the people who have been part of my epic journey in 2016 and my special friends that help me more then you could ever know. You have offered me the strength to keep going and I'm eternally grateful.

Jonathan Skinner, Garry Marvin, Ben Gwynne, Michael Gakuran, Richie Gowen, David Smith, Lucy Frier, Tristi Brownett, Nicole Charlotte, Peter Hauenhaus, Bas Van Der Pol, Andrew Avraam, Grazia Valentino Boschi, Arkadiask Podniesinski, Ryan Baldino, Sing Yin, Sa Vong, Jordan Ahnen, Helen Peatfield, Ian Hamilton, Luke Talmage, Irene Milden, Martyn Shaw, Rosanna Lord, Dean 'Douche' Samed, James Kerwin, Gemma Fraser, Simon Pollock, Jade Brimfield, Eli Locardi, Naomi Locardi, Cameron Burt, Michael Petong, Nguyen Vuong, Vincent Patry, Ganesh Singh, Megan Rae, Bang Yuki, Mary Craw-Seibert, Heather Scanlon Lee Summerson, Hernan Gibran, Mur Salim, Vikash Dev Mishra, Theo Leonid, Shannon Morrissey, Claudia Salkeld, Gillian Courtney, Jimer Dela Cruz Degracia, Anna Avaram, Clinton Lofthouse, Renee Robyn, Jess Norgrove, Udi Tirosh, Stefan Kohler, Michèle Dillon, Eyal Yassky Weiss, Jen Brook, Karen Yaniv Guidanian, John Aldred, Mezame Shashin-ka, Jared Polin, Janie Hass, Danny Litchfield, Richard Telborg, Roderique Arisiaman, Simon Elligworth, Rebecca Britt, Colin Tribe, Nicole Sakarra, Sabrina Dunn Gross, Dom Pardey, Dursty Haskins, Mark Rand, Paul Williamson, Melenie Pyndiah, Max Neonlife Monaghan, Anna Larsson, Helen-Lorraine Tope, Sarah Brooke, Talia Long, Chris Lavelle, John Fuller, Hugh Weller-Lewis, Danny Kaye, Rob Bevan, Sarah Winterflood, Bob Swan, Mark Williams, Sara Jakubowicz, Paul James Byrne, Susan Berry, Latex Zebra, Lieke Anna Haertjens, Alastair Jolly, Aviad Erich, Lisa Savage, Tina Eisen, Molly Mishi May, Elbie Bayley, Ronald Koster, Michel Maat, Mitchell Kanashkevich, Kirsty Mitchell, Stephanie Sigriz, Lisa Eryn, Nickie Shobery, Jospeh Parry, Sarah Beth Arnold, Linz Karma, Jonathan Karkut, Tony Roscoe, Vincent Minor, Joel Robison, Kristina Kashtanova, Chris Ravera, Sandra Ayala, Christian Boss, Adi Kaplan, Maria S. Varela, Johnny Joo, Ryan Tankersley, Dick Egan, Marian Egan, Kathy Madison, D Brandon, Dave Kai-Piper, Emerson Soriano, Diane Falconer, Sue Fox, Scott Neidermaier, Space Kitty Joanne, Kate Woodman, Faith Roswell, Wesley Thomas, Felix Kunze, Glenn May, Dai Smith, Ed Thompson, Moggi, Nadine Mogford, Matt Emmett, Linda Cott, Jos Bailey, Paul Powers, Pratik Naik, Bella Kotak, Rob Dietrich, Thomas Ludwig, Dave Geffin, Kevan Parker, Ziv Argov, Stefan Baumann, Neil Watts, Julia Brandt, Jakub Dino Hodr, Stephi Dunk, Rich Carter, Sean Dunk, Tegan Luker, Ben Luker, Radu Nastasia, Connie Hershberger, Joshua Genson, Karen Eng, Michelle Landis, Tommy Magpie, Patrick Di Fruscia, Lauren Josephs, Francesca Gaetone-Levorchchick, Boaz Arad, Luna Luneta, Tom Donnelly, Sophie Donnelly, Anton Vayvod, Nicola Miller, Jonathan Taylor Brittunculi, Ralph Young, Tim Sadler, Danny Lennihan, Yair Shahar, Stephan Epstein.

With special thanks to the following amazing companies, without your incredible equipment on this journey this wouldn't have been possible: Lowepro; Mamiya Leaf; 3 Legged Thing; Lee Filters; Lowel; Black Rapid.